Northwestern University
STUDIES IN *Phenomenology &*
Existential Philosophy

The Meaning of Modern Art

A Philosophical Interpretation

Karsten Harries

The Meaning of Modern Art

A PHILOSOPHICAL

INTERPRETATION

Northwestern University Press

1968 Evanston

Karsten Harries is Associate Professor of Philosophy
at Yale University.

PERMISSION HAS BEEN GRANTED to quote from the following books: *An Anthology of German Poetry from Hölderlin to Rilke in English Translation,* ed. Angel Flores, Doubleday and Company, New York, 1960. Otto von Simson, *The Gothic Cathedral: Origins of Gothic Architecture and the Medieval Concept of Order,* 2d ed., Copyright © 1962 by the Bollingen Foundation, Bollingen Series XLVII. John Canaday, *Mainstreams of Modern Art,* Simon and Schuster, Inc., New York, 1959. Hans Richter, *Dada: Art and Anti-Art,* McGraw-Hill Book Company, New York, 1965. Hans Konrad Roethel, *Modern German Painting,* English translation by Desmond and Louise Clayton, Reynal and Company, New York, n.d. Søren Kierkegaard, *Either/Or,* English translation by Walter Lowrie, D. F. and L. M. Swenson, Copyright 1944 by Princeton University Press. Herbert Read, "The Dynamics of Art," *Aesthetics Today,* ed. M. Philipson, The World Publishing Company, Cleveland, 1961. Jean-Paul Sartre, *Being and Nothingness,* English translation by Hazel E. Barnes, Philosophical Library, Inc., New York, 1956.

Contents

Preface

THAT MODERN ART is different from earlier art is so obvious as to be hardly worth mentioning. Yet there is little agreement as to the meaning or the importance of this difference. Indeed, contemporary aestheticians, especially, seem to feel that modern art does not depart in any essential way from the art of the past. One reason for such a view is that, with the exception of Marxism, the leading philosophical schools today are ahistorical in orientation. This is as true of phenomenology and existentialism[1] as it is of contemporary analytic philosophy. As a result there have been few attempts by philosophers to understand the meaning of the history of art—an understanding fundamental to any grasp of the difference between modern art and its predecessors.

As a matter of fact there is a widespread view of artistic creativity that rules out such understanding. Herbert Read, for example, following Freud and Jung, sees the artist as a "medium, a channel for forces which are impersonal"[2] and which transcend his historical situation. This leads the art critic to look for similarities in works of art belonging to different times and

1. The great exception is Heidegger. But I know of no attempt to base a philosophical interpretation of the meaning of the history of art on Heidegger's understanding of history as the history of Being. Such an interpretation would, I believe, be consistent with the present account. To show this, it would be necessary to demonstrate that the disintegration of the Platonic-Christian conception of man has its foundation in the history of Being as understood by Heidegger.

2. "The Dynamics of Art," in *Aesthetics Today*, ed. M. Philipson (Cleveland, 1961), p. 334.

different places. Similarly, Paul Klee compares the artist to the trunk of a tree, which collects and passes on what has come from below, while Max Ernst credits surrealism with having destroyed once and for all the fairy tale of the creative power of the artist. The artist's role, he feels, is purely passive. Reason, morality, aesthetic considerations, indeed all intentions, stand in the way of inspiration. The artist is his own spectator, watching a play of which he is not the author.

But if this were the whole story, how would it be possible to distinguish art from accident or natural happening? To be sure, the artist is never in complete control. Every painter is aware of the gifts of impersonal accident or inspiration: a few aimless lines or color patches put down on an empty canvas may suggest to the artist a way in which mere strokes can be transformed into a work of art. Or he may instead try to execute a firmly conceived plan and yet be forced by what he has put down to abandon it. But though the artist must acknowledge the stubborn independence of his creation, it is still his creation. He chose to make it and make it in a certain manner. He is more than a medium. Even where he makes an attempt not to stand in the way of accident or inspiration—consider Hans Arp's use of the acciden-tal—the attempt itself is a matter of choice and intention, and we can ask what it was that led the artist to attribute so great an importance to the accidental.

To choose, man must possess criteria to guide his choice. Imagine having to decide between two courses of action. Either there is a reason to choose one over the other or there is no such reason. In the latter case we cannot choose at all: if we are not to stand paralyzed before the alternatives, like the ass of Buridan before the two piles of hay, we must "choose" without reason, a "choice" which cannot be distinguished from accident, sponta-neity, inspiration, nature—call it what you will. If, on the other hand, there is a good reason, one can ask what makes it so: is it good because we chose it, or is its validity independent of our choice? Can the reason be freely chosen? Why this alternative and not another? Was this a rational choice? The original prob-lem reappears. Freedom is possible only where it is limited. To affirm himself and his future man must at least believe that he is given criteria which he can use to arrive at decisions. He may be mistaken in this; his belief may be unwarranted or in bad faith. Still, without such belief there is no choice.

The criteria man uses must not pull him in opposite direc-

tions. They must fit together to form what may be called an ideal image of man. Usually this ideal is not articulated. Few men have a clear idea of what constitutes the good life as they go about their daily tasks. Yet even where man has slipped into a routine which he follows unthinkingly, his actions and pleasures will speak more effectively than any theory can of the ideal image of man which he has accepted. Such an image is the goal of a fundamental project which can be uncovered in all human activity.[3] What is accepted as meaningful or significant will always be something which man feels can bring him closer to that ideal.

If artistic creation is to be understood as deliberate, intentional activity, it must be understood in terms of this project. Art, too, expresses an ideal image of man, and an essential part of understanding the meaning of a work of art is understanding this image. Such discovery is part of learning the language spoken by the artist. This is not to say that the artist must be a philosopher first. His acceptance of the ideal may be, and generally is, so immediate as to prevent him from giving the matter much thought. Yet it determines the direction taken by his art.

When this ideal image changes, art, too, must change. It is thus possible to look at the emergence of modern art as a function of the disintegration of the Platonic-Christian conception of man.[4] Where this tradition has lost its force art may be expected to take forms unknown to traditional aesthetics.

The modern artist no longer has an obvious, generally accepted route to follow. One sign of this is the fact that there is no

3. Cf. Jean-Paul Sartre, *Being and Nothingness*, trans. Hazel E. Barnes (New York, 1956), pp. 557–75. I agree with Sartre that this fundamental project is a project to become like God, i.e., "fundamentally man is the *desire to be,* and the existence of this desire is not to be established by an empirical induction; it is the result of an *a priori* description of the being of the for-itself, since desire is a lack and since the for-itself is the being which is to itself its own lack of being" (p. 565). This description of man remains empty as long as we are not told *how* man seeks to be like God. Different conceptions of God correspond to different interpretations of man's fundamental project. Which interpretation is accepted depends, according to Sartre, on the free choice of the individual. Yet Sartre misinterprets the human situation when he "recognizes nothing *before* the original upsurge of human freedom" (p. 569). Man's interpretation of the fundamental project is conditioned by what he is, and what he is is determined in part by his place in history.

4. That such an account cannot do justice to modern art and its origins is evident. Art is too rich to be caught in this simple a net. The phenomenon is distorted. But such distortion is dangerous only if the model offered is mistaken for an adequate picture.

one style today comparable to Romanesque, Gothic, Renais-
sance, or Baroque. This lack of direction has given the artist a
new freedom. Modern art is open as traditional art was not.
Today there is a great variety of answers to the question, "What
is art?" Such variety, however, betrays an uncertainty about the
meaning of art. How many artists of the nineteenth and twen-
tieth centuries have felt the need to write about their work in an
attempt to justify their art to themselves and to the public. One
may counter by calling attention to such movements as action
painting, *tachisme, automatisme;* do they not show that modern
artists are striving to work less self-consciously and more
immediately? The remarks made by Read, Klee, and Ernst point
in the same direction. But does not the attempt to create less
self-consciously presuppose a high degree of self-consciousness?
Is it childlike to wish to return to childhood? Can the desire to
return to paradise restore lost innocence?

An uneasiness about the meaning of art has led modern
artists to enter into a dialogue with art historians, psychologists,
and philosophers. Perhaps this interpretation can contribute to
that dialogue.

PART I

Historical Introduction

1,

1 / Christian Backgrounds

MAN STANDS BETWEEN what he has become and what he is to be. If it were not for this tension between a closed past and an open future, there would be no need to oppose an ideal to the actual. But man is not just another fact and as such complete; he has to choose what he is to be. The tension between past and future forces man to distinguish what he should be from what he has become. Man is in search of an ideal; yet in searching for this ideal, he only seeks to become truly himself.

Plato first gave clear expression to this view. Man, he suggests, has been cast from being into becoming. This fall has alienated him from his true nature, which must be sought in the realm of being. But this alienation is not total. Man is not completely lost in the temporal. The ideal, which for Plato is also the truly real, although no longer seen clearly, is not forgotten altogether. It still calls man to seek an escape from becoming where satisfaction is not to be found; for to be satisfied is to be complete, though as a temporal, conscious being man cannot escape an awareness of his own incompleteness. Inseparable from it is a desire to find more than fleeting satisfaction. This desire Plato calls love.

In the *Symposium* beauty is defined as the object of love. To be in love is to be in need; man loves because he seeks to complete himself in the loved. Such completeness can be found only beyond time. Beauty belongs thus to being rather than becoming. Plato interprets being as a realm of forms or ideas. The changing world with which our senses confront us is only

the image of these forms. Whenever something beautiful is discovered in the world, the form is recognized in the thing. Beauty is the epiphany of being.

Usually when Plato speaks of beauty he is not thinking of art. In the *Republic* he even discourages all attempts to relate his understanding of the beautiful to a theory of art: poets are twice removed from reality, imitators of imitations. And yet, Plato's understanding of beauty permits another view of art. After all, the forms do not dwell in some empyrean beyond in splendid isolation. They are imitated by and appear in the changing world. Whenever man finds something through which the form speaks with particular clarity, he is awakened to his own essence. Beauty can thus be defined as the sensuous appearance of the ideal, which recalls and to some extent restores man to his true being. Why, we can now ask Plato, must the artist be twice removed from reality, one who imitates appearances which are themselves but imitations of forms? Is it not possible, as Plato himself seems to suggest in the *Ion*, that the artist dwells closer to the ideal than other men and thus possesses the strength to act as mediator between gods and men? Is not the artist someone who more clearly than others senses the presence of the ideal in the sensuous and translates this awareness into works of art which are themselves lit up by a ray of the holy? Thus Plotinus, while he accepts the Platonic account of beauty, rejects Plato's criticism of the arts:

> Still the arts are not to be slighted on the ground that they create by imitation of natural objects; for, to begin with, these natural objects are themselves imitations; then, we must recognize that they give no bare reproduction of the thing seen but go back to the Reason-Principles from which Nature itself derives, and, furthermore, that much of their work is all their own; they are holders of beauty and add where nature is lacking. Thus Pheidias wrought the Zeus upon no model among things of sense but by apprehending what form Zeus must take if he chose to become manifest to sight.[1]

The beauty of the work of art is like the beauty of the appearing god. Art is not a mere copy of nature; rather it transforms nature into something higher. The divine origin of nature is made manifest.

1. *Ennead* V. 8. 1, trans. S. MacKenna, in *Philosophies of Art and Beauty, Selected Readings in Aesthetics from Plato to Heidegger,* ed. A. Hofstadter and R. Kuhns (New York, 1964), p. 152.

Yet a good Platonist can admire sensuous beauty only with a slightly bad conscience. Plotinus, too, dreams of a beauty which must elude the artist:

> But what must we do? How lies the path? How come to vision of the inaccessible Beauty, dwelling as if in consecrated precincts, apart from the common ways where all may see, even the profane? He that has the strength, let him arise and withdraw into himself, foregoing all that is known by the eyes, turning away for ever from the material beauty that once made his joy.[2]

The Platonic conception of the ideal places too great a stress on the spirit to permit anything else. Sensuous beauty, if allowed at all, has to be purified by subordination to a severe intellectual discipline. One only has to recall the famous passage in the *Philebus* which some modern artists seem to have adopted as their motto: beauty, Plato tells us here, is not to be found in the complexities of organic nature, but in geometry; not in flowers, animals, or the infinite subtlety of the human body, but in straight lines, circles, and squares.[3] The artist, were he to follow Plato's advice, would do well to turn to compass and ruler instead of to nature; instead of studying anatomy he should read textbooks on geometry. Plato approves of the sensuous only in its most disembodied form. Thus the purity of one of Mondrian's compositions could perhaps satisfy Plato's demands.

To stress purity to this extent is to run the risk of robbing the artist of his medium and asking him to become little more than a poor mathematician. And yet, the theory behind such demands is quite clear. By denying the sensuous as much as possible, the artist is to reveal beauties of a higher order which is free from the confusion and changeability of the temporal. Our recognition of this higher beauty is significant precisely because it is at the same time a recognition of man's true home.

> Our interpretation is that the Soul—by the very truth of its nature, by its affiliation to the noblest Existents in the hierarchy of Being—when it sees anything of that kin, or any trace of that kinship, thrills with an immediate delight, takes its own to itself, and thus stirs anew to the sense of its nature and of all its affinity.[4]

For a moment man is set at rest, freed from the tasks of becoming, dwelling among the gods.

2. *Ennead* I. 6. 8 (*Philosophies of Art*, p. 149).
3. *Philebus* 51.
4. Plotinus *Ennead* I. 6. 2 (*Philosophies of Art*, p. 143).

[2]

NEO-PLATONISM ACQUAINTED CHRISTIANITY with this conception of the beautiful, but its translation into a Christian context gave it a richness which it had not possessed before. While both accounts agree in interpreting man's present state as one in which man is removed from his true being, the Christian understanding of the fall gives new substance to this notion. The original state from which man has fallen can now be identified with the paradisical existence of Adam. This, however, changes the Platonic account into something quite different: the fall is interpreted by the Christian as having taken place within the terrestrial; it was not a fall into it. The terrestrial can be changed back into a paradise-like state, just as it had once been paradise. The second Adam, Christ, can redeem us from the sins of the first and thus bind matter to spirit, body to soul, re-establishing the bond which man's disobedience has loosened. Christianity with its stress on the resurrection not only of the soul, but of the body as well, could thus come to a more positive assessment of the body and the senses, even if it often failed to do so. Its conception of the ideal state is not as exclusively spiritual as the Platonic. Thus St. Augustine assures us that the blessed not only will know but also will see the splendors of the City of God. "I shall say no more, except that to us is promised a vision of beauty." [5] Beauty on earth is said to be an imitation of the splendors of the Heavenly Jerusalem, giving man a foretaste of the pleasures of the blessed.

[3]

THE ART MOST QUALIFIED to imitate the Heavenly City is architecture.[6] Just as the church, the community of believers on earth, is but an image of the invisible church above, so

5. *De ordine*, chaps. 19, 51, trans. R. P. Russell (*Philosophies of Art*, p. 185).

6. Cf. Günter Bandmann, *Mittelalterliche Architektur als Bedeutungsträger* (Berlin, 1951); Hans Jantzen, *Kunst der Gotik* (Hamburg, 1957); Otto von Simson, *The Gothic Cathedral: Origins of Gothic Architecture and the Medieval Concept of Order* (2d ed.; Princeton, 1962), Bollingen Series XLVII (New York, 1956); Hans Sedlmayr, *Die Entstehung der Kathedrale* (Zurich, 1950).

the beauty of the physical church is but an image of the city in heaven. For a glimpse of its beauty man could turn to revealed Scripture and mystic literature.

Given the general idea of the church imitating a city, the artist could still respond in different ways. What is a city? Among other things it is a place which protects man; in it he seeks refuge from the insecurity reigning outside; behind its walls he finds safety and peace. But it can also be a place of joy, welcoming the traveler with its delights. These two conceptions dominate the church architecture of the Middle Ages. The first tends to give way to the second with the rise of Gothic architecture. Where the idea of the church as a fortress is emphasized we can expect a military iconography. This finds its focus in the western part of the church, for it is in the west, which daily conquers the light of day, that man expects evil, while salvation lies in the east. As in Corvey (*ca.* 880) or Paderborn (11th century) the façade is conceived as a bastion against evil, a wall or tower, rising without large openings, defying the onrushing hordes of the devil.[7]

The painting of the period knows little of this tension; it possesses a serenity which seems to leave no room for the struggle against evil which is part of life in this world. The masters of the *Egbert Codex* (*ca.* 980) or the *Bamberg Book of Pericopes* (*ca.* 1010) did not find nature worth representing; the eternal alone mattered.[8] Consequently every attempt was made to eliminate that which might suggest the individual and the concrete. The artist tried to represent a disembodied, immaterial reality. All suggestions of corporeality were carefully avoided; human forms are seen in geometric abstractions. At this time an anonymous monk introduced the gold background into Western painting as a device to remove the portrayed events from the temporal.[9] The events depicted against this background do not happen at a given time or place. Thus "the visit of Christ to the house of Martha becomes a strange, mysterious event rather than a domestic incident, an event outside Time involving the solemn, frozen participation of paradigms of persons." [10] We find ourselves in an atemporal, spiritual realm which knows no heaviness, no matter.

7. Cf. Sedlmayr, *Die Entstehung der Kathedrale*, pp. 120–24.
8. Hans Jantzen, *Ottonische Kunst* (Hamburg, 1959), pp. 65–80.
9. *Ibid.*, p. 72.
10. John Beckwith, *Early Medieval Art* (New York, 1964), p. 112.

But this overemphasis on the spiritual and the implicit rejection of the sensuous posit the latter as something to be negated and overcome: a realm of sin and temptation.[11] Whenever an attempt is made to assert an ideal image of man which is too narrow to do justice to the richness of the human situation, the demand for another compensating view of man arises. This view is unacceptable since it denies the ideal; it must therefore be suppressed. And yet it is powerful enough to make such suppression only partially successful. The ideal which is too divorced from the actual casts a shadow; it is accompanied by a counter-ideal. The attractions of this counter-ideal are essentially temptations. Thus we find, next to an art which portrays the ideal, another devoted to the counter-ideal. Such art may be pressed into the service of the ideal. It may be tolerated as a teaching device which guards man against temptations by presenting him with warning images. It may be used to provide contrast which will reveal the ideal more clearly, just as Denis the Carthusian thought that watching the pains of the damned was part of the pleasures of the blessed. But the demonic side of medieval art can scarcely be reduced to this. Gislebertus must have known about the beauty of the horrible images he created; he must have taken some delight in the exquisite sensuousness of his Eve at Autun (before 1135). She, too, recalls man to his essential being, but her appeal is not to the spirit; she does not call man to the accepted ideal. Gislebertus' Eve is a temptress; her voice is that of evil. The suppressed demands of reality reassert themselves as the demonic. Experiencing the power of the demonic, man knows himself to be a sinner and distant from God. This distance characterizes Romanesque presentations of Christ. We see neither the suffering, human Christ of the passion, nor the redeeming Christ of Easter, but the Judge of the Apocalypse who divides the damned from the elect. As such he appears unforgettably in the tympanum over the main doorway at Autun. Equally unforgettable is a detail of the lintel: a screaming nude figure, strangled by two enormous claws. *Terreat hic terror/ quos terreus alligat error/ nam fore sic verum/ notat hic horror specierum.*[12]

11. Cf. Søren Kierkegaard, *Either/Or*, trans. Walter Lowrie, D. F. Swenson, and L. M. Swenson (New York, 1959), I, 59–63.

12. "Here let fear strike those whom earthly error binds, for their fate is shown by the horror of these figures." Inscription below the right half of the tympanum. Denis Grivot and George Zarnecki, *Gislebertus, Sculptor of Autun* (New York, 1961), p. 26.

The Beast Column in the crypt of the cathedral at Freising, carved by an anonymous master around 1160, sums up this view of the human situation. On the north and south sides of the column we see knights fighting with dragons rising from the west. Other dragons, at the base of the column, are doing their best to fell the struggling knights. On the east side we discover a woman staring into the east, a lily in her hand, apparently unconcerned and unaware of the fighting around her. Life is seen as a struggle against an enemy which seems all but invincible. Yet the fight must be waged, and the *ecclesia,* the City of God, remains serene, almost indifferent to man's fate.[13]

[4]

THIS VIEW OF MAN and the attendant conception of art lingered longer in Germany than elsewhere. While the idea of the church as a fortress found its last great expression in the cathedral at Limburg (first half of the 13th century) a different conception of the church had emerged in France—a conception of the church not as a fortress but as a place of joy. Already in the conception of façade and portals this difference is apparent. Christ still presides over the *porta coeli* as a threatening judge. But fear is only one element of Gothic faith; equally important are hope and love. A sign of this is the growing veneration of the Virgin who willed to receive God and thus let God become flesh in her. By giving birth to Christ, she reconciled the spiritual and the mundane. Closer to sinful man than her Son, she is *advocata nostra,* and yet as mother of God she is *regina coeli.* As such she appears on the façades of the cathedrals of Amiens, Reims, and Paris.[14]

This development is part of a shift away from the extreme tension between the actual and the ideal which still speaks to us in Gislebertus' tympanum at Autun or in *The Beast Column.* A new interest in the sensuous and concrete emerged. Thus while the early medieval miniaturists used every device to dematerialize their medium, the Gothic artist willingly accepted the

13. Cf. Michael Höck and Alois Elsen, *Der Dom zu Freising* ("Kleine Führer, Schnell und Steiner," no. 200), (3rd ed.; Munich, 1952), pp. 23–29.

14. Jantzen, *Kunst der Gotik,* pp. 115, 122 ff.; Alois Dempf, *Die unsichtbare Bilderwelt* (Einsiedeln, 1959), pp. 244–50.

sensuous without surrendering the claim that art is capable of giving us representations of the divine. An attempt was made to depict the ideal in the concrete; and looking at the statues at Reims and Bamberg or at the great cathedrals, one feels that here the demands of both were met.

Medieval speculation about light had prepared the way for the sensuousness of Gothic architecture.[15] Implicit in St. Augustine's belief that the blessed will not only know but will also see the splendors of the Heavenly City is the view that the light which makes vision possible here on earth bears an analogical relationship to the divine light illuminating the divine city. Such ideas were suggested by the first lines of the Gospel according to St. John, by Platonic and Neo-Platonic sources, and above all by the theology of Pseudo-Dionysius. Dionysius describes the hierarchy of beings as a cascade of light. Creation is a gift of light. To the extent that creatures share in divine being, they are illumined by the divine light. Today one is tempted to take such language to be merely metaphorical. But for the medieval artist light is more than a natural phenomenon; it points beyond nature to the spiritual,[16] and medieval speculation is only consistent when it relates the idea of beauty to the idea of light. Thus St. Thomas counts brightness or clarity among the three requisites for beauty.[17]

Otto von Simson has pointed out the crucial part played by Dionysian light metaphysics in the creation of the Gothic style under Abbot Suger at St. Denis. Suger, he suggests, used

> the stained-glass window as a visual "demonstration" of Dionysian theology. . . . These translucent panels, "vested," as he put it, with sacred symbols, are to him like veils at once shrouding and revealing the ineffable. What they meant to him, what they were to mean to others, is best shown by Suger's selection of the scene of Moses appearing veiled before the Israelites. St. Paul had used the image to elucidate the distinction between the "veiled" truth of the Old Testament and the "unveiled" truth of the New. In Suger's

15. Cf. von Simson, *The Gothic Cathedral,* and Jantzen, *Kunst der Gotik,* pp. 66–69, 139–46.

16. Von Simson, *The Gothic Cathedral,* p. 51. Cf. Etienne Gilson, *History of Christian Philosophy in the Middle Ages* (New York, 1954), pp. 81–85.

17. *Summa Theologica* I. 39. 8, trans. A. C. Pegis: "For beauty includes three conditions: *integrity* or *perfection,* since those things which are impaired are by that very fact ugly; due *proportion* or *harmony;* and lastly, *brightness* or *clarity,* whence things are called beautiful which have a bright color."

interpretation it epitomized his very world view, to which, in the footsteps of the Pseudo-Areopagite, the entire cosmos appeared like a veil illuminated by the divine light. Such a world view was peculiarly that of his century. The image he had found for it in the stained-glass window was so obvious, so irresistible, that it was bound to impress itself upon everyone's mind.[18]

As important to the medieval conception of beauty as light are measure and order. To create something beautiful the artist must endow his work with an order analogous to the order of the City of God. Von Simson shows this in his discussion of a passage by Abelard:

After identifying the Platonic world soul with world harmony, he first interprets the ancient notion of a music of the spheres as referring to the "heavenly habitations" where angels and saints "in the ineffable sweetness of harmonic modulation render eternal praise to God." Then, however, Abelard transposes the musical image into an architectural one: he relates the Celestial Jerusalem to the terrestrial one, more specifically to the Temple built by Solomon as God's "regal palace." No medieval reader could have failed to notice with what emphasis every Biblical description of a sacred edifice, particularly those of Solomon's Temple, of the Heavenly Jerusalem, and of the vision of Ezekiel, dwells on the measurements of these buildings. To these measurements Abelard gives a truly Platonic significance. Solomon's Temple, he remarks, was pervaded by the divine harmony as were the celestial spheres.[19]

Abelard's discussion suggests the "dual symbolism of the cathedral, which is at once a 'model' of the cosmos and an image of the Celestial City." [20] Such duality is to be expected, since the order of the visible world, especially that of the heavens, is itself analogous to that of the City of God.

[5]

REGARDLESS OF HOW LITERAL an interpretation is given to the idea of representation, this view of art makes sense only as long as the sensuous is believed to stand in an analogous relationship to the divine. It presupposes an acceptance of the

18. *The Gothic Cathedral*, pp. 120–22.
19. *Ibid.*, p. 37.
20. *Ibid.*

doctrine of analogy which holds that the visible and corporeal signifies the invisible and spiritual. This in turn reflects a belief in the ultimate continuity of the realm of being. Although there is a distance between the highest, purely intelligible sphere of being and the lowest, which partakes so little of the divine as to be almost nothing, there is no gap or abyss which cannot be bridged. Instead of a dichotomy there is a hierarchy.[21] Only this belief in a hierarchical ordering of the realm of being, where the lower levels imitate the higher and everything in one way or another imitates God, gives the artist the courage to reach for the eternal. Yet through medieval thought runs a streak of subjectivism which suggests that this schema may have to be abandoned. First a distinction is made between the world as it is in itself and as it reveals itself to man. The suspicion grows that the latter may not be an adequate picture of the former, until finally a thinker like Nicolaus Cusanus wonders whether it is a picture at all. Finite understanding is now said to be incapable of doing justice to reality and especially to the infinite God. Gradually man begins to discover that world is first of all world for him. A new emphasis is placed on the point of view of the individual. The world which man faces is no longer *the* world but *his* world, and this world is one which is fundamentally dependent on the knower. Man has constituted his world.

To be sure, to say that man has constituted his world is not to say that he has created it *ex nihilo;* his creation is only re-creation. In positing his world, man only follows God's creation. But it is important to see that this world and everything related to it are essentially dependent on man. Not only is there no place for God in it; there is also no place for Him above it. The attempt to use language and pictures describing the world known by man to find an expression, if only an analogical expression, for the being of God must fail. The finite and the infinite are incommensurable. Eckhart insists that man, if he is to find God, must free himself of all "creature language," of all words and images which tie him to the finite. God must be sought not beyond the world but within man. Man encounters God not through the mediation of the visible but more immediately as the ground of his own being. With this realization the hierarchical universe of the Middle Ages collapses and with it goes the medieval conception of beauty. Man no longer discovers the image of the divine in the

21. Cf. Sedlmayr, *Die Entstehung der Kathedrale,* p. 314.

visible, nor can he take comfort from knowing his assigned place halfway between the devil and God. Rather each individual stands at the center of his world. The world has lost its natural up and down. It has become flatter, more homogeneous.

The threat which this conception of man poses to religious art is apparent. The medieval conception of art rests on the belief in an analogy between the work of art and a higher portrayed reality. Once the incommensurability of the infinite and the finite has been recognized, the doctrine of analogy has lost its foundation, and with it the traditional conception of art. The problem which Nicolaus Cusanus attempted to solve in philosophy, i.e., to show how it is possible to find a name for the infinite God in spite of the fact that all names name the finite, also faced the artists of the time: how can a sensuous image stand in a meaningful relationship to the sacred?

A first consequence of cutting the bond tying the infinite to the finite is that the sensuous, no longer hallowed by its analogical relationship to the divine, threatens to become the merely worldly. A sign of this is an increasing interest in being true to nature. Thus the gold background began to disappear in the fourteenth century. It had lost its *raison d'être* with the disappearance of the doctrine of analogy. At the same time a new interest in perspective and corporeality made itself felt. When Maritain deplores this growing willingness of the artist to be content with illusion and the appearance of reality instead of revealing the truly real, he fails to do justice to the reasons behind this development and its ultimate irrevocability.[22] To retrieve what has been lost man would have to surrender his increased self-awareness; but this self-awareness is his fate rather than his choice.

Is religious art still a possibility given this emphasis on the point of view? If the sensuous has become the worldly, can art, which must accept the sensuous, be more than a daughter of the world? Does the attempt to create a religious art under such circumstances not debase and falsify religion? The artist can still try to portray the divine where it has entered the world, above all in Christ. But this entry of the divine into the finite has now become a paradox to which art cannot do justice. It can reveal only the humanity of Christ.

The Reformation's attack on religious art was only a develop-

22. *Art and Scholasticism,* trans. J. W. Evans (New York, 1962), p. 52.

ment of thoughts which were common in the later Middle Ages. With the breakdown of analogy, the separation of the sensuous and the spiritual had become so complete that any mingling of the two was likely to be interpreted as a debasement of the latter. Art and religion tend to part ways. Reformation and Renaissance stress different aspects of the same realization that the visible can no longer be used to imitate the divine. While the Reformation follows Eckhart's admonition and looks for God within, the Renaissance makes man the measure of the world. A humanistic art and a religion without art are the consequences.

[6]

IN SPITE OF THESE DIFFICULTIES, the Counter-Reformation provided Europe with one more answer to the demand for a visual art which is hallowed not accidentally by its use but more essentially by its artistic statement. The first traces of this new conception can already be discovered in late medieval architecture. A good example is the Franciscan church in Salzburg. This church is dominated by the contrast between the heavy, dark nave of the first half of the thirteenth century, which is still Romanesque in feeling though it uses Gothic forms, and the light, airy choir, built two centuries later. Rising ethereally out of the darkness, the choir does not invite us to step closer and to enter it; the architecture becomes a picture, the altar room a stage. The whole is dominated by a double motion. The eye is led forward to the bright altar region where it receives the impetus of the rising piers. This second motion does not come to rest within the structure; from the point of view of the spectator it is not resolved, but leads to an indefinite beyond. The *Franziskanerkirche* may be said to be ec-centric in that it does not possess its center within itself. It thus challenges the traditional requirement that a work of art be a whole. This church is not experienced as such. Rather we are confronted with a work of art which is open rather than closed. The spectator is not permitted to come to rest within the finite and sensuous. The work of art imparts a motion, but no terminus. Such art can no longer be said to present us with an image of the supersensible. The sensuous is no longer used as a step in the soul's gradual ascent to the divine. Rather we receive an impulse which invites us to make a movement beyond the merely sensuous and finite. Such

art makes a sensuous appeal only to negate it by its own motion. It posits an illusion only to deny it. In this the *Franziskaner-kirche* points to a development which includes Bernini, Borromini, and the brothers Asam, whose church at Weltenburg, built three hundred years after the Salzburg church, speaks a very different language and yet shows a similar approach to religious architecture.

In this development we can still describe the beautiful as the sensuous appearance of the ideal or sacred, but the relationship between the sensuous and the sacred can no longer be understood in terms of an analogy. Instead such art points to the sacred by expressing the desire which relates man to the sacred not as to something known but as to something unknown.

Two conceptions of religious art can thus be distinguished, one static, the other dynamic. The former makes art a picture of the eternal; the latter is an expression of man's desire for the eternal. With the breakdown of the doctrine of analogy, only the latter is still possible. In a more self-conscious age, religious art can no longer be imitative in the traditional sense.

2 / The Cartesian Tradition

[1]

IF ONE KNOWS MEDIEVAL ART only from reproductions, one is sometimes disappointed by the originals. A photograph not only can show what may be hidden in some dark corner of a church or placed so high above the spectator that he has to strain his neck to see it at all, but it can also give an appearance of unity to something which does not seem unified when seen as part of a larger whole. Divorced from this context a detail can acquire a significance which is lost in its original setting. Beside the reproduced detail, the entire work may seem confusing and unclear; events which happened at different places and different times are pieced together; the unity of time and place which we have come to expect of art is lacking.

We owe this kind of unity to the Renaissance. It has its foundation in the demand that the work of art be designed with respect to a particular point of view. This results in a new homogeneity: all objects in the painting are located in one space and are enveloped by the same light and atmosphere. This distinguishes a painting like Meindert Hobbema's *The Avenue of Middelharnis* from all medieval art. It is based on a few fundamental proportions. The clear statement of the horizon line, marking off perhaps three-quarters of the canvas as the sky, emphasizes the flatness of the Dutch landscape. Vertically the painting is divided into three approximately equal parts by the closest of the trees seaming the avenue running toward the spectator. The converging lines of the avenue, the water-filled ditches alongside it, the receding rows of trees—all point to the center of the horizon.

The Avenue of Middelharnis is almost a case study in perspective. This perspective transforms the world in such a way that it now has its center in the spectator. Hobbema presents us with a complete, very tidy, secular world in which we, like the wealthy burghers promenading on the avenue, can feel at home.

But is it right to call this world secular? To be sure, this world does not picture a higher reality; it does not invite us to transcend the finite. And yet it is more than a copy of nature. Hobbema, too, idealizes. The real world is less orderly, less comprehensible. Hobbema reconstructs the world in the image of man—or better, in the image of reason. But to say that Hobbema humanizes the world is not necessarily to say that he secularizes it. If to affirm reason is to affirm what makes man most like God, to present a more reasonable world is to present a world more divine. This belief is the foundation of Renaissance theories of art. It still plays an important part in the rationalist aesthetics stemming from Descartes.

[2]

As PERSPECTIVE GIVES a new homogeneity to the work of art, Cartesian emphasis on the knowing subject denies the heterogeneity of lived experience and puts in its place the picture of a homogeneous, objective world which has its foundation in the knowing subject.[1] Yet Descartes refused to make the subject its sole foundation: man's grasp of the world is coupled with an awareness that his understanding is not so much creative as re-creative. In his finite and imperfect way man follows the thoughts of God. Human knowledge has its measure in divine knowledge.[2]

What must knowledge be like in order to be true, i.e., an image of divine knowledge? Descartes' answer is familiar: man has the most adequate grasp of reality when he is thinking as clearly and distinctly as the mathematician. A downgrading of the sensuous is the inevitable consequence, and as the arts depend on the sensuous, this results in a downgrading of the arts. If art is to do justice to what man should be, we have to demand

1. Cf. Martin Heidegger, "Die Zeit des Weltbildes," *Holzwege* (Frankfurt a.M., 1950), pp. 69–104.
2. Cf. my "Irrationalism and Cartesian Method," *The Journal of Existentialism*, VII, no. 23 (Spring 1966), 295–304.

that it become clear and distinct. Art must strive to become as much like thought as possible. This is the paradox with which the Cartesian tradition seems to confront the artist. Art is asked to become like thought, and yet it cannot become thought without ceasing to be sensuous, i.e., without ceasing to be art.

More sensitive to the claims of the immediate, Leibniz pointed out that sometimes we are quite convinced that something is true without being able to say clearly and distinctly why:

> When I am able to recognize a thing among others, without being able to say in what its differences or characteristics consist, the knowledge is confused. Sometimes indeed we may know clearly, that is without being in the slightest doubt, that a poem or picture is well or badly done because there is in it an "I don't know what" which satisfies or shocks us. Such knowledge is not yet distinct.[3]

Leibniz' suggestion that one can attribute truth not only to clear and distinct ideas but also to confused ideas was taken up by Wolff. Not only did Wolff agree with Leibniz, but he also went one step further by arguing that such knowledge must take its place beside clear and distinct knowledge if our knowledge of reality is to be made more adequate. All clear and distinct knowledge has to pay a price for its desired clarity and precision: it loses the individual and particular. Wolff called therefore for history, which is concerned with individuals, to complement this deficiency of clear and distinct knowledge.[4]

By reasserting the pole of sensuousness Wolff made it possible for Baumgarten to establish his own aesthetics on a Cartesian foundation.[5] Baumgarten, too, distinguished distinct from confused cognition. Cognition becomes distinct as it becomes focused and the irrelevant is left out. Thus philosophic or scientific knowledge abstracts from the confusions of the concrete. Yet there is another more immediate mode of knowledge— sensibility. Sensibility is inferior to understanding for not being clear and distinct; it is superior to it for not having sacrificed the

3. *Discourse on Metaphysics*, XXIV, in *Discourse on Metaphysics, Correspondence with Arnauld and Monadology*, trans. George R. Montgomery (La Salle, Ill., 1953), p. 41.
4. Cf. Alfred Bäumler, *Kants Kritik der Urteilskraft. Ihre Geschichte und Systematik* (Halle, 1923), I, 193–97.
5. Alexander Gottlieb Baumgarten, *Reflections on Poetry*, trans. and introd. K. Aschenbrenner and W. B. Holther (Berkeley and Los Angeles, 1954); *Aesthetica* (Frankfurt d.O., 1750).

richness of the concrete. Although both understanding and sensibility thus give us access to reality, the two cannot be reconciled. Cognition gains in extension as it loses in distinctness, and vice versa. Man cannot have a clear and distinct idea of what is concrete and individual. The texture of reality, the concrete or existential moment, escapes the philosopher as well as the scientist. He knows no individuals, only universals. It is this deficiency of the understanding which enabled Baumgarten to argue that sensibility is equally necessary and complements the scientist's knowledge of reality. Only God can grasp reality in an immediate intuition which combines richness with distinctness, extensive with intensive clarity; for finite man this is impossible. Trying to pattern his knowledge after the knowledge of God, he must fail to do justice to one side or the other. Art, which reveals the world in its richness, is needed to complement the sciences, which reveal the structure of the world.

Baumgarten defined the work of art as a sensuous presentation of perfection. Here we encounter that phrase which appeared in so many pre-Kantian discussions of the beautiful: *beauty is sensuous perfection.* The work of art must present a manifold in such a way that a unity is produced to which every part makes an essential contribution, with no loose ends or missing pieces. A single impression is thus never beautiful; we discover beauty only where a manifold has been united in such a way as to form one work of art. Baumgarten insisted, however, that this unity may not be apprehended clearly and distinctly. The unity of a work of art is not like the unity of a logical argument where every step is required to enable us to infer the conclusion. Reason, understood as the faculty of clear and distinct understanding, precludes beauty.[6] On the other hand, something rather like reason must be operative whenever there is a recognition of beauty, the difference being that this faculty apprehends connections indistinctly. Baumgarten called this faculty the *analogon of reason* or *taste.* It should thus be possible, Baumgarten thought, to describe the ways in which this latter faculty operates, just as the logician describes the ways in which reason operates. Just as *logic* is the science of reason, so *aesthetics* is the science of taste.[7] As this lower faculty is the one by which man recognizes beauty, the term aesthetics came to be used to refer to the philosophy of art. Today the two terms have

6. Baumgarten, *Metaphysik*, trans. H. Meyer (Halle, 1783), par. 468.
7. *Reflections on Poetry*, par. 116.

indeed become all but indistinguishable. Yet this terminology is itself a reflection of a particular view of man which led to a particular view of beauty.

To be beautiful, the work of art must possess unity. Baumgarten developed this idea further by pointing out a relationship between the universe, described by the Leibnizian philosopher as a pre-established harmony, and the work of art. The artist creates another world, a microcosmos, which stands in an analogous relationship to the macrocosmos. It thus possesses a perfection similar to the perfection of creation, although on a far smaller scale.[8] It is precisely this reduction in scale which enables finite man to grasp beauty in the work of art more clearly than he is able to do when looking at nature. Nature is too rich for man's faculties. The philosopher and the scientist may indeed patiently and laboriously try to uncover the basic order displayed by nature; however, their understanding is not only incomplete but also lacks the immediacy with which God apprehends, as in a flash, the glory of his creation. However, in the work of art, e.g., in a painting like *The Avenue of Middelharnis*, man confronts perfection in a way which is commensurate with his abilities. He is set at rest. The artist succeeds in translating divine perfection into a language finite man can understand, thus making it accessible to him. Thus it is first of all the artist and secondly those who are able to recognize the beauty of art who come closest to imitating God.

Baumgarten would have rejected this last statement as making too strong a claim. He was content to correct the Cartesian overemphasis on reason by giving sensibility its due. Yet it is easy to imagine a philosophy of art which moves further in this direction than Baumgarten himself did. Thus one could stress more vehemently the antagonism between the two faculties of man, making reason the enemy of taste and science the enemy of art. One could argue that the intellect, searching for reality in

8. "The poet is like a maker or creator. So the poem ought to be like a world. Hence by analogy whatever is evident to the philosophers concerning the real world, the same ought to be thought of a poem" (*Reflections on Poetry*, par. 68). Just as the poem or work of art is unified by a theme—Baumgarten defines *theme* as "that whose representation contains the sufficient reason of other representations supplied in the discourse, but does not have its own sufficient reason in them" (*Reflections on Poetry*, par. 66)—so the universe has its sufficient reason in God. God is the theme of the world.

its abstractions, succeeds only in losing hold of the concrete— like a spider spinning out a web and mistaking this web for the world—while the senses and the imagination give man a taste of reality. The Cartesian emphasis would be reversed. Such a reversal is indeed quite characteristic not only of many a modern view of value but also of eighteenth-century thought.

Baumgarten was still far from such speculations. He insisted that both art and the sciences reveal reality. And although Baumgarten suggests that one road is as good as the other, he never convinced all of his readers. Among his successors we discover a tendency to return to the original Cartesian emphasis on reason. For, if it should be possible for man to increase his intellectual powers to a point where he could successfully combine extensive and intensive clarity, would he not have arrived at a knowledge far more perfect than that given to man by the arts? Is it, for example, not possible to argue that the mathematician, who grasps a complex theorem immediately, without having to go through a number of steps, sees a beauty which is more perfect than that to be discovered in works of art? Moses Mendelssohn reminds us not to think too highly of the arts, since they are only a sign of human weakness. Baumgarten would have granted this point. But he could have added that man, being what he is, needs art as much as he does clear and distinct knowledge. Only in the pursuit of both does he do justice to his own destiny as a being created in the image of God.

[3]

THE PHILOSOPHIC THINKING of the seventeenth and eighteenth centuries oscillated between these two poles. Two images of man vied with each other: on the one hand we find a stress on reason, on the other hand a stress on sentiment. While the Cartesians, upholding the ideals of reason, demanded that knowledge exhibit its credentials, the adherents of sentiment wanted intuitive certainty, an innate sense of what is right which cannot and need not give account of itself. Such innate good sense was called taste. This concept first became prominent toward the middle of the seventeenth century in Spain. Baltasar Gracián and his many followers, developing ideas of the Italian Renaissance, supplied Europe with a new image of man: the

man of taste.[9] Unlike the Cartesian man of reason, the man of taste has no principles by which he governs his actions. He needs no rule. Instead he knows intuitively what to do in a given situation, how to behave at court or in the world. He immediately grasps what is demanded and acts accordingly. He is the man of tact, who listens to a voice within himself which is more reliable than the cumbrous doctrines of philosophers. His is an artistry which has not been learned, for which he himself cannot account, and which others only clumsily imitate. He cannot share his secret with them since he himself does not know it. Taste is inevitably private, the property of one individual. The man of taste is a successful, but lonely, actor on the stage of life.

The concept of taste became particularly important in discussions of the beautiful. Leibniz' point that man cannot say what it is that constitutes the beauty of an object was repeated over and over. Thus Du Bos spoke of the sense of beauty as a sixth sense; speculations about the principles of beauty, he felt, are just as fruitless as speculations about why we call something yellow. Similarly Bouhours emphasized heart and feeling, while Boileau praised good sense as a guide even more reliable than Virgil. Shaftesbury clothed a similar view in vaguely Platonic language. Beauty is identified with truth, but not the truth of Descartes. It is not attained by clear and distinct reasoning; rather it refers to a mysterious ordering of the universe which only the inspired artist can grasp. The only criterion of truth is inspiration. The artist must be infused with the divine presence. He is a seer who cannot explain what allows him to give expression to the divine. From here it is only a step to the later conception of genius giving rules to art.

The individualism implicit in such theories easily leads to the opposite extreme, to absolutism. For while one may admit that the man of taste needs to follow only his own convictions, such men of taste are rare. This immediate knowledge of what is right, be it in art or in ethics or politics, is not granted to many. From where then are the less gifted to take their principles? Where are they to discover a standard of taste? Lacking taste, they have to borrow from others rules by which to govern their life or art. Seeing the man of taste and his success, yet unable to discover his secret, they strive to imitate him nonetheless. As a

9. Cf. Bäumler, *Kants Kritik der Urteilskraft*, Vol. I, and Ernst Cassirer, *Die Philosophie der Aufklärung* (Tübingen, 1932) with the following discussion.

result man demands that he be given rules. A sense of insecurity is implicit in this demand. Not trusting his intellect, man tries to subordinate it to logical rules; not trusting his own sense of right or wrong, he requires rules for behavior; not trusting his aesthetic judgment, he requires rules telling him how to paint or how to write. Descartes and Leibniz are part of an age which was fascinated with logic, which would do man's thinking for him; with ceremonial, which would free man from having to decide what to do in a given situation; with the Academy, which would provide man with a standard of taste in the field of art.

The tension between a stress on the independence of taste from all rules, on the one hand, and a desire to establish a standard to guide those lacking taste, on the other, can be discovered in much of the literature of the time. Now and then it seems as if the freedom which the theory of taste could have given to the artist had frightened both thinker and artist. They seem to have recoiled, as if in dread, from their own daring and made amends by advocating a return to the safe harbor of academicism. Lacking a clear awareness of the ideal, lacking the courage to affirm himself without an ideal, responsibility becomes for man a burden from which he wants to be liberated. A pseudo-ideal takes the place of the ideal, a substitute which has not been posited by the individual himself but which he receives from the outside. Thus Shaftesbury seems to be afraid of the freedom which is given to the artist by his own theory of inspiration. How are we to tell inspiration from mere enthusiasm—where enthusiasm is defined as inspiration which has lost its roots in an awareness of the divine? To provide some tangible criteria of beauty, Shaftesbury emphasizes the importance of rules and examples. Thus he recommends the study of antique statues. Here, rather than in nature, we find beauty. While he points out that the most ingenious way of becoming foolish is to follow a system,[10] Shaftesbury shares the horror of his age at what seemed to be the confident and undisciplined freedom expressed in gothic or baroque architecture. "Harmony is harmony by nature, let men judge ever so ridiculously in their musick. So is symmetry and proportion founded still in nature, let men's fancy rove ever so barbarous, or their fashions ever so gothick in their architecture, sculpture or whatever designing art." [11]

10. Anthony, Earl of Shaftesbury, *Characteristicks of Men, Manners, Opinions, Times* (2d ed.; London, 1714), I, 290.
11. *Ibid.*, p. 353.

Similarly Hume, while he seems to agree with those who argue that sentiment is always right, attempts to find a standard of taste. He points out that there is considerable agreement among people as to what is pleasing. In durable admiration he finds a criterion of beauty. But what if we do not like what tradition has approved? Should we have the courage of our convictions? To Hume such disagreement suggests that we lack delicacy of judgment. He thus confronts artist and spectator with an agonizing dilemma: he seems willing to admit that sentiment is in the end the sole guide to beauty; still, if one's sentiment does not agree with that of others, one probably lacks delicacy of judgment and is a man of bad taste. Thus to discover whether one is indeed a man of good taste one has to look at what others believe; there is no other criterion for evaluating one's own preferences. The theory of sentiment leads here to its opposite; we inquire into what has generally pleased and in this manner arrive at a standard of taste. The artist, instead of following his own judgment, should follow established rules.

[4]

THE POLARITY OF REASON and sentiment was seen to generate another: that of freedom and alienation. Sentiment, uncertain of itself, looking for criteria by which to decide whether it is not perhaps merely false enthusiasm, surrenders its claim to decide what is beautiful or ugly and asks to be given a rule. The clear and confused, whose priority was asserted by the theorists of sentiment, is subordinated again to the clear and distinct. This, however, does not constitute a return to the original Cartesian position. Descartes placed the criteria of right and wrong within the individual; all appeals to external authorities were denied. Now the individual, incapable of discovering criteria on his own, demands to be given them. Thus we find that under Louis XIV art received official blessings and became doctrinaire. Discipline was exerted from above. The Academy, sanctioned by Colbert and the King, presided over by Le Brun, assumed the burden of laying down criteria, thus freeing the individual from having to decide what art is all about. How comforting it must have been to have the Academy as the highest arbiter of taste, to be able to use Roger de Piles' system of credits to give grades to the great painters of past and present.

To know, e.g., that Raphael received eighteen credits for drawing, while Rembrandt only deserved six, is very helpful; presumably it warns one not to copy Rembrandt if one wants to learn how to draw.

By providing art with a center in the Academy it was easy to make it serve the political system. Art, more or less willingly, joined to sing the praises of absolute monarchy. These tendencies were not confined to France, although she provided the model. Thus in Vienna we find Fischer von Erlach trying to establish the *Reichsstil,* a style which would express the grandeur of the Danube monarchy. Smaller principalities tried their best to emulate the giants, and the smaller the resources the more grandiloquent the gesture.[12] Even the smallest potentate imitated Versailles.

A look at the ideal plan for Versailles is instructive. The town no longer clusters around churches; they have lost their importance and are given subordinate positions. The center of the plan, the hub of a gigantic wheel, is occupied by the palace. But the palace, although the center of the plan, is not the center of the city. The city is located on part of the periphery; it is eccentrically located. While the ruler does not dwell among his people, he is still their center. The central position of the palace is reinforced by the baroque park. Infinite vistas open out; there are no limits. The park merges with the country. Its vocabulary is usually borrowed from the Renaissance—again geometry triumphs over nature; but a comparison between, let us say, the Boboli Gardens in Florence and Versailles immediately suggests the difference. In Florence we have a small, bounded hillside; in Versailles the unbounded plain. Versailles is the focal point of a work of art which ideally is identical with the entire land. Everything receives its proper place in relation to the royal point of view.[13]

There is a similarity between the ec-centricity shown by the baroque palace and that of the baroque church, suggested in the preceding chapter. Both presuppose an inability to find a valid measure which can give meaning to man's actions. But while the baroque church is based on a subjective interpretation of the *imago Dei* concept, the baroque palace supplies man with an artificial finite center. Instead of *imago Dei* man becomes *imago*

12. Cf. Victor-L. Tapié, *The Age of Grandeur,* trans. R. Williamson (New York, 1961), pp. 84 ff.
13. Cf. Hans Rose, *Spätbarock* (Munich, 1922).

regis. We can thus distinguish spiritual and secular ec-centricity. In both cases the work of art no longer confronts the spectator as a unity, with beginning, middle, and end. But whereas as *imago Dei* man can still affirm his individual point of view, as *imago regis* he is forced to deny it. Only the point of view of the ruler is admitted. He presents each subject with the illusion of a new center. One should not view the building activity of the baroque, which often seems out of all proportion to the available resources, only as exploitation of the citizenry. Life at court was a theatrical performance, which assigned a place to the individual and once more gave him a sense of security. This spectacle required rules and a proper stage to make the illusion convincing.

The beautiful has been defined as the sensuous appearance of an ideal in which man finds his measure. Versailles, too, gives man such an ideal. But it no longer does this by relating him to the infinite ground of his being. The relationship between man and God has lost its importance. An art such as that presented by Versailles is born out of an awareness of man's metaphysical loneliness. Man's search for a measure finds an answer, if only an aesthetic answer. This answer is different for subject and ruler. While it furnishes the former with a new center outside himself, it makes the latter that center. The subject has his measure in the King. The work of art provides man with an illusion of completeness; but now the price to be paid for this illusion is man's autonomy. Man himself becomes part of such a work. The work of art swallows the individual.

[5]

AFTER 1714, when work began on the park at Stowe, the English developed a conception which was consciously opposed to the idea of the French park.[14] By 1830 this conception had conquered all of Europe. Both the English and the French parks deny the individual's point of view and thus free man from himself, but they do so in very different ways. Where one remains clear and distinct, the other becomes vague and indefinite. The English park tries to break the hegemony of finite man, of reason, of architecture. Man no longer stands in an active rela-

14. Cf. Nicholas Pevsner, *The Englishness of English Art* (Harmondsworth, 1964), pp. 173–85.

tionship to nature, using it, building on it, subjecting it, but becomes passive. He listens to nature, trying to lose his identity in her. Nature takes the place of God. Man melts into unity with the indefinite. This diffuseness of feeling corresponds to the diffuseness of the English park with its meandering paths, its hedges, brooks, and meadows. The architect of the English park induces nature to reveal her secrets to man. Thus he may build an artificial ruin, overgrown with ivy, to remind man of the instability of the finite work of man, to assert all the more strongly the force of the maternal earth. A particularly striking example of this is the "ruined" *Roman Water Castle* in the park at Schwetzingen, near Heidelberg. The "old" aqueducts have "collapsed" under the onslaught of time and nature. Once chained by the labor of man, the water has now freed itself, a waterfall playing with the crumbling walls. One can find such ruins throughout the English parks of Europe, designed to remind us of the inadequacy of man, of his ultimate impotence before time. And yet, instead of feeling oppressed, man glories in this, for he knows that here, rather than in the artificial world of reason, he can feel at home. Nature restores him to that unity which has been disrupted by self-consciousness. The English park, too, reminds man of what he believes to be his essence; but again the traditional understanding of this essence is rejected. As with Shaftesbury, God has become diffuse and vague. Similarly, the English park does away with structure. For as long as man discovers in a work of art beginning, middle, and end, he confronts it as something other and thus cannot lose himself in it. The charm of the English park lies in its ability to seduce us into surrender.

Both the French and the English parks invite us to shed the burden of individuality. Both presuppose a secular, atomic conception of man and offer an escape. In this they foreshadow later movements which take up these same ideas more stubbornly, more relentlessly.

3 / Classicism

WHEN PIGAGE AND SCKELL built the *Roman Water Castle* in the park of Schwetzingen, they wanted to show not merely the impermanence of human works but also the irrevocable passing of an age in which the eighteenth century discovered its ideal image: even the achievements of the ancients did not last, but were conquered by water and vegetation. This victory of time is accepted as final. There is no attempt to re-create the golden age in the present. The ideal no longer functions as an invitation to action; it lies in ruins. Nature and time have defeated man's labors. But man submits gladly, as such submission releases him from having to be himself. Art becomes a form of escape.

Antiquity and nature—both have a claim on man. One gives him an ideal to imitate; the other promises peace in surrender. In such works as the *Water Castle* Roman grandeur serves only to emphasize the seductive power of nature. Antiquity is still idealized; but the ideal seems so remote as to be powerless. It is asserted only to be negated. The artists built a classical structure, but as a ruin. In this contrast we experience the triumph of time.

Such contrasts are characteristic of much of the classicism of the late eighteenth and early nineteenth century and distinguish it from another, generally earlier, more optimistic and moralistic classicism, which hoped that art, by reviving classical ideals, could help to transform reality. By viewing the world of the ancients as a secular paradise, that earlier classicism had

brought the ideal down to earth. This paradise was sought not only in the past but also in the future. The past was to be equaled and surpassed; man was to triumph over time. In his *Vitruvius Britannicus* Colin Campbell compared "the great *Palladio* who has exceeded all that were gone before him . . . whose ingenious labours will eclipse many, and rival most of the Ancients," with his own contemporary, the still greater Inigo Jones:

> Let the Banqueting House, those excellent pieces at *Greenwich*, with many other things of this great Master be carefully examined; and I doubt not, but an impartial Judge will find in them all the Regularity of the former with an Addition of Beauty and Majesty, in which our *Architect* is esteemed to have outdone all that went before; and when the plans he has given of *Whitehall* . . . are carefully examined into I believe all mankind will agree with me, that there is no Palace in the World to rival it.[1]

By contrast, a melancholy contemplation of the past characterizes the later classicism of Piranesi and Winckelmann. Both, one by portraying the colossal remainders of antiquity, the other as a historian and archaeologist, presented an ideal in ruins. Winckelmann concluded his *History of the Art of the Ancients* on this melancholy note:

> Although in looking at this decline I felt almost like a person who in writing the history of his own fatherland had to touch on its destruction which he himself had experienced, I could not abstain from following the fates of these works as far as my eye would reach—just as a girl, standing by the side of the ocean, looks with tears in her eyes after her departing lover, without any hope of ever seeing him again, believing to see his face in the distant sail. Like this girl, we have, as it were, only a shadowgraph of the object of our desire, which for this reason awakens an all the stronger longing.[2]

Winckelmann was not alone in longing for the world of the ancients while believing that it could not be resurrected; for Keats too the intervening time had made such a recovery impossible.

> My spirit is too weak—mortality
> > Weighs heavily on me like unwilling sleep,
> > And each imagin'd pinnacle and steep

1. *Vitruvius Britannicus*, quoted by Victor-L. Tapié in *The Age of Grandeur*, trans. R. Williamson (New York, 1961) pp. 187–88.
2. *Geschichte der Kunst des Altertums* (Dresden, 1764), p. 430.

Of godlike hardship, tells me I must die
Like a sick Eagle looking at the sky.
 Yet 'tis a gentle luxury to weep
 That I have not the cloudy winds to keep,
Fresh for the opening of the morning's eye.
Such dim-conceived glories of the brain
 Bring round the heart an undescribable feud;
So do those wonders a most dizzy pain,
 That mingles Grecian grandeur with the rude
Wasting of old Time—with a billowy main—
 A sun—a shadow of a magnitude.
 ("On Seeing the Elgin Marbles," 1790)

On the one hand, "a billowy main," "the rude wasting of old Time"; on the other, "a sun," "Grecian grandeur"—both are superimposed, leaving "a shadow of a magnitude." This shadow mingles with the gentle melancholy of the poet which is not without its pleasures: "yet 'tis a gentle luxury to weep."

Hölderlin's hymn about the Greek islands is governed by a similar tension. First he evokes the world of the ancients:

Do the cranes wheel back to you again? And do the ships
Turn singing toward your shores once more? Do the light,
Longed-for breezes breathe upon your quiet waves?
And do the dolphins, lured from the depths, now sun their backs
In the new light? Does Ionia bloom? Is it time? For always,
In the spring, when the heart revives in the living, when
 strong young love
Awakes in men with memories of a golden age,
I come to you and greet you, silent and great Old Man!

This image of the spring of mankind is opposed to the present:

But, alas, our generation wanders in darkness, it lives
As in Orcus, without God. Men are bound to their own tasks
Alone, and in the roaring workshop each can hear
Only himself. They work like savages, steadily,
With powerful, restless arms, but always and always
The labor of the fools is sterile, like the Furies.

Man is alone; there are no lights to guide him; there is no God to hear his call in "the roaring workshop" where men work next to one another and still are unable to communicate. Again we have an experience of contrast. Yet while the poet resigns himself to the lot of finite man, subject to the raging of destruc-

tive time, he refuses to affirm himself only on that level. In his soul man dwells with the gods, listening to their words:

But you, O immortal sea-god, if the song of the Greeks
No longer rises from the waves to please you, as before,
Still sound for me often in my soul, that over your waters
The fearless, lively spirit, like a swimmer, may move
In freshness and strength and understand the speech of the gods,
Change and becoming, and if this destructive, raging time
Should seize my head too firmly and the needs and errors
Of mortal men should rock my life with blows,
Let me remember then the silence of your depths.[3]

The ideal belongs to the past. But even in this age, man can escape into his own self and there hear the voices of the gods; in the midst of life he can remember that silence from which all finite being has emerged and to which it will again return.

A movement of resignation, born of despair over the hollowness of the present and a feeling that nothing can be done about it, is characteristic of later classicism. Antiquity was posited as the ideal, but without real conviction. Man lacked the strength to restore it to life. Only in art could its echo be preserved. This frequently led to a divorce of art from reality; a make-believe aesthetic realm was invented which lay beyond and had little relation to the world in which the artist found himself. A classicism resulted which at times was little more than a dream about antiquity, too often a pale and bloodless dream. Piranesi and Hölderlin were able to escape this aestheticism by placing an emphasis on time that kept the contrast between past and present alive. Implicit in this contrast is a reference to the situation of the artist. The present is revealed as an age of need. But often the artist was content to assume a posture and imitate what he considered ancient art to have been like. Instead of using antiquity to interpret his own situation, he accepted a ready-made pseudo-ideal. Classicism bred academicism. Artists took too seriously Winckelmann's admonition to study the ancients carefully in order to gain a measure of their strength.

Our beauty will scarcely produce as beautiful a body as that possessed by the Antinous Admirandus and our ideas will prove incapable of going beyond the more than human proportions of a

3. Friedrich Hölderlin, "Der Archipelagus," trans. Stephen Stepanchev, in *An Anthology of German Poetry from Hölderlin to Rilke in English Translation*, ed. A. Flores (New York, 1960), pp. 10–20.

beautiful god which we encounter in the Vatican Apollo: what nature, spirit, and art could produce lies here before our eyes. I think that imitation of these works will teach us to become intelligent more quickly, because we find in the former object the essence which is otherwise dispersed throughout nature, while in the latter we see to what degree even the most beautiful nature can rise above itself. Such imitation will teach us to think and to design with certainty, as here the highest limits of human and divine beauty are encountered.[4]

[2]

THE HISTORICISM of Winckelmann and his followers allied itself with what one is tempted to call Cartesian Platonism. Winckelmann considered himself a Platonist, but his conception of beauty and painting owed more to rationalist aesthetics than to Greek thought or art.

Painting reaches to things which are not sensible; these are its highest goal. . . . The painter who thinks further than his palette reaches, desires a store house of learning from which he can take significant and sensible signs for things which are themselves not sensible. The brush which the artist holds should be steeped in understanding. . . . He should leave more to thought than he shows to the eye.[5]

These ideas are indeed reminiscent of Plato. But with Winckelmann, Plato's forms had become mere abstractions. Content was not excluded, but Winckelmann insisted that it should be presented in the most abstract manner possible. Here he sided with orthodox Cartesianism against the modifications demanded by Baumgarten and his followers, who had stressed the individual and the concrete. Lessing, who remained a classicist in his discussion of the visual arts, warned sculptors not to introduce expressive features, which would destroy beauty, into art; the Laocoön group is praised by him for precisely the reason which we are likely to use today to condemn it: its vacuity and lack of expression. The spirit of classicism is apparent in Lessing's advice on how to depict Venus: "Venus is to the sculptor simply

4. Johann J. Winckelmann, *Gedanken über die Nachahmung der griechischen Werke in der Malerei und Bildhauerkunst,* (Dresden and Leipzig, 1756) p. 14.
 5. *Ibid.,* p. 40.

love. He must therefore endow her with all the modest beauty, all the tender charms, which, as delighting us in the beloved object, go to make up our abstract idea of love." The sculptor tries to express an abstract idea!

> The least departure from this ideal prevents us from recognizing her image. Beauty distinguished more by majesty than modesty is no longer Venus, but Juno. Charms commanding and manly rather than tender, give us instead of a Venus, a Minerva. A Venus all wrath, a Venus urged by revenge and rage, is to the sculptor a contradiction in terms.[6]

With its emphasis on abstract ideas, this classicism blurred the distinction between philosopher and artist. Thus Winckelmann's friend Raphael Mengs and Daniel Webb, who helped to popularize Mengs's ideas, subordinated the "mechanical" to the "ideal part" in art. The mechanical requires only the skills of the artisan. Thus, while it is not difficult to represent the ideal once it has been found, to discover it takes talent—the talent of a philosopher. This view discourages the creation of symbols in which the ideal is so immediately present that it cannot be abstracted without loss; the artist has to be content with pale allegories which are appreciated only upon reflection. It did not occur to Mengs that art is superfluous if it does not reveal the ideal in some way in which reason cannot.

Mengs tried to practice what he preached, and as head of the Academy of Rome he exerted considerable influence. The more faithfully he followed his own precepts, the more uninteresting were the results. Only when he was forced to concern himself with the individual and the particular, as for instance in his portraits, did he show that, given a less stifling climate, he might have developed into a significant artist. Today his paintings have little more than historical interest. He is one of those very important historical figures who failed as artists.

We can criticize Mengs on two counts. For one, his conception of art as a representation of abstract ideas provides the artist with an impossible task. Art cannot possibly become clear and distinct; to do so it would have to leave the world of sense altogether, i.e., it would have to cease to be art—and at times Mengs is perilously close to such success. But even the most extreme defender of this view has to compromise in the end.

6. Gotthold Ephraim Lessing, *Laocoön*, trans. E. Frothingham (New York, 1957), p. 58.

When the classicist admits linearity, when he argues that the painting should be a colored drawing, he takes the first steps in this direction. Winckelmann himself, after having opposed expression as being characteristic of the individual, later allowed it, if only to the extent that it did not interfere with the demands of formal beauty.

Our second objection to Mengs is that the particular ideal which he seeks to express is too flat to do justice to man. His art seems fundamentally false; the ideal advanced seems to be a pseudo-ideal. We approach it with our own conception of man and find it wanting. Yet we should not forget that Mengs was once considered perhaps the foremost painter of Europe and overshadowed Tiepolo at the court of Madrid. His art and the ideal which it advanced must have appealed to his contemporaries. His paintings posed no problems and made no demands, but offered others, like Webb, an opportunity to escape from reality and lose themselves in pleasant moods.

> The mind, in these moments, grows ambitious; and feels itself aspiring to greater powers, and superior functions: These noble and exalted feelings diffuse a kind of rapture through the soul; and raise in it conceptions and aims above the limits of humanity. The finest, and at the same time, most pleasing sensations in nature, are those, which (if I may be allowed the expression) carry us out of ourselves, and bring us nearest to that divine original from which we spring.[7]

Webb's description of aesthetic pleasure recalls Plotinus. Art is still said to bring us nearer "to that divine original from which we spring." But while Plotinus stressed the revelatory character of the work of art, Webb reduces art to a mere occasion to elicit a mood which can then be enjoyed. Such enjoyments Mengs could provide.

[3]

THOUGH THE CLASSICISTIC IDEAL did find its victims, some of its best painters—David, for example—were able to push beyond its limitations. David was not content to create an

7. Daniel Webb, *An Inquiry into the Beauties of Painting and into the Merits of the Most Celebrated Painters, Ancient and Modern* (London, 1760), p. 45.

insipid copy of what he imagined the art of the ancients to have been like. The ideal furnished by the ancients was made part of a higher synthesis; it served to express another view of man which answered the needs of the age. With David, classicism is not an assumed posture but serves the artist to interpret the meaning of his own situation. David's classicism is a heroic pessimism. This finds expression in an art which is fundamentally antithetical. Such paintings as *Andromache Grieving Over the Dead Hector* and *The Oath of the Horatii* are dominated by tensions which are never resolved. In *Andromache Grieving Over the Dead Hector* David opposes the diffuse, dark background to the clearly defined group of the dead Hector and the mourning Andromache. The foreground presents us with an idealized image of humanity; but man is surrounded by the ominous darkness of the background. The antithetical aspect of David's art is further heightened by the grouping of his figures. Traditionally the work of art is organized around a positively defined center. A familiar example of this is the traditional representation of the crucifixion, where the central cross dominates the composition. David frequently leaves the center empty. It remains an empty field, filled with the tensions created by the different groups confronting one another. Thesis and antithesis are opposed without mediation.[8]

In this respect David's image of man differs from that of the romantic classicism of Hölderlin. In Hölderlin the tensions are resolved in a movement of resignation; in David there is no resolution. Art like David's gives us a new interpretation of authentic existence. The ideal is no longer sought in paradise, nor in a past golden age. Man dwells on earth, subject to the ravages of time, surrounded by an encompassing darkness which he does not understand and which is indifferent to his demands. In its dialectic David's art is related to the *Roman Water Castle* at Schwetzingen or to Hölderlin's classicism. But whereas Hölderlin demands self-surrender, David's art demands self-affirmation. He glorifies the individual who possesses the strength to act decisively in an indifferent world.

8. For an examination of the antithetical structure of classicistic art, in particular that of David, cf. the excellent study by Rudolf Zeitler, *Klassizismus und Utopia,* Studies Edited by the Institute of Art History, University of Uppsala (Uppsala, 1954).

4 / The Beautiful and the Sublime

[1]

DAVID'S INTEREST in antithetical compositions is characteristic of his time. Rudolf Zeitler has pointed out similar tensions in the work of Piranesi, Canova, Carstens, and Thorvaldsen.[1] And not only among the classicists do we find such developments. Romantic landscape painters used the contrast between a definite foreground and a diffuse background to create symbols of man's loneliness and helplessness before the incomprehensible power which surrounds him. Caspar David Friedrich, for example, set lifeless objects such as gravestones, a ruined monastery, or bare oaks against an atmospheric background—often the heavy, snowladen sky of a winter evening. The foreground objects form a screen barely concealing something indefinite and incomprehensible which threatens to envelop them. As Helmut Rehder points out, "What is behind the screen is what really matters, and this is for the imagination to figure out."[2] Often these landscapes have their focus in figures seen from the back, contemplating the scene before them and us. "Motionless the figures sit, lost, as they seem, in their thoughts and waiting for nothing or for all."[3] Like David, Friedrich presents the encompassing other as an ominous force; but its threat carries a promise of release from the burdens of finite existence.

1. Cf. Rudolf Zeitler, *Klassizismus und Utopia,* Studies Edited by the Institute of Art History, University of Uppsala (Uppsala, 1954).
2. "The Infinite Landscape," *Texas Quarterly,* V, no. 3 (Autumn 1962), 149.
3. *Ibid.*

It is, as Rudolf Otto describes the numinous, *mysterium tremendum et fascinans*. Friedrich's landscapes make this *mysterium* visible.

A sense of the numinous is implicit in man's awareness of his own finitude. Man has not chosen his situation; he has been cast into the world, at the mercy of accidents which make no sense. And although he can try to guard against the unforeseen and secure his existence, he remains an island in an unknown sea which in the end will engulf him. Impotent, yet demanding security, man confronts that power which has cast him into being only to destroy him again as a *mysterium tremendum*. But besides dread there is fascination. Is not individuation painful? A longing to return to his origins, to regain peace and lost completeness, accompanies man's desire to assert himself as this individual. His attitude towards the encompassing other is thus ambivalent. It is *mysterium tremendum et fascinans*.[4]

As long as man understands himself as *imago Dei* he can identify this transcendent other, which is the ground and limit of his being, with a God who cares and has given man His law. But to say that God created man in His own image makes sense only as long as we know what God is. The more diffuse our idea of God, the more difficult it is to see in Him the measure of man. A God who is grasped only in ineffable moods or feelings cannot be the author of a law. To identify religious experience with a sense of the numinous is to divorce religion and ethics; religion becomes a retreat from action. Similarly an art which reveals the numinous cannot have moral significance. Such art still is witness to a project, but this project has no definite goal. An indefinite transcendence has taken the place of definite ideals. The ideal has become empty; it no longer tells man what is to be done. Friedrich's lonely women, watching ghostlike ships appear out of the evening fog, are thus not really at home in the world. The concerns and cares which tie man to the world have been silenced. In this silence man recognizes that there is something in him, too, which transcends his situation in the world and demands the infinite.

The awakening interest in the numinous led to the discovery of landscapes which up to this time had been found threatening and ugly. Just as sentiment had favored the gentle landscape of

4. Rudolf Otto, *The Idea of the Holy*, trans. J. W. Harvey (2d ed.; London and New York, 1957).

southern England, the menacing beauty of the raging ocean or of the Alps now began to be admired. A diary entry by Carl Ludwig Fernow, describing a tour in the Ticino, shows this new, ambivalent attitude to nature, made popular by de Saussure and Rousseau:

> Here is the eternal home of horror. I have not seen anything more terrible. . . . We heard the increased thunder of the stream. Astonished we looked at it, breaking its way through the rocks, cascading deep below us. We rolled large stones into the roaring abyss which were soon crushed by the stream and colored the foam red. With every step the sublime spectacle became more awe-inspiring. One is unable to speak; the shouts of joy are submerged in this thousand-voiced thunder; all of nature trembles in this valley of terror. . . . All this arouses the power of the soul in its innermost depth; it is the image of eternity. Sensible nature shudders in its nothingness, but the free spirit rejoices.[5]

[2]

To SUCH EXPERIENCES, where dread gives way to joy, traditional aesthetics could not do justice. And yet they had become too common to escape attention. Throughout the eighteenth century numerous attempts were made to oppose to the traditional conception of beauty another quality—the sublime. The most important of these attempts was Edmund Burke's *A Philosophical Enquiry into the Origin of Our Ideas of the Sublime and Beautiful.* Burke not only recognizes that there are two kinds of aesthetic experience but provides an interesting analysis of this difference. He begins by positing two basic human instincts: "Most of the ideas which are capable of making a powerful impression on the mind, whether simply of Pain or Pleasure, or of the modifications of those, may be reduced very nearly to these two heads, *self-preservation* and *society*." [6] Beauty is explained in terms of the latter. "By beauty I mean, that quality or those qualities in bodies by which they cause love, or some passion similar to it." [7] This is the Platonic definition, only *eros*

5. Diary entry of March 29, 1794, quoted by Rudolf Zeitler in *Klassizismus und Utopia*, p. 35.

6. *A Philosophical Enquiry into the Origin of Our Ideas of the Sublime and Beautiful*, ed. J. T. Boulton (New York, 1958), p. 38.

7. *Ibid.*, p. 91.

has been brought down to earth. It is given a foundation not in being, but in society.

> There are two sorts of societies. The first is, the society of sex. The passion belonging to this is called love, and it contains a mixture of lust; its object is the beauty of women. The other is the great society with man and all other animals. The passion subservient to this is called likewise love, but it has no mixture of lust, and its object is beauty; which is a name I shall apply to all such qualities in things as induce in us a sense of affection and tenderness, or some other passion the most nearly resembling these.[8]

Beauty establishes a community between the beautiful object and the world. To see the world in its beauty is to see it as a community of which I am part. The beautiful lets us feel at home. In this sense Hobbema's *The Avenue of Middelharnis* is beautiful, while Friedrich's landscapes lack beauty; they are sublime.

The sublime is said by Burke to have its foundation in the desire for self-preservation:

> The passions which belong to self-preservation, turn on pain and danger; they are simply painful when their causes immediately affect us; they are delightful when we have an idea of pain and danger, without being actually in such circumstances; this delight I have not called pleasure, because it turns on pain, and because it is different enough from any idea of positive pleasure. Whatever excites this delight, I call *sublime*.[9]

Unlike the beautiful, the sublime depends on a lack of harmony between the aesthetic object and man. Nature seen in her sublimity confronts man as an alien power. And yet, Burke suggests, when man is able to stand up to this power, he gains from the confrontation a heightened sense of being alive. Man seeks the illusion of danger to awaken his will to live.

Yet while Burke recognizes the dialectic ambivalence of the sublime, his explanation of it is inadequate. Burke argues that "whatever is fitted in any sort to excite the ideas of pain, and danger, that is to say, whatever is in any sort terrible, or is conversant about terrible objects, or operates in a manner analogous to terror is a source of the *sublime*." [10] "But surely," as one

8. *Ibid.*, p. 51.
9. *Ibid.*
10. *Ibid.*, p. 39.

of Burke's reviewers wrote, "this is false philosophy: the brode-quin of *Ravilliac,* and the iron bed of *Damien* are capable of exciting alarming ideas of terror, but cannot be said to hold anything of the sublime." [11] What makes the Alps sublime, while a visit to a torture chamber evokes rather different feelings? Not everything that is terrifying becomes "at certain distances, and with certain modifications" sublime. Burke fails to see that the apparent lack of harmony between the sublime and man hides an affinity, as Addison had already recognized:

> Our Imagination loves to be filled with an Object, or to grasp at any thing that is too big for its Capacity. We are flung into a pleasing Astonishment at such unbounded Views, and feel a delightful Stilness and Amazement in the Soul at the Apprehension of them. The Mind of Man naturally hates every thing that looks like a Restraint upon it, and is apt to fancy it self under a sort of Confinement, when the Sight is pent up in a narrow Compass, and shortened on every side by the Neighbourhood of Walls or Mountains. On the contrary, a spacious Horizon is an image of Liberty, where the Eye has Room to range abroad, to expatiate at large on the Immensity of its Views, and to lose itself amidst the Variety of Objects that offer themselves to its Observation.[12]

The sublime is "the image of Liberty."

In his *Meditations* Descartes suggests that what makes man most like God is his freedom. Freedom knows no limits; in itself it is infinite. Human understanding, on the other hand, is finite; it is re-creative rather than creative. The understanding fetters freedom by confronting it with some given. This given ties man to a particular situation: it assigns him a place in the world. The sublime invites man to forget this place and thus recalls his original freedom. It does so by breaking the rule of the understanding. Kant thus sees the sublime not simply as posing a threat to finite man, but as defeating him. As Addison observes, the immensity of the sublime makes it "the image of Liberty"; this immensity prevents man from taking its measure. The sublime thus exhibits the impotence of human understanding and forces man to become aware of its limits. Yet to recognize these limits is to be in some sense beyond them; and since man's finitude is rooted in his understanding, to transcend it is to

11. *Ibid.,* p. 39, n. 10.
12. *Spectator,* No. 412.

transcend the finite. The lack of harmony between the sublime and human understanding reveals to man that he transcends the finite. What appears at first as a lack of affinity gives way to a higher affinity.

[3]

ARISTOTLE HAS TAUGHT US to think of the work of art as possessing beginning, middle, and end. Such unity would seem to exclude the sublime. It makes the work of art into something finite or bounded. How then is it possible to reconcile this with the immensity demanded by the sublime? Attempts to portray sublime nature are usually failures. Nature, when caught within the boundaries of a frame, is brought under control. This is especially true when a landscape is painted according to the rules of perspective. Perspective reveals a world which has its measure in the spectator and leaves no room for the transcendence of the sublime. Yet perspective also can be used to negate the spectator's point of view and the finite world which has its foundation in it. The landscapes of Albrecht Altdorfer and Pieter Bruegel are illustrations.

Looking at Altdorfer's *Battle of Alexander* we are at first carried along by the great rhythm pervading the picture. A second glance casts us into confusion. At the bottom of the painting we see masses of men struggling beneath an equally agitated sky. We do not know where to look: should we follow the pursuing Alexander or the fleeing Darius? The eye, unable to embrace the whole, singles out a scene only to move on to something else. The painting possesses what Kant called absolute greatness—what is before us is so complex that as our attention passes from one part to another, we cannot gain a fuller understanding. What is gained on one hand is lost on the other. The understanding is confronted with limits beyond which it cannot go. But more important than this immense richness is Altdorfer's use of perspective. The perspective of the foreground demands that the spectator assume a position perhaps one or two hundred feet above the ground. As the eye moves upward from foreground to background the point of view is continually shifting. The spectator is forced to ascend until, when the eye arrives at the curved horizon line, it is miles above the landscape. The

painting thus imparts a motion, which, with steady acceleration, pushes man upward until it releases him, at the horizon, into swirling clouds, the realm of sun and moon. The same rhythm is echoed by the different presentations of struggle. In the foreground we see individuals, further back groups of men, still further back armies, until we leave the human sphere and the protagonists become water and mountain, sun and moon. In the midst of this movement, like the eye of a hurricane, hangs a sign defying gravity, proclaiming this the battle of Alexander and Darius. Every part of this painting stands in a relationship of tension to other parts; its different parts cannot be synthesized from one point of view. We cannot take its measure.

Unlike Altdorfer's *Battle of Alexander*, Bruegel's *Fall of Icarus* strikes one at first as a rather transparent painting. There is no confusion of detail as there is in the Altdorfer work. Only as we attempt to make sense of the painting does this first impression give way to puzzlement. Again we discover that there is no correct perspective and therefore no correct point of view. But unlike the *Battle of Alexander* this painting does not demand a continuous movement of ascent. Rather it falls into segments, each of which seems to be a self-contained unit with a perspective of its own. The clash of one such unit and the next is sometimes disguised by a hedge or a concealed cliff. This use of perspective isolates the different scenes of the painting. Each individual is caught in his own world. The peasant plowing his field, the angler, the shepherd, and the man on the sailing vessel going by—all are unaware of what is going on in other parts of what seems to be their immediate neighborhood; all are unaware of Icarus, who is just about to disappear in the water. As the spectator moves from one unit to the next, he feels that Bruegel has failed to give sufficient attention to scale. Thus the ship is much too small and much too close to shore when we compare it with the shepherd. We are reminded of a child's playthings. The world in which Icarus disappears seems to be a world of toys, and to restore these objects to the size they should possess we must once more change our point of view and ascend. Only this time the movement is in jerks. It is precisely this jerkiness— particularly in the relationship of Icarus to the sailing vessel going by, where there is nothing to disguise the abrupt change of scale—which suggests an alternative interpretation: we retain our point of view and let the world shrink.

There is a conflict: although we find again a movement of transcendence comparable to that found in the Altdorfer painting, this movement is set against an increasing awareness of the pettiness of the world. The desire to transcend receives a final impetus from the actual horizon line, which seems to be just a little lower than we would expect. Bruegel employs here a technique which is only too familiar today, having been reduced to a cliché by its frequent appearance in surrealist painting: the horizon demanded by the perspective of the painting is contrasted with the painted horizon, which is too low. The tension between the demanded and the painted horizon presents the spectator with a kind of visual paradox which invites him to transcend. Yet, as we remember that this is the *Fall of Icarus* we ourselves fall back into the finite. Bruegel's intent would thus seem to be satirical. He pokes fun at the dumbness and pettiness of man which can let an event such as this go unnoticed. Yet the satire is directed not only against Icarus and his pretensions but also against the spectator and his attempt to transcend the pettiness of the finite. Thus while the painting at first seems to satisfy the demands of the sublime, it can no longer be adequately understood in terms of these demands alone. Rather it ironically negates them and restores man to his place in the finite.

Another example of Bruegel's mastery of perspective is found in his *Conversion of Saul*. A huge fir tree splits the painting in two. This split is so radical that it is possible to see the work as two paintings, hung very closely together, each of which possesses a unity of its own. On the left-hand side we see a group of armed men winding their way out of a ravine. The distant horizon shows us how high above the sea we must be. The right-hand side presents us with that part of the journey which is still ahead of us: a steep ascent into a confused mass of rocks and cloud fragments which seem to swallow the men who crawl around in this primeval landscape, seemingly insignificant. In the big fir tree the two worlds meet—the left-hand side, where the horizon line still enables us to orient ourselves, and the right-hand side, where there is no horizon and where orientation no longer seems possible. Beneath this tree we discover Saul, very small, lying on the ground next to his fallen horse. At first it seems as if Bruegel had used the theme of Saul's conversion only as an excuse to confront us with a sublime landscape; but he has portrayed a conversion in a more significant way than any psychologizing art

could have done. Man, in this case Saul, stands between the finite and the infinite. The tension of Bruegel's painting is immense, and only against this background does Saul's conversion become meaningful.

Both Altdorfer and Bruegel are part of that first era of insecurity and excitement which followed the assertion of the point of view and the breakdown of the doctrine of analogy. This era was followed by a more complacent and optimistic age. Cartesian rationalism was able to erect a screen to hide man's fright of the ineffable. Presented with an orderly, comprehensible, human world, he could feel at home as never before. Academic perspective is part of this effort. It transforms the world into a world which exists for man. Yet Cartesian optimism gave way to a more intense subjectivism, a subjectivism raised to the second power. The first subjectivism makes man the center of the world; the second subjectivism lets him recognize that as the measure of this world man transcends it. The world reveals itself as a world of mere appearances. In such a world man cannot be at home. This recognition leads to new attempts to break the rule of the finite. The emerging interest in the sublime reflects this.

Around 1800 paintings like Altdorfer's *Battle of Alexander* again became objects of admiration after a period of neglect. Thus the *Battle of Alexander* was Napoleon's favorite painting at St. Cloud, and Friedrich Schlegel recommended it to the artists of his time. Nevertheless, perspective had become too much a part of what was considered correct painting to permit the artist to use it as freely as did Altdorfer and Bruegel. The search for the sublime in art had to move in different directions. Thus Friedrich used the contrast between a clearly defined foreground and an indefinite background to overcome and negate the hold of the finite. William Turner, almost an exact contemporary of Friedrich, let the dynamic defeat the static. In his *Burning of the Houses of Parliament,* buildings and spectators have lost all substantiality. They are dissolved in the dynamism of atmospheric conditions. Turner's fascination with the dynamic and atmospheric carried him to almost abstract compositions. Thus in his *Steamer in a Snowstorm* the ship is barely noticeable, a last reminder of structure, almost swept away by the swirling paint on the canvas, submerged by snow, wind, and water. Would it have been more "logical" had Turner taken this last step which still separates him from abstract expressionism? Given an interest in the sublime, it is just the tension between the definite

and the indefinite which gives such art its appeal. The ship is necessary; it has a part to play in the dialectic of the sublime.

[4]

WE CAN DISTINGUISH a *positive* and a *negative* sublime. By negating finite sensuous appearance, the sublime points to a transcendence beyond appearances. It allows man to look through the finite into the infinite. The finite becomes the veil of the infinite. This infinite can be identified with a numinous reality transcending man. The positive sublime can thus be defined as the epiphany of the numinous. The transcendent ground of man's being, although no longer understood as the measure of man, is still experienced as in some sense meaningful and as having a claim on man. This presupposes something like faith, even if this faith lacks definite content.

The negative sublime, too, presents the world in its nothingness, but not to reveal a meaningful reality beyond or behind the finite. The only transcendence revealed is that of man himself. The finite is negated only to liberate the subject. The negative sublime is the epiphany of freedom.

We have come to the end of the development which began with the assertion of the point of view and the destruction of medieval analogy. The emphasis on the point of view is an expression of an awareness that the world is first of all world for man. This implies, although this implication may at first go unrecognized, that man is not just another object in the world. This is perhaps true of his body, but as the subject thinking about the world and about himself as another object in it, man is in some sense beyond the world. As the being for whom the world is, man transcends the world. The negative sublime reveals this transcendence. By leading man to recognize that he is not at home in the world, it invites him to rise above it. If this movement of introversion lets man lose touch with the world, it also lets him gain a new freedom. A new ideal image of man has emerged which does not acknowledge a measure beyond man.

PART II

The Aesthetics of Subjectivity

5 / The Search for the Interesting

[1]

SCHILLER, IN HIS POEM *The Veiled Image of Sais* (1795), tells of a young man who comes to Sais in Egypt, the old seat of priestly learning, in search of wisdom. Dissatisfied with truths which never provide more than fragmentary knowledge, he demands to understand the meaning of the whole and to know *the* truth. Before the image of Isis he is told that behind her veil the truth lies hidden; yet he is warned not to lift it. The meaning of this warning is not clear to him. He who lifts the "holy and forbidden" veil, it is said, will *see* the truth; no other punishment is indicated. But is the vision of the truth to be feared? Is not this what he wants? The warning is rejected. The next day he is found unconscious at the base of the veiled image. He never tells what he has seen but warns others not to let the search for the truth lead them into guilt. Unable to forget the dreadful experience, he soon dies.

Why is it dreadful to *see* the truth? Schiller italicized "see," suggesting that there may be other, less dreadful ways of knowing. We can contrast seeing with listening. The listener lets the other speak; listening presupposes respect for the independence of the speaker; it is dialectic as seeing is not. Thus Sartre suggests that with our eyes we can do violence to the seen:

> What is seen is possessed; to see is to *deflower*. If we examine the comparisons ordinarily used to express the relation between the knower and the known, we see that many of them are represented as being a kind of *violation by sight*. The unknown object is

given as immaculate, as virgin, comparable to a *whiteness*. It has not yet "delivered up" its secret; man has not yet "snatched" its secret away from it. . . . Figures of speech, sometimes vague and sometimes more precise, like that of the "unviolated depths" of nature suggest the idea of sexual intercourse more plainly. We speak of snatching away her veils from nature, of unveiling her (cf. Schiller's *Veiled Image of Sais*).[1]

The look tends to degrade the seen by transforming it into an object. Objects have their foundation in the subject. To wish to know or see something as object is to wish to appropriate and possess it. The desire to see the truth is a desire to be its master and thus master of all. The young man in the poem is unwilling to accept the fact that man, although transcending known objects, is in turn transcended by an unknown reality and is not the author of his being. By knowing all, he wants to become his own foundation and to put himself as pure knowing subject in the place of God.

The poem does not say what the young man saw when he lifted the veil of Isis. Did he see anything? To see the truth is to know the whole—but how is this possible? Objective knowledge must be of a determinate "this," opposed to what it is not, opposed also to the knowing subject. This twofold opposition makes an objective knowledge of the whole impossible. The whole permits neither limit nor opposition; it is infinite. The infinite is not a definite something which can be seen; it is not any-thing, and in that sense it is nothing. Having lifted the veil, the young man must have found himself staring into the void.

But then, why the terror? If nothing was hidden behind the veil, nothing was to be dreaded. Or is it just this emptiness which fills man with dread?

Objective knowledge presupposes the transcendence of the knower over the known. The attempt to know the world objectively leads to man's emancipation from the world, which is reduced to a collection of mere facts. In such a world man cannot feel at home; it has no claim on him. The attempt to extend this mode of knowledge beyond the world of facts to the whole makes it equally impossible for man to hear the call of the divine. The insistence that only that is real which can be known

1. *Being and Nothingness*, trans. Hazel E. Barnes (New York, 1956), p. 578.

objectively leads to a dreadful loneliness which man could stand only if he were self-sufficient. The young man of the poem does not have this strength; so he falls.

Three years after Schiller, Novalis treated the same myth in *The Novices of Sais*. Like Schiller, Novalis recognizes that to be a finite subject is to be expelled from the whole and therefore homeless. Finite man is necessarily dissatisfied, for to be satisfied is to be at one with oneself, but this is denied by man's temporality; having a future, man is essentially incomplete. But if final satisfaction is precluded by man's situation, the longing for it persists, even if man has to escape from his place in the world to fulfill it. Unlike Schiller, Novalis believes in the possibility of such an escape. Although there can be no objective knowledge of the infinite whole, because the understanding condemns us to the finite, the imagination can carry us beyond these limits. The veil of Isis can be lifted by the poet or artist; the infinite can be recovered in the depths of the human soul. Such a recovery presupposes the destruction of the finite. The rule of the understanding must first be broken, the ordinary significance of things destroyed. Novalis strives for a magic transformation of the world: things which do not belong together are joined; relationships are suggested which make no sense and cannot be understood; by asking us to accept them, he bids us go beyond the understanding and the limits which it imposes. Past and present, fairy tale and nature mingle in such a way that we lose our bearings. We are released from our situation in the world, free to join in the infinite play of the imagination.

Like Plato, Novalis understands beauty as the object of love. For him, too, love is an expression of man's dissatisfaction with the temporal and finite where completeness is not to be had. In the loved the lover seeks to complete himself. But for Novalis completeness is to be found only in the infinite. Beauty therefore cannot be understood as the appearance of a form or idea; it is the revelation of the infinite in the finite—the epiphany of Isis. By lifting the veil of Isis, the artist lets man return to the whole.

But is this interpretation of the myth, which at first seems so much more positive than that given by Schiller, really so? Should we interpret the recovery of the infinite as a breakthrough to a more fundamental level of reality or as a flight from reality into nothingness? In his *Hymns to the Night* Novalis celebrates the night, in which all polarities are reconciled, and opposes it to the

more shallow day. Yet from the point of view of finite under-
standing the desire to return to the infinite is a desire to be
annihilated. To be sure, one can try to distinguish between mere
annihilation and annihilation which lets us return home. But
what meaning can be given to this return?

Novalis' description of life as a journey home recalls the
Christian view of man as a wayfarer on the road to the Heavenly
Jerusalem. Man is still said to have his home in the supersen-
sible. But the being to which he will return has become the
absolutely other. With this the foundation of the *imago Dei* con-
ception has been destroyed. It makes sense only as long as there is
a bridge between the infinite and the finite, such as was provided
by medieval analogy. The God of the romantics is the infinite to
which man can return only by renouncing the finite. Romanti-
cism demands what Kierkegaard has called a movement of infi-
nite resignation, without making the return to the world possible.
Death and salvation become indistinguishable and fuse. At
this point it makes little difference whether we retain the lan-
guage of tradition and identify the infinite with God or whether
we speak of the death of God. The call of God has become
indistinguishable from silence. The other side of romantic fasci-
nation with the infinite is an awareness of the homelessness of
the individual in the world. Romantic enthusiasm turns to dread
and boredom.

[2]

IN THE FIRST VOLUME of *Either/Or* Kierkegaard de-
scribes such a romantic nihilist. His aesthete no longer tries to
draw away the veil hiding the infinite; he does not believe in a
saving beyond in even this weak and rather foggy sense. He finds
himself alone and bored in a world which is indifferent to his
demand for meaning. Yet the demand for meaning persists.
Despairing of discovering meaning, he attempts to invent it and
thus to escape from the absurdity of his situation.

As Camus points out, the absurd has its foundation in the
confrontation of man's demand for meaning and the silence of
the world: "I said that the world is absurd, but I was too hasty.
The world in itself is not reasonable, that is all that can be said.
But what is absurd is the confrontation of this irrational and the
wild longing for clarity whose call echoes in the human heart.

The absurd depends as much on man as on the world." [2] If Camus is right, it should be possible to escape from the absurd by escaping from the polarity which opposes a questioning subject to a mute world. This can be done by negating either or both of the poles constituting it. There are three such escape routes:

1. One can affirm the subject and deny the world. The autonomy of the free spirit is emphasized; an attempt is made to escape from the polarity into subjectivity, in defiance of the muteness of the other.

2. One can deny the polarity in its entirety; the finite is negated to make a return to a more immediate mode of being possible.

3. One can deny the questioning subject and accept the world as it offers itself.

Kierkegaard's aesthete chooses the first route. Instead of accepting the world as it presents itself or surrendering to the infinite, he attempts to become self-sufficient by replacing the world with make-believe worlds of his own construction. This forces him to struggle against the world, against the hold which it has on him, even as he recognizes the absurdity of his involvement. To achieve the freedom he seeks, the aesthete has to try first of all to reject the claims which the world presents. Here his project parallels that of the romantic who sacrifices the world to the infinite; but Kierkegaard's aesthete seeks to emancipate himself from the world not to return home to a higher reality but only to escape from the absurdity to which his situation in the world condemns him.

Nil admirari is his fundamental principle. "No moment must be permitted so great a significance that it cannot be forgotten when convenient; each moment ought, however, to have so much significance that it can be recollected at will." [3] The world should provide no more than a reservoir of material out of which the aesthete takes whatever he needs to fashion the imaginary life he has chosen for himself. Life is replaced with poetic construction.

To gain the distance necessary to treat the world as a mere source of material for aesthetic play, the aesthete uses irony. The ironic destruction of his engagement in the world begins with reflection. The aesthete surveys his environment and eagerly

2. *The Myth of Sisyphus*, trans. J. O'Brien (New York, 1955), p. 21.
3. Kierkegaard, *Either/Or*, trans. Walter Lowrie, D. F. Swenson, and L. M. Swenson (New York, 1959), I, 289.

seizes everything negative, accidental, or absurd: "I opened my eyes and beheld reality, at which I began to laugh, and since then I have not stopped laughing." [4] More clearly than the rest of mankind, he sees the devaluation of everything, which is the result of the disintegration of the traditional world view. The ironist dreads and rejoices over the reduction of the world to an accidental conglomeration of objects which do not really matter. Oppressed by the absurdity of man's situation, he dwells on it in order to liberate himself from his place in the world. There is thus a melancholic side to irony: ironic laughter does not create a community; it only reveals the ironist's transcendence over the world, and thus his loneliness. But it also has a positive side: loneliness is the price paid for freedom. The ironist dares to emancipate himself from the world because he feels within himself the strength to be like God and endow his own activities with meaning. Freedom is put in the place of God. Still, even a master of the aesthetic life cannot become completely self-sufficient. Even he needs the "external circumstance which furnishes the *occasion* for the actual production." [5] But the world may not do more than furnish such occasions; it may not limit his freedom by demanding that he act in a certain way. Aesthetic freedom precludes respect, for respect obligates. The occasion is to be esteemed not for what it is in itself but for what it gives rise to; its worth depends on the artists's inclination. It is up to him alone to make an otherwise boring and absurd life interesting.

The interesting depends on a movement of reflection which enables the individual to detach himself from his engaged being in the world in order to enjoy it. Imagine yourself watching a football game, cheering with the rest. Kierkegaard's aesthete would use an occasion such as this to enjoy himself in a literal sense; gently he might poke fun at himself for enjoying something so plebeian as football. This does not mean that he would therefore stop watching the game. No, perhaps he would cheer more enthusiastically than anyone else, divorcing himself at the same time from that cheering individual, becoming his own spectator, enjoying his own superiority over the rest of the watching crowd, thus doubling his enjoyment by enjoying not only the game but himself as well. The aesthete avoids true passion, for passion enslaves the individual; instead he acts as if

4. *Ibid.*, p. 33.
5. *Ibid.*, p. 231.

he were passionate; he plays at being passionate. He is passion-
ate as long as passion suits him, but he knows that it is within
his power to shift into another mood should he desire to do so. "If
another could see my soul in this condition, it would seem to him
like a boat that buried its prow deep in the sea, as if in its terrible
speed it would rush down into the depths of the abyss. He does
not see that high on the mast a lookout sits on watch." [6] The
aesthete remains the ruler of his moods, free to enjoy them as he
pleases. Engaged in a love affair or watching a football game, he
never surrenders to the situation; he is too careful to watch
himself and his own reactions. Like a diarist who enjoys not so
much life as the entries in his diary, he puts life at a distance
and filters it through the medium of reflection; it is precisely this
distance which safeguards his freedom and enables him to pick
out some things and leave out others, transforming life into
something more interesting. "How beautiful it is to be in love,
how interesting to know that one is in love. Lo, that is the
difference." [7] Someone actually in love will be unhappy about the
absence of the beloved. The aesthetic person will enjoy this stage
too; perhaps he will enjoy it more, for the absence of the beloved
makes it easier to use her only as an occasion around which to
construct his reveries—and unhappiness is itself good material
for poetic enjoyment. What is more poetic, and in a reflective
sense more enjoyable, than the profound melancholy caused by
the absence or the death of the beloved? Dante Gabriel Rossetti
was quite aware of this. Thus the melancholy portraits of his
wife were all done after her death. Only then did she become
really interesting.

Interest is the negation of boredom. Both are brought out
into the open by reflection. As man reflects on his situation, as he
disengages himself from his life, the question can arise: is that
all? Every morning the same train to New York City, the same
bank, the same wife. What makes such a life interesting? And
why should one be committed to a dull life, be faithful and act as
if everything depended on balancing one's accounts? Such reflec-
tion, Kierkegaard's aesthete remarks, "causes a dizziness like
that produced by looking down into a yawning chasm, and this
dizziness is infinite." [8] The chosen image suggests that there is
something sublime about boredom. Like the sublime, boredom

6. *Ibid.*, p. 320.
7. *Ibid.*, p. 330.
8. *Ibid.*, p. 287.

awakens us to the fact that what has been accepted as meaningful has really no claim on man. This recognition makes man free to play with the world. Kierkegaard calls boredom the demonic side of pantheism. Boredom and pantheism are both moods which leave the individual paralyzed before the world—in one case because God's presence is recognized equally in everything and there seems no way of valuing one thing over another, in the other because all things are found equally meaningless:

> I do not care for anything. I do not care to ride, for the exercise is too violent. I do not care to walk, walking is too strenuous. I do not care to lie down, for I should either have to remain lying, and I do not care to do that, or I should have to get up again, and I do not care to do that either. *Summa summarum:* I do not care at all.[9]

Artistic activity offers itself as an answer to boredom. Already Kant had described it as carefree activity having its end within itself. To become in this sense self-sufficient is the project of the bored man. Finding no meaning without, he strives to find it within himself and tries to live his life as if it were a work of art, or, more exactly, he tries to transform life into a construction which owes its meaning only to the freedom of the artist. As a matter of fact, such transformation cannot succeed. We are unable to liberate ourselves so completely from our situation in the world and the demands which it makes on us as to become truly independent. But this does not rob the aesthetic life of its status as an ideal for one who has tasted the hollowness pervading everything. It may, however, lead him to try to realize this ideal in art itself. Instead of being a revelation of a higher reality, such art offers an escape from reality. In it man seeks to forget his inability to emancipate himself from his dependence on the world. Here he can deceive himself and play at being God and salvage at least a modicum of meaning.

Kierkegaard's analysis of the aesthetic life can thus be read—and has been read [10]—as a commentary on modern art. Still, such art will always tend to leave its narrow confines and insist on furnishing a program for life itself.

Kierkegaard's own answer to boredom is given in the "rotation method." To defeat boredom, he suggests, man will strive to discover meaning beyond a situation which suddenly seems in-

9. *Ibid.,* pp. 19–20.
10. Hans Sedlmayr, "Kierkegaard über Picasso," *Der Tod des Lichtes* (Salzburg, 1964), pp. 63–85.

tolerable. Thus he may try to escape from boredom at home by traveling to foreign countries; bored abroad, he dreams of journeys from star to star. But such attempts show a lack of ingenuity. They will only compound boredom. Instead, Kierkegaard's aesthete admonishes us, we should not change the field, but rather its method of cultivation, i.e., adopt the rotation method. This has the power of transforming everyday boredom into something more interesting. The first demand of this aestheticism is that the world of care be bracketed; for the truly bored person this is no problem—he is already carefree. With the bracketing of care everything is transformed into an occasion, into something arbitrary; thus it is made available for aesthetic play.

> The whole secret lies in arbitrariness. People usually think it easy to be arbitrary, but it requires much study to succeed in being arbitrary so as not to lose oneself in it, but so as to derive satisfaction from it. One does not enjoy the immediate but something quite different which he arbitrarily imports into it. You go to see the middle of a play, you read the third part of a book. By this means you insure yourself a very different kind of enjoyment from that which the author has been so kind as to plan for you.[11]

The world assigns man a place; it tells him what to do. Nature, society, religion, and art fetter him by making demands. Defying these demands, the romantic nihilist posits freedom as his ideal. His conception of freedom is negative: to be free is to be free from the place which the individual has been assigned, to act other than one is expected to act, to enjoy what one is not expected to enjoy. The interesting serves this ideal. It dislocates man by presenting him with something unexpected or novel. Its appeal depends on certain expectations which are then disappointed. Thus the normal is boring, the abnormal interesting. Something taken out of its normal context, e.g., a can of Campbell's soup presented as a work of art, is interesting. To stress the unimportant, giving it great importance, can be interesting. To give just one example: how often do we sit in a concert hall trying to listen to a piece which we have trouble understanding, only to be distracted by the coughing of some neighbor. But an aesthete of even modest ability can make use of this and integrate the clearing of the throat, the coughs, and the sniffling into the piece of music. After all, they, too, are sounds. Is this not one

11. Kierkegaard, *Either/Or*, I, 295.

thing John Cage has taught us? As a matter of fact, we can make these sounds the center of our attention and enjoy the struggle of the unfortunate individual with his cough. By shifting our attention, we transform an annoying distraction into a dramatic work of art, making the best of what would otherwise be a rather unpleasant situation.

[3]

MODERN ART HAS REALIZED the aesthetic potential of the interesting. When Duchamp placed his urinal on exhibition this made it not beautiful, but interesting. Similarly Tinguely's self-destroying machine is not beautiful, but interesting. Someone who tries to discuss these works in terms of the traditional conception of beauty is either blind or is trying to be interesting. Yet it is possible to understand the interesting as a species of the beautiful. If, following Plato's hints, we understand beauty as a manifestation of the ideal, the interesting also is beautiful. It, too, manifests an ideal, although it is an ideal which lacks content. It is witness to the idealization of infinite freedom.

The concern for the interesting leads to the adoption of arbitrariness as an aesthetic principle. The artist subordinates himself to chance and accident.

> It is extremely wholesome thus to let the realities of life split upon an arbitrary interest. You transform something accidental into the absolute, and, as such, into the object of your admiration. This has an excellent effect, especially when one is excited. This method is an excellent stimulus for many persons. You look at everything in life from the standpoint of a wager, and so forth. The more rigidly consistent you are in holding fast to your arbitrariness, the more amusing the ensuing combinations will be. The degree of consistency shows whether you are an artist or a bungler.[12]

Hans Arp has been a pioneer in the exploration of the magic of the arbitrary. His illumination came one day when, after having worked for a long time with little success on a drawing, he disgustedly tore it into pieces and scattered them on the floor, only to discover in the resulting pattern the expression which he had sought in vain. Carefully he picked up the pieces and glued them down as he had found them. Arp's discovery proved to have

12. *Ibid.*, p. 296.

been an important one. The creative power of arbitrariness was recognized not only in the visual arts but in literature and music as well. One should beware of trying to discover in art created according to this principle profundities which were never intended. Or rather, one should look at such art, discovering profundities, while realizing at the same time that the discovered profundities have been put there by us, the spectators. The artist no longer engages the spectator in a dialogue; he provides no more than an occasion. It is up to the spectator to make something interesting of this occasion. The work of art is really his creation. One problem with those attacking and those defending such art has been that defenders and critics alike have often taken themselves too seriously. Thus, a critic like John Canaday should not be attacked for his supposed lack of sympathy with such experiments but, rather, should be hailed as the discoverer of the great modern artist Ninguno Denada.[13] It is such levity which makes Duchamp so much more enjoyable than most of his imitators. Alas, he soon gave up painting, turning to chess instead—after all, perhaps a more interesting diversion.

Kierkegaard argued that the attempt to defeat boredom by means of the interesting must in the end fail. A urinal is interesting the first time we see it in a museum; but if we take this initial success as a cue to bring other bathroom fixtures into exhibitions, it soon gets rather boring. To exhibit a crushed Buick as a work of art is rather interesting, but it would not do to take this as an invitation to crush Cadillacs, Fords, and anything else that's helpless. The interesting demands novelty. If one has an interest in the interesting, to say that something has already been done is devastating criticism.

Friedrich Schlegel was perhaps the first to use the concept of the interesting to interpret the meaning of the "modern" in "modern art" and "modern poetry." This led him to expect an accelerating race for the ever more interesting. The desire for the interesting has to lead to dissatisfaction with whatever is being offered. When the interesting has become the expected men will demand more intense stimulations. First they will demand the piquant and spicy. This will give way to the shocking, until in the end the shocking itself is expected and only boredom remains.[14]

13. John Canaday, *Embattled Critic* (New York, 1962), pp. 14–20.
14. Friedrich Schlegel, "Die moderne Poesie," *Schriften und Fragmente*, ed. E. Behler (Stuttgart, 1956), pp. 114–21. Cf. Hans Sedlmayr, *Die Revolution der modernen Kunst* (Hamburg, 1956), p. 60.

It is possible to interpret the development of art since 1790 or 1800 in the light of this conception of the search for novelty. One can point out that there has been a steadily accelerating development which since 1925 or 1930 shows signs of having exhausted its possibilities. Since then art has become increasingly boring. On the other hand, the period of greatest acceleration, the decade preceding the First World War, is perhaps the most interesting period in the entire history of art. The search for novelty hardly gives us an adequate schema for understanding the development of modern art; but it does point to a side of this development.

In defense of the interesting it can be argued that one is caught in this self-defeating pattern only if one does not heed sufficiently Kierkegaard's admonition that one should limit one's inventiveness: "The more you limit yourself, the more fertile you become in invention." [15] Doodling is such a limited and therefore very fertile activity. Many of us, I am convinced, exhibit our most interesting side in our doodles. Kierkegaard also warns the artist not to get caught in a groove which robs him of his freedom. Just when everyone has pegged you as a serial composer, assert your freedom, fool your critics, and write in a very retrogressive style; or, if you are a painter, give up your abstract expressionism and turn neo-classical or whatever else may hit your fancy. A strictly realistic painting by a known avant-garde painter is interesting for a change, while the same painting by an unknown painter may well be boring. The masters of the interesting will therefore never permit themselves to be caught in a particular way of doing things for too long a time. The foundation of their artistic progress is discontinuity, novelty. Like Proteus, such artists change their masks, appearing absolutely successful in each one. As Sedlmayr has suggested, the painter who represents this Protean character of modern art better than any other is Picasso; [16] a less imaginative, less skillful artist would have suffered shipwreck a long time ago.

15. *Either/Or*, I, 288.
16. *Der Tod des Lichtes*, pp. 63–85.

6 / Negation, Abstraction, and Construction

[1]

IN HIS *Vorschule der Aesthetik,* in a section called "Poetic Nihilists," Jean Paul Richter criticized his contemporaries for their attempts to liberate the subject by destroying reality and replacing it with poetic constructions, projected into the void.[1] Even more readily than these romantics some modern artists have sacrificed the world in order to gain an empty field for their inventions.

A first and key determination of such art is its negativity. It is anti- : anti-religion, anti-morality, anti-nature, and in the end even anti-art. "We were all propelled," writes Hans Richter, reminiscing about the time when Dada was born in Zurich, "by the same powerful vital impulse. It drove us to the fragmentation or destruction of all artistic forms, and to rebellion for rebellion's sake; to an anarchistic negation of all values, a self-exploding bubble, a raging *anti, anti, anti,* linked with an equally fervent *pro, pro, pro!*"[2] The world and its values were rejected for the sake of freedom. Art became a weapon in the struggle against reality. And how, as Gottfried Benn suggests, could art be anything else, given the world in which these artists found themselves? "Between 1910 and 1925 there was no style in Europe other than the anti-naturalistic style, for there was also no reality, only its caricature." Realistic art had become an impossibility, as the sense of reality had been lost. "Reality—that meant

1. *Vorschule der Aesthetik,* ed. N. Miller (Munich, 1963), p. 31.
2. *Dada: Art and Anti-Art* (New York, 1965), p. 35.

allotments, industrial products, mortgages, everything that could be given a price . . . reality, that meant war, hunger, humiliation, power. The spirit knew no reality. It turned to its inner reality." [3] Perhaps this passage goes a little further than it should. If the world really had no weight, it would be unnecessary to struggle against it. But it is there and demands to be acknowledged. Man is engaged in it, even as he recognizes the absurdity of this engagement. To cast off this burden, the artist tries to convince himself and others that the world is not worth having and has no rightful claim on man. He seeks out what is unacceptable, abnormal, perverse. He chooses the side of evil, not because he is committed to it, but because he wants to escape from his unhappy relationship to the old value system in which he can no longer believe and which yet has a claim on him. An art results which is unthinkable without the Christian background, but its relationship to this background is negative. Christianity offers the artist a point of departure, leading to the assertion of its opposite, the satanic. Thus many nineteenth-century artists were preoccupied with satan, hell, witches' sabbaths, and black masses. A rather extreme example of this is Félicien Rops's *Temptation of St. Anthony*. Christ on the cross has been replaced with a voluptuous nude, INRI with EROS. This was not intended as a Nietzschean inversion of the old value system; Rops believed in the redemptive power of Eros no more than he believed in that of Christ. The erotic was used merely as a weapon of destruction.

Just as Rops used the erotic to attack Christianity, Aubrey Beardsley used obscenity to challenge the traditional norms governing sexual behavior. This attack did not aim at revolution; there was no attempt to put new values in the place of those under attack. Beardsley was no reformer. With him abnormality was its own reward. We are reminded of Kierkegaard's answer to the question, "What is wrong with innocent pleasures?" "That they are so innocent," was his reply. For the sake of the interesting, artists like Beardsley toy with the abnormal and perverted. Beardsley lacked the seriousness of the revolutionary. His drawings are playful; they possess a lightness which amuses rather than shocks and which prevents even his more extreme efforts from being pornography. The machine-like precision of his draftsmanship and his formal mastery, e.g., the deliberation

3. *Essays*, (Wiesbaden, 1958), I, 245.

with which he exploits the contrast of black and white, further create a sense of distance which robs sex of its immediate reality. We witness the triumph of the free spirit, not only over bourgeois morality but over the flesh as well, an inhuman victory which for the sake of freedom denies what man is.[4]

But not only the inherited value system stands in the way of freedom. Indeed, as it loses its power, attacks on it, too, become increasingly pointless. Only Victorians find attacks on Victorian morality interesting. As the moral sense becomes less rigid and more uncertain, it no longer provides the artist with a suitable foil. So the target changes. The world itself comes under attack. A first step leading to its destruction is deformation. There always has been deformation in art for the sake of positive expression. Early medieval art provides good examples. Yet there is a tendency toward deformation in modern art which is essentially negative. The artist deforms an object not in order to reveal it but to deny the normal and to disappoint expectations. Familiar objects are taken out of context, distorted, fractured, or dismembered. Anticipating such art, Baudelaire wrote of the artist's imagination decomposing the materials of the world. He called such decomposition idealization. The work of art presents the idealized image of the world. With this any Platonist could agree. But while traditionally idealization suggested the reconstruction of the given in the image of a higher reality, the term is now understood purely negatively. Idealization for Baudelaire and for many modern artists is derealization. The ideal guiding it is completely empty.[5]

Applied to man himself deformation implies dehumanization. One sign of this is that the portrait loses its importance. Kokoschka's interest in the portrait is out of step with the times. Portraits make sense only as long as art is born out of respect for man in his finite situation. Where this respect is lacking, the subject of the portrait becomes a mere occasion which the artist manipulates as he sees fit—consider Picasso's portraits—if indeed portraits are painted at all. "The human figure is progressively disappearing from pictorial art, and no object is present except in fragmentary form. This is one more proof that the human countenance has become ugly and outworn, and that the

4. Cf. Hans Hofstätter, *Symbolismus und die Kunst der Jahrhundertwende* (Cologne, 1965), pp. 177–203.

5. Cf. Hugo Friedrich, *Die Struktur der modernen Lyrik* (Hamburg, 1956), pp. 93–106.

things which surround us have become objects of revulsion." [6]
Just as a phrase degenerates into a cliché after constant unthink-
ing use, so, Hugo Ball suggests, modern man has become so used
to the world, to others, to his own face that they have become
opaque and nauseating. Bored with his face, bored with himself,
he invents destructive games. Serving an inhuman freedom he
destroys himself. Alfred Jarry, Arthur Cravan, and Jean Genet
tried to live what others dared to express only in their art.

Another weapon used by the artist in his struggle to free
himself and us from the tyranny of the expected is disorienta-
tion. Thus perspective, which prescribes a definite point of view,
is rejected. It has been suggested, for instance by Maritain, that
this development has something in common with the pre-per-
spectival art of the Middle Ages which spurned perspective be-
cause it tied the spectator to appearances and prevented the
artist from revealing a higher reality.[7] But the modern movement
away from perspective hardly has its foundation in such a pro-
ject—the belief in a higher reality is lacking. Admitting this, one
can defend the "distorted" perspective of an artist like Cézanne
as actually more faithful to what is seen than that of the acade-
mies. This may be granted, but many a modern artist has pushed
perspective to a point where such an argument no longer makes
sense. Thus in many Cubist paintings, the rejection of tradi-
tional perspective is better understood as part of a project of
liberation which denies the expected means of orientation for the
sake of greater freedom.

For the same reason up and down tend to become less impor-
tant in much modern art. Thus it is not always obvious which
side of an abstract painting is up. This uncertainty may lead to a
painting's being hung upside down. Or the artist may himself
point out that there is no right way of hanging the picture and
suggest that we rotate it every few weeks by 90 degrees to see it
in different ways.

The artist's struggle for freedom may turn against art itself.

Dada not only had *no* programme, it was against all programmes.
Dada's only programme was to have no programme . . . and, at
that moment in history, it was just this that gave the movement its
explosive power to unfold *in all directions*, free of aesthetic or

6. Hans Richter, *Dada*, p. 41.
7. *Art and Scholasticism*, trans. Joseph W. Evans (New York, 1962),
p. 52.

social constraints. This absolute freedom from preconceptions was something quite new in the history of art. The frailty of human nature guaranteed that such a paradisal situation could not last. But there was to be a brief moment in which absolute freedom was asserted for the first time.[8]

For the sake of freedom Tristan Tzara demanded the destruction of art by artistic means: "Art falls asleep . . . 'ART'—a parrot word—replaced by Dada . . . Art needs an operation. Art is a pretension, warmed by the diffidence of the urinary tract, hysteria born in a studio."[9] This destructive intent is obvious when Duchamp supplies the *Mona Lisa* with mustache and goatee or offers such mass-produced objects as a bottle dryer or a snow shovel as works of art.

> In New York in 1915 I bought at a hardware store a snow shovel on which I wrote *in advance of the broken arm.*
> It was around that time that the word "ready-made" came to my mind to designate this form of manifestation.
> A point that I want very much to establish is that the choice of these "ready-mades" was never dictated by aesthetic delectation.
> The choice was based on a reaction of *visual indifference* with a total absence of good or bad taste . . . in fact a complete anaesthesia. . . .
> At another time, wanting to expose the basic antinomy between art and "ready-mades" I imagined a *reciprocal ready-made:* use a Rembrandt as an ironing board![10]

Nevertheless, such non-art, created to provoke and scandalize, was soon canonized and collected. The tradition which men like Duchamp wanted to dissolve with their irony not only survived but profited from their attempts. Their creations were bought, collected, put into museums, and imitated.

> This Neo-Dada, which they call New Realism, Pop Art, Assemblage, etc., is an easy way out, and lives on what Dada did. When I discovered ready-mades I thought to discourage aesthetics. In Neo-Dada they have taken my ready-mades and found aesthetic beauty in them. I threw the bottle-rack and the urinal into their faces as a challenge and now they admire them for their aesthetic beauty.[11]

8. Hans Richter, *Dada,* p. 34.
9. *Ibid.,* p. 35.
10. *Ibid.,* p. 89.
11. *Ibid.,* pp. 207–8.

Common to these tendencies is their negativity, a negativity which has its foundation in the idealization of freedom. Freedom is to be raised to a new state of purity. To do so, the artist creates works which are as free as possible from all that reflects man's dependence on the world with its cares and concerns. And yet, what does such negation lead to? As long as the underlying conception of freedom is fundamentally negative there can be only one answer: silence. Yet before art reaches this last stage, there is a phase where some communication remains, although the strain is such that the spectator or reader struggles with the meaning of the work before him. This aspect of modern art has often been noted. Frequently those who have made this charge have been charged in turn with being unsympathetic, lazy, stupid, or ignorant of the fact that modern art has always been ahead of its time. Such supposed defenses rest on a misunderstanding: modern artists should not feel apologetic about the fact that their creations frequently meet with a lack of comprehension. Rather, the very attempt to measure modern art by a standard of communicability derived from traditional art is mistaken. The situations of art and artist are no longer comparable. The hermetism of much modern art is an inevitable outcome of the idealization of freedom. As long as this emphasis is retained a truly public art is unattainable.

The term "hermetism," which I have used to refer to a tendency toward privacy and incomprehensibility, was used first to describe the work of a number of Italian poets, including Ungaretti, Montale, and Quasimodo.[12] The very fact that literary criticism has adopted it is noteworthy. In no way should it be thought of as implying a negative judgment. It simply describes an aspect of modern poetry—and it need not be confined to poetry. What may make hermetism seem suspect is the fact that it makes it difficult, in extreme cases perhaps impossible, to distinguish nonsense from art. Thus in Australia nonsense verse was published as the *opus postumum* of a miner and admired for its profundity.[13] Or we can point to a misprint in an edition of Yeats's poems which in "Among School Children" had "soldier Aristotle" instead of "solider Aristotle," a misprint which led some young poet to wonder about the profundity of the mysterious "soldier Aristotle."[14] It is easy to continue with such examples

12. Friedrich, *Die Struktur der modernen Lyrik*, p. 131.
13. *Ibid.*, p. 133.
14. *Ibid.*

and to turn to chimpanzees winning art awards or to random noises being broadcast as the work of an obscure Polish avant-garde composer and meeting with the approval of reputable critics. Such confusions are to be expected where definite meaning is thought to be incompatible with artistic freedom.

[2]

THE HERMETIC WORK of art points toward silence. Ungaretti suggested that the poem should be like a brief tearing of silence; Mallarmé argued that ideally a poem should be silent, white. Of all modern painters Kasimir Malevich followed such a program most rigorously and self-consciously.

In his theoretical writings Malevich makes it clear that his suprematism has its foundation in a desire to escape from the absurdity of the human situation. Like Camus, Malevich discovers the origin of the absurd in the vain demand that there be a higher meaning, a goal. Religion, science, and art are said to express this demand in different ways; they are witness to man's delusions that the world exists for his sake and that life is a task. But the world is indifferent to man; it doesn't care what man does; there is no final goal.[15]

Suprematism is supposed to deliver man from these delusions. To life conceived of as a vocation, Malevich opposes a freedom which knows of no tasks. "Generally one understands by 'creative freedom' the freedom to do what one wants. But this freedom seems questionable to me, for the question of the 'what' remains." [16] As long as man asks, "What am I to do?" the absurd remains a threat, for in the end such questions receive no satisfactory answer. Supposed answers can be shown to involve a refusal to question further. The threat of the absurd is overcome only when such questions are no longer asked. Only then is man truly free. "By creative activity I understand a free expression, an activity which raises no question. Questions belong to the province of the inventor, not to that of the creator. Freedom can exist only where there are no questions and no answers." [17] Malevich's freedom is beyond meaning and thus beyond absurdity. If

15. Kasimir Malevich, *Suprematismus—Die gegenstandslose Welt,* trans. and ed. H. von Riesen (Cologne, 1962), pp. 40 ff.

16. *Ibid.,* p. 86.

17. *Ibid.,* p. 116.

man demands nothing of the world it cannot disappoint him. As Malevich emphasizes, such freedom is also beyond willing.[18] Freedom is transformed into spontaneity. And yet, to seek this transformation is to have a goal. In the sense in which Malevich understands freedom, he himself cannot be free.

Malevich knows that in order to achieve this freedom it is necessary to go beyond the everyday mode of existence. As long as man cares he is not free but bound to the object of his care. Freedom requires calm, yet our involvement in the world makes such calm impossible. It is therefore necessary to replace the world with a more adequate environment for freedom. This is provided by non-representational art. It alone invites the "white state of mind" which emerges when all cares and concerns have been silenced and man desires nothing.

Not all non-representational art is conducive to such calm. Abstract forms and colors can move and excite us; they can suggest nature without being its representation—consider Kandinsky's *Improvisations*. To make sure that all representational ballast, all suggestions and reminiscences of the world in which we live, are cast off, Malevich turns to the square as the most abstract form and to white as the most abstract color. The key to suprematism, Malevich tells us, is the white square.[19]

Malevich sees himself as a prophet. His "white suprematism" is an instrument of salvation. It, too, serves an ideal image of man. But this ideal of a "white mankind" [20] is empty, as empty as Malevich's conception of freedom. Malevich is only consistent when he equates the holy with zero.[21]

Malevich's white square points toward a limit of modern art. Beyond it the artist cannot go. Destruction having done its work, a new positive is demanded. Malevich himself interpreted the white square as marking the border which separates suprematism from the art of the past. This new art was to be no longer the realization of an intention, but spontaneous expression: "I have not invented anything, only the night I have sensed, and in it I saw the new which I called suprematism." [22] The night sub-

18. *Ibid.*, p. 120.
19. *Ibid.*, p. 224.
20. *Ibid.*, p. 227.
21. *Ibid.*, p. 57.
22. Walter Hess, *Dokumente zum Verständnis der modernen Malerei* (Hamburg, 1956), p. 98.

merged the world; yet in it new worlds of geometric forms took shape.

[3]

FOUR YEARS before Malevich discovered suprematism, Wilhelm Worringer wrote his *Abstraction and Empathy*,[23] which suggested that the situation of modern man demanded an abstract geometric art. Like Burke, Worringer distinguishes two basic ways of responding to the world: one either feels at home in it, or one moves in it as a stranger, confronted by a hostile ominous other. The former mood is pantheistic, the latter nihilistic. Corresponding to these two moods, we find two very different approaches to art. For an understanding of one the key concept is *empathy*, for an understanding of the other, *abstraction*.

Worringer accepts Theodor Lipps's analysis of empathy. Lipps's discussion is reminiscent of Kant, who had argued that aesthetic enjoyment is rooted in the harmonious play of man's faculties. Appreciation of a beautiful object, Lipps argues, is effortless. The object harmonizes with man's faculties. Man feels at one with the object. In it he discovers himself. An object is called beautiful only when such harmony is found; it is called ugly when it offers resistance to man's attempts to understand it. The former is called *positive empathy*, the latter *negative empathy*.

Beauty or positive empathy presupposes a feeling of being at home with the objects contemplated, a point which had been made already by Burke and Kant. This, Worringer suggests, is not enough. Empathy gives us only one pole of aesthetic appreciation. There is art—and this was recognized by all theorists of the sublime—which is born of a sense of homelessness. The impermanence and contingency of human existence gives rise to a desire to establish something which will endure and offer a refuge from time. Man seeks something to which he can escape from the insecurity and confusion which is his lot. Religion offers one escape route; art offers another. In art, Worringer suggests, such attempts will lead to abstraction, to forms which are stable, ordered, and comprehensible. While empathy presup-

23. *Abstraktion und Einfühlung* (Munich, 1908; new ed., 1959).

poses a happy acceptance of man's finite, temporal being, abstraction has its foundation in a desire to transform time into space and thus to cause time to stand still. Abstraction seeks the transcendent in an effort to escape from becoming. This transcendent reality may be the truly real, as Plato would have us believe, or it may be only an illusion, a mere construction of the spirit born out of its unwillingness to accept its fate, which places it at the mercy of time. Though Worringer stresses the former, I would like to leave the issue open. Worringer's main point, that a feeling of homelessness is at the root of abstraction, is not affected by it.

The word "abstraction" has a negative as well as a positive meaning. While it recalls such words as "deformation," "decomposition," "dehumanization," it also suggests "construction" and "composition": the artist not only destroys but *dictates* a new order which bears the imprint of the human spirit. The productive imagination of Kant and the romantics becomes the "dictatorial fantasy" of the modern artist.[24] "Dictatorial" suggests violence, subjection, a disregard of the claims of the victim. Thus Kandinsky speaks of the canvas fearing the act of creation as it would a rape. Such comments invite a Freudian interpretation. Daniel Schneider suggests that abstract formalism in art is a sign of the inability of the artist to cope with the hostile world he faces as he turns instead to a narcissistic preoccupation with his own self.[25] His abstract fantasies become a substitute for a real encounter. Sexual aggression is directed only against a piece of canvas. The explanation Worringer suggests is indeed similar, even if a very different evaluation is given. According to both, abstract formalism has its root in an attempt to escape from a hostile world by turning to a substitute reality which has its foundation in the subject. In this sense such art is fundamentally narcissistic. It seems to me, however, that this narcissism cannot be interpreted in terms of the artist's inability to love. This inability must itself be understood as one symptom of a more fundamental crisis which prevents the subject from establishing a meaningful relationship with the surrounding world. This crisis has its foundation in the rise of subjectivism and the subsequent isolation of the individual. Valéry's definition of modern poetry applies to modern art as well. It, too, is *"an effort of*

24. Friedrich, *Die Struktur der modernen Lyrik,* pp. 61, 104–5.
25. *The Psychoanalyst and the Artist* (New York, 1962), p. 121.

man in isolation to create an artificial and ideal order by means of a substance of vulgar origin." [26] In the case of the poem, the "substance of vulgar origin" is presumably everyday language. As long as it is not transformed by being subjected to an ideal order, it has no aesthetic value. It only furnishes the poet with occasions for his ingenuity. The ideal which guides the poet in this transformation is provided by the nature of his own spirit. The poem, Valéry tells us, should be a feast of the intellect; poetry should be a kind of calculus, as Novalis, Poe, and Baudelaire believed.[27] Such a view of poetry is characterized by a distrust of the emotions and of unconscious inspiration. Instead, a severe intellectual muse is invoked. The artist appears disguised as an engineer.

This conception of art is more readily recognized in the work of painters like Picasso, Braque, Gris, Léger, or Feininger. Braque tells us that the artist should not think that he can be truthful by imitating supposedly stable things, since they are actually continuously changing. "Things in themselves do not exist at all. They exist only through us." [28] Confronted by a reality which does not satisfy the spirit's demand for clarity and stability, the artist creates a new and less evanescent world in the image of the spirit.

In his *Aesthetic Meditations,* which are in fact a Cubist manifesto, Apollinaire announces proudly that the artist in his striving for "purity, unity, and truth" has finally subjugated nature.[29] In striving for purity, the artist "humanizes art" and "makes man divine." Art is created by the human spirit according to its own laws. Here it is allowed to unfold in relative freedom from outside forces. Ideally the work of art is a construction of the spirit in the void. Only then is the artist in his creative freedom truly like God and by this token free of God's creation; only then has he achieved complete autonomy and defeated the absurdity which is rooted in man's inability to escape from the opaque world into which he has been placed. Still, Apollinaire seems to possess a rather curious image of man when he speaks of "humanizing art." Man is no longer seen as essentially in the world, caring for himself and for others;

26. Haskell M. Block and Herman Salinger (eds.), *The Creative Vision: Modern European Writers on Their Art* (New York, 1960), p. 27.
27. Friedrich, *Die Struktur der modernen Lyrik,* p. 30.
28. Hess, *Dokumente,* p. 54.
29. *Ibid.*

rather, man the artist should stand in godlike isolation, beyond the world, treating it as his toy.

This conception of art likes to claim Cézanne for itself. Cézanne's assertion that the artist should use sphere, cone, and cylinder to organize his paintings seemed to call for attempts to replace organic with geometric forms. Yet Cézanne himself never used geometry to conquer nature. His landscapes are products of a dialogue between the artist and nature. Such a dialogue presupposes an ability to listen to the other, a willingness to let the other be what it is. Art only helps to reveal the other. Cézanne's followers tended to eliminate this dialectic element. Instead of a dialogue we have subjugation. The artist reinterprets the world in the image of geometry and thus forces her to abandon her incomprehensible organic character. Nature becomes crystalline or metallic. One could point to Léger, who "more literally than any other painter of the time, seems to have taken to heart Cézanne's famous remark about interpreting nature by means of the cylinder, the sphere, and the cone," [30] creating a machine-like world which has been purged of life, a world where people seem to be made of stainless steel or wrought iron. Less vigorous, far more refined, and yet related in its underlying attitude is the glassy, cool world of Feininger. Feininger is perhaps more self-consciously trying to dematerialize the world in order to escape from the temporal and organic. His fascination with the city, a landscape made by man, is symptomatic. Feininger transforms it into a crystalline landscape in which man himself has become an abstract, impersonal cipher. Braque and Picasso present us with still different variations on the same theme: nature is recreated in the image of the spirit; it is forced to submit to an order dictated by man.

But is this at all unusual? Could it not also be asserted of traditional art, of Vermeer's apparently realistic *View of Delft* or of Hobbema's *The Avenue of Middelharnis*, for example? But like the paintings of Cézanne, these landscapes are products of a dialogue between artist and nature. They are portraits, just as Cézanne painted portraits of Mont Sainte-Victoire. Feininger's cityscapes lack this portrait-like quality. Whether he painted Halle or Tollersroda, in the end it is always the same city of the spirit. The dialectic element which we find in Cézanne is lacking.

30. Herbert Read, *A Concise History of Modern Painting* (New York, 1959), p. 87.

Abstraction here no longer aims at revelation of the portrayed, but at its derealization. One is reminded of Baudelaire's construction of an imaginary place, without space, without time, and without sound: "Here a constructive spirituality has become picture, announcing its victory over nature and man in mineral and metallic symbols, and projecting its constructed images into empty ideality, out of which they gleam back, glittering to the eye, deeply disturbing to the soul." [31]

A surprising anticipation of this attitude to beauty is found in Swift's *Gulliver's Travels*. In his description of life on the flying island of Laputa, Swift gives us a caricature of autonomous man. The Laputans, Swift tells us, display a peculiar fondness for mathematics and music. "If they would, for example, praise the Beauty of a Woman, or any other Animal, they describe it by Rhombs, Circles, Parallelograms, Ellipses, and other Geometrical Terms." The phrase "other Animal" suggests that in giving such descriptions the humanity of man is overlooked. Man has difficulty recognizing his fellow human beings. "It seems, the minds of these people are so taken up with intense Speculations, that they neither can speak, nor attend to the Discourses of others, without being roused by some external Taction upon the Organs of Speech or Hearing." One can infer that the art of such literally rootless, floating people, each caught in a private world of his own construction, would have to be geometric and abstract.

31. Friedrich, *Die Struktur der modernen Lyrik*, p. 41.

7 / Kitsch

THE PHILOSOPHY OF ART too often fails to recognize
the existence of bad art. If one understands why a certain work
is a masterpiece, however, one must also understand why some
other piece of art is bad. If a philosophy of art fails to provide
criteria by which to distinguish the good from the bad, it is
inadequate. To avoid this inadequacy, the philosopher of art has
to consider not only what is commonly considered excellent but
also what is commonly considered bad. In this chapter, instead
of developing categories which apply to recognized masterpieces,
I shall make an attempt to understand a certain kind of bad art,
that art which art criticism calls "Kitsch." Indirectly, at least,
this should reveal something about the nature of art.

The term Kitsch seems to have originated in the second half
of the nineteenth century, perhaps in Munich art circles. There
are two theories concerning its derivation. The first relates it to
the English word "sketch." When English visitors to the Bavarian
capital wanted to take some cheap artistic mementos home with
them, they demanded sketches, quickly done pictures, depicting
perhaps some icy peak; or a lovely Alpine valley complete with
morning sun, milkmaid, and handsome young forester; or some
jolly monks, brandishing beer steins and huge white radishes. A
second, more plausible theory, relates Kitsch to the obscure Ger-
man verb *kitschen* which suggests playing with mud, smoothing
it out. Anybody familiar with nineteenth-century academic

painting can appreciate how well this verb suggests both the color and the texture of much that was produced at that time.[1]

Regardless of which version we adopt, it seems likely that the term Kitsch was first applied to certain genre paintings, such as the innumerable works celebrating the pristine life of the mountaineer—visions of innocence and vigor, designed with an eye to an unsaturated market. The word soon acquired overtones of moral disapproval: those paintings were called Kitsch which seemed to show a lack of integrity and which catered to the longings of the sentimental bourgeois. It is in this sense that the word appears in art criticism today.

But is it legitimate to condemn a work of art for being false or dishonest? Do such judgments have a rightful place in art criticism, or do they betray an unfortunate confusion of ethical and aesthetic categories? Such questioning points out the strange ambiguity of the word Kitsch. On the one hand, the word does belong to art criticism—Kitsch is considered bad art; on the other hand, Kitsch is not simply bad art, but bad art of a particular kind. Here "bad" is used not so much in an aesthetic as in a moral sense. Kitsch is perverted art, and to understand this perversion, we have to relate art to a standard of truth or morality. If aesthetics conceives itself to be only an autonomous discipline, divorced from ethics and ontology, it must fail to understand Kitsch, for Kitsch is a hybrid. If, on the other hand, we find Kitsch a meaningful term to use in judging works of art, we have committed ourselves to a theory of art which places itself in a wider framework. From this point of view, to strive for purity in art, to isolate aesthetics from ethics, is to misunderstand what art is all about.

John Canaday's appraisal of Bouguereau's paintings and Joseph Kerman's reaction to Richard Strauss's *Salome* illustrate this ambiguity of Kitsch. "The wonder of a painting by Bouguereau," Canaday writes, "is that it is so completely, so absolutely, all of a piece. Not a single element is out of harmony with the whole; there is not a flaw in the totality of the union between conception and execution." [2] Bouguereau does indeed present us with works of art that should be almost perfect, according to many an aesthetic theory. And yet, Canaday condemns these

1. Cf. *Trübners Deutsches Wörterbuch*, ed. A. Götze (Berlin, 1943), IV, 152–53, entry on "Kitsch."
2. *Mainstreams of Modern Art* (New York, 1959), p. 154.

paintings as Kitsch, though he does not use the word. "The trouble with Bouguereau's perfection is that the conception and the execution are perfectly false. Yet this is perfection of a kind, even if it is a perverse kind." [3] Most of us would agree with this judgment. I know of no one today who would argue that Bouguereau's *Youth and Cupid* is a masterpiece, or even good. And yet, why do we reject this painting as bad *art*?

Canaday's reaction to Bouguereau has a strong parallel in Kerman's evaluation of *Salome*.

> Consistency, power, unity, ingenuity, yes . . . the whole is bound together with the greatest skill. . . . The musical progress comes to its triumphant conclusion on the very last page, in a very famous, very loud passage which carries harmonic audacity farther than ever before. In musical technique, masterly; in sentiment, the most banal sound in the whole opera. John the Baptist's severed head might as well be made of marzipan. And it is for this sugary orgasm that all the fantastically involved aphrodisiac machinery has been required. . . . *Salome* and *Der Rosenkavalier* are false works in which everything goes depressingly right. [4]

The passages from Kerman and Canaday give us some clues as to the nature of Kitsch. Kitsch has nothing to do with inadequate technique. Frequently we find Kitsch which is technically excellent. There is, of course, a great deal of Kitsch which is inferior in this respect, too, but there are works which can be condemned only because they are recognized as Kitsch. If we refuse to accept this—because the work in question does not strike us that way or because we consider Kitsch to be a term which has no place in the evaluation of works of art—we will acclaim such works as masterpieces. Great art and great Kitsch are often very close, so close that it is difficult to draw a sharp line between them.

[2]

KITSCH, it has been argued, differs from art in its cloying sweetness. The sugary stickiness of Kitsch is opposed to the sense of distance which is said to be characteristic of art. [5] Good art, as Edward Bullough, for instance, suggests, involves a

3. *Ibid.*
4. *Opera as Drama* (New York, 1959), pp. 259–63.
5. Ludwig Giesz, *Phenomenologie des Kitsches* (Heidelberg, 1960), p. 50.

kind of bracketing. "It has a *negative,* inhibitory aspect—the cutting-out of the practical sides of things and of our practical attitude to them—and a *positive* side—the elaboration of the experience on the new basis created by the inhibitory action of Distance." [6] I disengage myself from the world; I put the world in a frame. It becomes unreal, fictitious, no longer something in which I am involved and which I manipulate. The concept of psychical distance enables us to understand the lack of agreement in aesthetic judgments. As Bullough points out, "Distance may be said to be *variable both according to the distancing-power of the individual, and according to the character of the object.*" [7] A hungry man may be unable to appreciate the beauties of a still life dominated by a Westphalian ham and a bowl of fruit. The food stimulates his appetite, and it is just the presence of this desire for food which makes it impossible for him to approach the painting aesthetically. Similarly, if a work of art arouses sexual desire, it fails as a work of art. Yet the fault need not be that of the artist. The "difference in the Distance-limit between artists and the public has been the source of much misunderstanding and injustice. Many an artist has seen his work condemned, and himself ostracized for the sake of so-called 'immoralities' which to him were *bona fide* esthetic objects." [8] The artist was misunderstood because his power of distancing exceeded that of the public.

Kitsch has always been considered immoral. Should we then simply say that Kitsch is under-distanced art, remembering that distance depends as much on the individual as on the work of art? Thus when Kerman condemns *Salome* as Kitsch, a defender of the opera might accuse him of an inability to assume the proper aesthetic attitude. Kerman, he might say, is so involved with certain irrelevant moral issues that he cannot rise sufficiently above the opera to appreciate it as art. From this "aesthetic" point of view, those who admire a work of art because of its erotic appeal and those who reject it for the same reason are on the same level.

Unfortunately the matter is not quite that simple. The concept of psychical distance, as Bullough developed it, lacks the

6. Edward Bullough, "Psychical Distance as a Factor in Art and an Esthetic Principle," in *A Modern Book of Aesthetics: An Anthology,* ed. Melvin Rader (New York, 1952), p. 404.
7. *Ibid.,* p. 410.
8. *Ibid.,* p. 411.

precision necessary to enable us to understand the nature of Kitsch. Two examples will clarify this. Bullough points out that much ecclesiastic art was originally not enjoyed as art at all. Instead it made a more immediate appeal. The same altar piece may evoke a spectrum of responses ranging from the most immediate devotion to the most refined, most distanced aesthetic appreciation. One person may appreciate the picture as "art," another may be touched more immediately, perhaps more properly, a third may hover between these two positions—yet at no level would it be appropriate to speak of the painting as Kitsch. Or we can imagine a hot summer day. An artist might respond to the colors and textures of such a day aesthetically; someone else may simply enjoy the smells, the warm air, the noises which are peculiar to such a day. Again we could not speak of Kitsch. Distance understood in Bullough's sense enables us perhaps to understand the difference between simple and aesthetic enjoyment; it does not enable us to understand what is characteristic of Kitsch.

Bullough's claim that those works of art which lack distance are most likely to be thought of as vulgar is subject to qualification. Often it is the work which has greater distance which is called indecent, while a less distanced work, exhibiting a similar theme, is accepted without much ado. A case in point is given by Canaday. Discussing the scandal caused by Manet's *Olympia,* he calls attention to the *Birth of Venus* by Cabanel, "as audaciously erotic a nude as has ever been put on public exhibition. The critics admitted that this studio Venus was 'wanton' but were able to discover refinements in Cabanel's painting to counteract its lasciviousness. These were the same critics who called *Olympia* a dirty picture." [9] We might want to think of these refinements as devices to increase distance, but a glance at the two pictures shows this to be an impossible gambit. Manet's art is clearly the more distanced one. The tools which Manet uses to achieve this distance are not important here—in part they are certainly due to his formal mastery. But this distance does not make it irrelevant that this is a picture of a nude. On the contrary, distance reveals the portrayed subject. Canaday points this out:

> Yet, at the risk of confusing the point and at the same time committing a heresy, we must admit that *Olympia* as a subject has

9. Canaday, *Mainstreams of Modern Art,* p. 170.

an interest aside from the major one of art for art's sake. Granted that Manet does not interpret or moralize or tell a story or make a comment of any kind; granted that his own interest in the subject was incidental to his interest in painting it a certain way; granted that the fascination of this way is in itself enough to hold one in front of the picture—granted all this, it is still true that *Olympia* is not only a representation of reality but a revelation of it.[10]

What does revelation mean here? Something is revealed to us when we recognize it as just what it is and as nothing else. *Olympia* is a nude; she lies revealed in her nakedness. It is this that must have shocked the critics who condemned *Olympia*. If we compare *Olympia* with Cabanel's *Birth of Venus*, we can understand the critics who found this Venus wanton but discovered certain refinements to compensate for this. The studio waves, the putti, and even the wanton pose itself disguise the nudity. They are clichés, and like all clichés they strike us as familiar. Such clichés effectively prevent a true encounter by decreasing distance. When we look at such a painting we don't really confront anything. In the end all that remains is an atmosphere, and it is precisely this atmosphere which Kitsch seeks to elicit. The picture itself becomes unimportant; it is merely a stimulus to evoke a mood. No longer does the spectator confront an object which stands unveiled before him.

The Kitsch experience lacks the distance separating subject and object which alone makes a genuine encounter possible. In this respect it is like simple enjoyment. The difference between Kitsch and simple enjoyment becomes clearer when we ask what gives Kitsch its appeal. What made a painting like Cabanel's *Venus* a popular success? It is not that Kitsch creates desire for an object. Obscene art is often understood in this way; but in this sense Kitsch is not obscene. The interest has shifted from the object of desire to the desire itself. What was originally an object of desire is transformed by Kitsch to what, with Kierkegaard, we may call a mere occasion which is used to stimulate desire. The consciousness of the object is peripheral. Kerman points to this characteristic of Kitsch when he calls *Salome* an aphrodisiac. An aphrodisiac is something which stimulates desire but not by presenting desire with an object which it can desire.

The need for Kitsch arises when genuine emotion has become rare, when desire lies dormant and needs artificial stimula-

10. *Ibid.*, p. 167.

tion. Kitsch is an answer to boredom. When objects cannot elicit desire, man desires desire. More precisely, what is enjoyed or sought is not a certain object, but an emotion, a mood, even, or rather especially, if there is no encounter with an object which would warrant that emotion. Thus religious Kitsch seeks to elicit religious emotion without an encounter with God, and erotic Kitsch seeks to give the sensations of love without the presence of someone with whom one is in love. But even where such a person is present, love can itself be said to be Kitsch if that person is used only to stimulate a feeling of love, if love has its center not in the beloved but within itself. Kitsch creates illusion for the sake of self-enjoyment. It is more reflective than simple enjoyment in that it detaches itself from the original emotion in order to enjoy it. On the other hand, this reflective distance may not become so great as to force man to see his emotion for what it really is—self-deception.

Distance is used here in a sense which differs from what we took it to mean when we talked about it in relation to art and enjoyment. Bullough saw the possibility of drawing a distinction between the two senses of distance but considered it unimportant. Psychical distance, he points out, "appears to lie between our own self and its affections. . . . Usually, though not always, it amounts to the same thing to say that the Distance lies between our own self and such objects as are the sources or vehicles of such affections." [11] If we are to understand the peculiar nature of Kitsch, this distinction is all-important. The distance which applies primarily to a discussion of Kitsch is distance within a subject. Kitsch is essentially monological; it is self-enjoyment. Any theory which reduces art to mere self-enjoyment reduces art to Kitsch.

By an increase in reflective distance, the illusion which Kitsch requires can be destroyed. Kierkegaard analyzes the categories which describe this higher state in the first volume of *Either/Or*. In his discussion of Scribe's *First Love*, he sketches a life devoted to Kitsch: Emmeline is caught in a net of illusions; she lacks the distance necessary to see these illusions as illusions; indeed, she has to run away from this recognition, as it would force her to face the humdrum of the everyday. The truly aesthetic individual has made this further movement. It is this which enables him to play with illusion, knowing that it is only

11. Bullough, "Psychical Distance," p. 403.

illusion. His life, his emotions, are still based on illusion, but an illusion over which he retains control, which he manipulates. In respect to his illusions he is free; his freedom finds expression in play. Kitsch becomes play with an increase of reflective distance. Sentimentality becomes funny. Thus I think that Arnold Böcklin, perhaps the first important painter to whom the term Kitsch was applied, has created some of the funniest paintings in the history of art, paintings which were first admired as masterpieces, which were then rejected as degenerate products of nineteenth-century academicism, and which only now begin to be admired once more—not for their grandeur but for their naïve, almost sublime pretense. Only today have we acquired enough distance from his art to enjoy it once more, although not in the way in which it was meant to be enjoyed.

Hermann Broch, in his discussion of Kitsch, emphasized its monological character, while failing to do justice to its comparative lack of distance.[12] This led him to confuse Kitsch with art for art's sake. Much modern art is indeed related to Kitsch. It is Kitsch with an increase of distance. This added distance gives it a freedom, a lightness, which Kitsch lacks. Such art shares with Kitsch its monological character. For it, as for Kitsch, objects are mere occasions. But they are no longer occasions for self-enjoyment; they are occasions for play. The development of Klee, Kandinsky, or Schoenberg illustrates this escape from late romantic Kitsch. This, however, should not lead us to argue that all modern art has passed beyond Kitsch. On the contrary, Kitsch remains the great temptation of the modern artist as it was the great temptation of the romantics. Wherever we find boredom, an inability to discover enjoyment in the world, we can expect a movement away from the world to the pleasures of self-enjoyment. We can escape from the danger of Kitsch only by escaping from this sense of emptiness which Kierkegaard takes to be characteristic of the situation of modern man. The modern artist or art lover who prides himself in having unmasked the Kitsch of preceding generations is likely to worship it in a new metamorphosis. We may oppose our own good taste to that of our benighted grandparents who were titillated by the erotic Kitsch of a Bouguereau or the mythological grandiloquence of a Böcklin, but let us not forget that modern art has produced its own clichés and its own brand of Kitsch. As Broch has suggested, there is

12. *Dichten und Erkennen: Essays* (Zurich, 1955), I, 43 ff., 295–350.

sweet Kitsch and there is sour Kitsch. The nineteenth century preferred the sweet, the twentieth prefers the sour. If we think that in changing sweet into sour we have escaped from Kitsch, we are ourselves victims of an illusion. Thus George Grosz comes perilously close to Kitsch, while Dali embraces it wholeheartedly. Nor should we confine Kitsch to representational art; there is much abstract Kitsch. Abstraction has developed its own clichés. The connoisseur of Kitsch will find a visit to a contemporary art school hardly less rewarding than a visit to a nineteenth-century academy would have been. How many abstract paintings decorate homes and offices to lend them an air of culture, a certain dignity, which creates a proper environment for someone who wants to escape from his own hollowness into a civilized environment prepared for him by his interior decorator?

If modern art is to avoid the pitfalls of Kitsch it must practice the art of self-irony. The modern artist who has read Nietzsche and finds it impossible to believe that God created man in his own image must not take himself too seriously. Man cannot be his own foundation; he cannot escape from the nothingness pervading everything. But this nothingness brings him a gift which the artists of other ages did not possess: his is a lightness, a flexibility, a freedom which is impossible as long as man sees himself occupying a place in a meaningful order. Play against the background of despair—what honest alternative is there in an absurd world?

Yet a warning is in order: how easy it is to wax lyrical over despair, to wallow in it, to enjoy it. What, as Kierkegaard points out, is more enjoyable than despair? The popularity of decline, anguish, nothingness, absurdity, and death illustrates this. This, too, is Kitsch, sour Kitsch.

But why condemn Kitsch, why not extol it as the savior of modern man? For if the world is indeed a meaningless conglomeration of facts, does not Kitsch offer us the only escape from the absurdity of life? If the world does not satisfy our demands, what remains except to enjoy ourselves? In Kitsch man strives for an immediate relationship to himself which offers an escape. Man strives to regain paradise, not by returning to what has been lost, but by building a substitute and by forgetting that it is his own invention. Man enjoys himself, his illusions, and even his anxieties and thus escapes from the problems posed by his being cast into a world which ultimately seems to make no sense. That this project is built on illusion does not matter; that Kitsch is a

structure without a foundation is unimportant. Why be honest? Kitsch is successful precisely because it lets man forget his self-deceit. Has not despair been silenced?

Was this Nietzsche's meaning when he said that man had been given art so that he should not perish over the truth?

8 / The Demonization of Sensuousness

IN HIS STUDY of the nude, Kenneth Clark calls attention to the distinction between "naked" and "nude": "To be naked is to be deprived of our clothes, and the word implies some of the embarrassment most of us feel in that condition. The word 'nude,' on the other hand, carries, in educated usage, no uncomfortable overtone." [1] Accepting this distinction we should expect Christian art to be suspicious of the nude, for to present man as nude is to present him as at ease with himself; but, as Augustine insists, this comfort is denied to fallen man. "By the just retribution of the sovereign God whom we refused to be subject to and serve, our flesh, which was subjected to us, now torments us by insubordination." Given a view which takes man to be essentially spirit, the demands made on him by his body must be found degrading. They become a source of shame.

> Justly is shame very specially connected with this lust; justly, too, these members themselves, being moved and restrained not at our will, but by a certain independent autocracy, so to speak, are called "shameful." Their condition was different before sin. For as it is written, "They were naked and were not ashamed"—not that their nakedness was unknown to them, but because nakedness was not yet shameful because not yet did lust move those members without the will's consent; not yet did the flesh by its disobedience testify against the disobedience of man. . . . But when they were stripped

1. *The Nude: A Study in Ideal Form* (Garden City, 1959), pp. 23, 400–46.

of this grace, that their disobedience might be punished by fit retribution, there began in the movement of their bodily members a shameless novelty which made nakedness indecent: it at once made them observant and made them ashamed. And therefore, after they violated God's command by open transgression, it is written: "And the eyes of them both were opened, and they knew that they were naked." [2]

According to Augustine, man discovers his body to be shameful when he recognizes that it shatters his dream of freedom. Subject to sexual desire, man becomes aware of his distance from God and His autonomy. In his shame man tastes the failure of his project of pride. By positing the autonomy of the free spirit as the highest value, pride posits the body and its claims as something to be suppressed; it permits only the instrumental use of the body. Just because of this Augustine sees in the flesh's independence of the will the just punishment of pride. Pride leads the flesh to assert itself as an independent, demonic force.

How difficult it is even for modern man to free himself from this uneasiness with the body is shown by Sartre. For Sartre, too, the body is something to be ashamed of:

Shame is the feeling of an *original fall,* not because of the fact that I may have committed this or that particular fault but simply that I have "fallen" into the world in the midst of things and that I need the mediation of the Other in order to be what I am.

Modesty and in particular the fear of being surprised in a state of nakedness are only a symbolic specification of original shame; the body symbolizes here our defenseless state as objects. To put on clothes is to hide one's object-state; it is to claim the right of seeing without being seen; that is, to be pure subject. This is why the Biblical symbol of the fall after the original sin is the fact that Adam and Eve "know that they are naked." [3]

As Sartre no longer believes in God, he cannot interpret shame as a punishment for man's disobedience. Yet Sartre agrees with Augustine in making pride the foundation of shame. Pride is given an even greater importance by being made constitutive of man. Behind all man's strivings, Sartre argues, lies the desire to be like God. Pride is man's most fundamental project. This rules out any possibility of a reconciliation of the spirit and

2. *The City of God,* XIV. 15, 17, trans. M. Dods (New York, 1950), pp. 463, 465.
3. *Being and Nothingness,* trans. Hazel E. Barnes (New York, 1956), pp. 288–89.

the flesh. Sartre cannot hope for redemption; there is no escape from shame. His extreme view of freedom retains and exaggerates the traditional emphasis on the spirit. This forces him to come to an even more negative assessment of the body.

We may wish to disagree with Augustine, Sartre, or both, on the importance of pride; yet we have to grant them that as long as man remains subject to pride, the ideal which he has adopted prevents him from giving sensuousness its due. Pride must lead to a disturbed, ambivalent relationship to all that threatens man's autonomy: to nature, to the body, and especially to the other sex. For, as the object of his desire, woman leads man to identify himself with his flesh. Anyone who considers such identification as a denial of what man should be must resent his own weakness and woman's power to seduce man into a betrayal of himself. By accepting his desire, man chooses to be submerged in the flesh; yet this choice is incompatible with the project of pride. Given that project it must fill him with a sense of inadequacy and shame.

[2]

I don't know, now, when I first looked at Hella and found her stale, found her body uninteresting, her presence grating. It seemed to happen all at once—I suppose that only means that it had been happening for a long time. I trace it to something as fleeting as the tip of her breast lightly touching my forearm as she leaned over me to serve my supper. I felt my flesh recoil. . . . I sometimes watched her naked body move and wished that it were harder and firmer, I was fantastically intimidated by her breasts, and when I entered her I began to feel that I would never get out alive.[4]

If Sartre's view of man is correct, this fear of the aggressive softness of the feminine body, expressed here by one of James Baldwin's heroes, is not perverse, but normal. The fault is not with him. Woman *is* intimidating and obscene. "The obscenity of the feminine sex is that of everything which 'gapes open.' . . . Beyond any doubt her sex is a mouth and a voracious mouth which devours the penis—a fact which can easily lead to the idea of castration. The amorous act is the castration of the

4. James Baldwin, *Giovanni's Room* (New York, 1964), p. 209.

man." [5] "Beyond any doubt . . ." Sartre writes; yet he especially should have suspected that this supposed description of the act of love has its foundation in a particular project which can and should be challenged. Only if we were to grant Sartre that the desire to be pure subject is as important as he takes it to be, would we have to admit that man cannot but be ashamed of his body and intimidated by the body of woman which makes him aware of his own. Yet although we can question whether Sartre is describing the situation of man, chapters five and six of this study have shown that he is at least describing a project which underlies much modern art. Even if Sartre provides a one-sided interpretation of the human situation, this interpretation has its foundation in the way in which modern man understands himself. What Sartre takes to be the fundamental project of man is a possible and widely adopted response to the dread which is made manifest by the death of God. This enables us to use his analysis to interpret the meaning of certain tendencies in modern art. Thus it lets us understand why the idealization of the spirit should have its counterpart in a demonization of the feminine.

The tendency to see woman as a witch is most readily apparent in the popularity of themes giving the artist a chance to show her destructive power over man. She is painted as a vampire, sphinx, Medusa, Salambo, Salome. Toward the turn of the century Salome becomes

> the archetypal image of the "femme fatale," which is also embodied in the figures of Messalina, Judith, or Cleopatra, and others; or simply in the many strangely disturbing portraits of young girls with desirous eyes, half-open lips, and flowing hair, which appeared around the turn of the century. Behind these representations appears in the end the frightening image of the female vampire, who—like the sphinx half animal, half human—seizes man in order to suck his blood. [6]

Gustave Moreau painted such a Salome—her veils have fallen to the ground; a large jewel glistens between her breasts; crystalline and starlike rubies, emeralds, diamonds, and garnets glitter on her flesh, which bears, yet rejects them, more naked, more nakedly alive in this rejection. At times Moreau's interest in these ornaments and in the shimmering walls of his Byzan-

5. Sartre, *Being and Nothingness*, pp. 613–14.
6. Hans H. Hofstätter, *Symbolismus und die Kunst der Jahrhundert-wende* (Cologne, 1965), p. 194.

tine or Arab interiors seems to become an end in itself, as if the artist's fascination with ornamental detail had led him to forget the painting in its entirety. Moreau's versions of *The Dance of Salome* are thus less homogeneous than, for example, paintings by Renoir. Renoir's nudes are of a substance with their environment. They belong to the world and are at ease in it. Renoir paints nudes rather than the naked flesh. Moreau, on the other hand, does not let us forget that man has fallen; his Salome is decadent, unchaste, as is the Salome of Huysmans and of Oscar Wilde, which it inspired. This decadence finds expressions in the contrast of the living flesh and the alien, inorganic, almost abstract ornamentation covering and surrounding it. Such contrasts were to become characteristic of *art nouveau*. No painter exploited them more than Gustav Klimt. Extremely realistic portrayals of the human body, often bordering on pornography, contrast with two-dimensional, abstract, ornamental areas. Often Klimt's decorative patterns are geometric; we see colored rectangles, circles, triangles, and spirals. Set into these carpet-like surfaces are faces, hands, and bodies, modeled with great care, alive and beckoning, yet intimidating and threatening, like Moreau's Salome, the sphinxes of Félicien Rops and Franz von Stuck, or the vampire of Edvard Munch.[7]

Such presentations betray an awareness, coupled with a resentment, that woman has a claim on man which he cannot escape. Sexual desire is interpreted as a form of bondage, an interpretation which presupposes that man demands of himself a freedom which rules out such dependence. This demand leads to attempts to defeat the power of the other sex. A sadistic streak runs through nineteenth- and twentieth-century art. The artist violates just what attracts him to free himself from the claim it has on him. Man's shame before his own flesh turns into hatred against woman, who lets him be this flesh. "Sadism is a refusal to be incarnated and a flight from all facticity and at the same time an effort to get hold of the Other's facticity."[8] The sadist refuses to be incarnated because such incarnation negates his freedom. Yet he cannot escape the power of woman, any more than he can rid himself of his own body. Woman, especially when she is beautiful, is seen as a witch, and witches should be persecuted. Doré and Masereel thus show witches being

7. Cf. *ibid.*, pp. 187–203; also Hans H. Hofstätter, *Jugendstilmalerei* (Cologne, 1965), pp. 219–23.
8. Sartre, *Being and Nothingness*, p. 399.

tortured.[9] There is a fascination with slaughter and rape in many of Goya's works which cannot be reduced to a humanistic indictment of the inhumanity of his contemporaries. When Goya paints savages decapitating naked women he is not engaging in social criticism. These visions of man's brutality are disgusting, but they also tempt and excite. The hell which Goya portrays not only surrounds him but also lives within him—and us—as a temptation. And yet it is a hell man creates himself as he attempts to make the spirit the sole foundation of his projects. The life of the spirit is an inhuman life; it cannot be lived by man. There will always be moments when reason sleeps, and—as Goya calls one of his etchings—*The Sleep of Reason Produces Monsters*.[10]

Sadism in art need not show itself in so obvious a way. Instead of representing sadistic behavior, as Goya, Masereel, and Doré do, the creation of the work of art can itself be such behavior. Thus sadism is part of the very conception of a "dictatorial fantasy" which uses the world, in particular the human body, as a mere occasion for formal composition. By making the world serve art instead of having art serve the world, the artist asserts his mastery over it. Abstraction becomes a tool of violence. Thus de Kooning's or Picasso's abstract portrayals of women cannot be adequately understood as mere formal arrangements. As Picasso himself insists, he always begins with something taken from the world, and, regardless of how it is transformed in the work of art, it leaves indelible signs. This gives a tension to Picasso's work which a purely abstract work of art cannot possess. Picasso presents us with the transformed image of reality. This presupposes that in the work of art what has been transformed is present. Especially in his Cubist works Picasso shows himself to be a violent artist, and this violence is confirmed rather than denied when it is pointed out that what is represented in these pictures matters little. It has provided merely the occasion which the artist successfully has incorporated into his composition; it should not be looked upon as a likeness. But this is just to say that the work of art reveals how complete the victory of the artist has been. Picasso's portraits of women are the result of a struggle with the portrayed which aims at subjection. And yet, that he engages in this struggle, that he keeps returning to the task of

9. Cf. Hofstätter, *Symbolismus*, p. 75.

10. Cf. René Huyghe, *Ideas and Images in World Art* (New York, 1959), pp. 316–19.

painting woman and finds it more fascinating than painting tomatoes or fish or flower pots or even man, is witness to her power.

[3]

THAT WHICH MOVES US to shame we call obscene. The obscene cannot be reconciled with the ideal which has been adopted. It moves us as we should not be moved. Thus it makes us aware of what is base in us. Recognizing our distance from the ideal we are ashamed.

If the ideal is, as Sartre suggests, godlike autonomy, and the fundamental project of man is a project of appropriation and subjection directed against the world which threatens that autonomy, man cannot but find obscene whatever denies this dream of being pure subject.

To be pure subject is to be the foundation of the world; to become this foundation man must appropriate and transform the world into something which can be possessed. But man can possess only what endures. The more ephemeral an object the more it eludes our grasp. Clouds, flowers, soap bubbles; a smile, the motion of a hand pouring red wine, an embrace; music—all that becomes, grows, and decays resists our attempts at appropriation. To wish to be pure subject is to wish for an adamantine, inorganic world: for stars, gems, metal, stone; for indestructible atoms; for a view of the world *sub specie aeterni*. Man can be autonomous only if he succeeds in escaping from the rule of time. Subject to time, man cannot be his own foundation. Time is the ultimate source of what Heidegger calls man's guilt.[11] As is the case with Sartre's understanding of shame, guilt may not be understood here as the consequence of some action. Man is called guilty because he is unable to be his own foundation as he desires. He is subject to time, vulnerable, and mortal. Guilt has its foundation in pride. It is pride come to grief. Yet pride itself may lead man to deny that pride must come to grief. Such a denial must take the form of an attempt to escape from time. Given that project, all that emphasizes the rule of time becomes a symbolic representation of what is incompatible with the adopted ideal. Thus the organic is associated with the counter-

11. *Sein und Zeit* (Tübingen, 1953), pp. 280–97.

ideal. From this perspective, cubism, constructivism, and suprematism can be said to provide man with a purer, more ideal environment. Compared with these artificial worlds, nature is obscene, chaotic, slimy. The slimy represents here, as Sartre argues, an "antivalue."

> Throw a slimy substance; it draws itself out, it displays itself, it flattens itself out, it is *soft;* touch the slimy; it does not flee, it yields. . . . The slimy is compressible. It gives us at first the impression that it is a being which can be *possessed.* . . . Only at the very moment when I believe that I possess it, behold by a curious reversal, *it* possesses me. Here appears its essential character: its softness is leechlike. . . . I open my hands, I want to let go of the slimy and it sticks to me, it draws me, it sucks at me. . . . It is a soft, yielding action, a moist and feminine sucking, it lives obscurely under my fingers, and I sense it like a dizziness; it draws me to it as the bottom of a precipice might draw me. There is something like a tactile fascination in the slimy . . .[12]

Why this fascination? If man knew only the desire to possess, there would only be disgust. The fascination of the slimy presupposes a desire to be possessed, to grow and melt rather than to act. Thus it reveals that the chosen project of pride fails to do justice to what man is. Slime possesses the ambivalence of the obscene. It compromises man and makes him ashamed.

> At this instant I suddenly understand the snare of the slimy: it is a fluidity which holds me and which compromises me; I can not *slide* on this slime, all its suction cups hold me back; it can not slide over me, it clings to me like a leech. The sliding however is not simply denied as in the case of the solid; it is *degraded.* The slimy seems to lend itself to me, it invites me; for a body of slime at rest is not noticeably distinct from a body of very dense liquid. But it is a trap. The sliding is *sucked* in by the sliding substance and it leaves its traces upon me. The slime is like a liquid seen in a nightmare, where all its properties are animated by a sort of life and turn back against me. Slime is the revenge of the In-itself. A sickly-sweet, feminine revenge which will be symbolized on another level by the quality "sugary." [13]

Why does Sartre speak of revenge? Revenge is for some action. By calling slime "the revenge of the In-itself" Sartre suggests that the In-itself has not been given its due. Its revenge

12. Sartre, *Being and Nothingness*, pp. 608–9.
13. *Ibid.*, p. 609.

has its roots in prior neglect. Sartre's idealization of freedom does violence to what man is. Man cannot be his own foundation. To demand this is to make a demand which is at variance with man's nature. Its one-sidedness invites the revenge of the slimy. It not only posits it as nauseating but gives it its tactile, demonic fascination.

> To touch the slimy is to risk being dissolved in sliminess. Now this dissolution by itself is frightening enough, because it is the absorption of the For-itself by the In-itself as ink is absorbed by a blotter. But it is still more frightening in that the metamorphosis is not just into a thing (bad as that would be) but into slime. . . .
> The horror of the slimy is the horrible fear that time might become slimy, that facticity might progress continually and insensibly and absorb the For-itself which *exists it*. It is the fear not of death, not of the pure In-itself, not of nothingness, but of a particular type of being, which does not actually exist any more than the In-itself-For-itself and which is only *represented* by the slimy. It is an ideal which I reject with all my strength and which haunts me as *value* haunts my being, an ideal being in which the foundationless In-itself has priority over the For-itself. We shall call it an *Antivalue*.[14]

Every man, according to Sartre, seeks to lose himself as man in order to become God. To be God is to have overcome guilt and to be one's own foundation. What man is no longer limits freedom; rather freedom determines what man is. Given that ideal, the counter-ideal must invite man to give up his dream of autonomy, of establishing a foundation on which to stand and act. It, too, beckons man to lose himself as man, not in order to become God, but in order to return to the chaotic life from which he emerged.

[4]

JUST AS MEDIEVAL ART opposed to the province of heaven that of hell, modern art has not only given us visions of a purer, inorganic, crystalline world but has also created nightmares of a world turning into slime, without stable forms, a moist, humid, swampy world, embryonic or decaying, chaos before or after creation. Tchelitchew's *Hide and Seek* gives us thus

14. *Ibid.*, pp. 610–11.

a counter-image to the glassy cityscapes of Feininger. "In a wondrous tangle of membranes, blood vessels, plant forms, bodies, and suggestions of internal organs, we are led in and out of recognizability as one image merges with or is transformed into another." [15] Every form in Tchelitchew's painting is organic; yet these forms do not define organisms; we are given only hints, fragments, ambiguities. Tchelitchew paints a slimy, embryonic world awaiting the act of creation which will give individuality, structure, and definite color to what is incomplete and opalescent. Opalescence is a pictorial representation of the slimy. Like the slimy it cannot be grasped. It does not permit us to come to rest but "lives obscurely" under our glance.

While Tchelitchew shows us a world which has not yet emerged from slime, other surrealists paint a world turning into slime. In Valentine Hugo's *Constellation* we see a lip, the lip of René Crevel, become liquescent; the flesh forms a drop and falls. Similarly Dali paints a disintegrating, melting world. Arms, feet, heads, and breasts become independent of the bodies to which they once belonged. Bones become soft and malleable; hard, metallic ojects such as watches turn limp. Dali's slick technique underscores the slimy character of his art.

In the organism the organic assumes definite form. Just this prevents it from being slime. An organism can be covered with slime, like the Tritons, Nereids, mermaids, and sirens of Böcklin, but this slime does not penetrate and dissolve the body. It looks as if it could be washed off and titillates more than it disturbs. The essence of slime is incompatible with definite, enduring structure. Attempts to reveal it lead therefore easily towards abstraction, not to the geometric abstractions of Malevich but to the organic abstractions of Wols. Many of Wols's early works suggest the demons created by Bosch or Grünewald. The organisms found in the world are dismembered; out of these fragments new fantastic creatures are formed. Parts which do not belong together are joined. Thus we see faces with one eye and an upper lip, heads with two faces, bodies with limbs where the head should be or with sexual organs where the face should be. Wols's works become more abstract as his line becomes more independent of its representational function. Like a cancerous growth his line covers, attacks, and dissolves faces and bodies.

15. John Canaday, *Mainstreams of Modern Art* (New York, 1959), p. 542.

Finally only such growths remain. In *Phallicités* or *Sorcières en marche*, Wols constructs an organic world in which there are no individuals; there is only an obscene, demonic life, too diffuse to permit the emergence of organisms. Wols once suggested that one could represent God by means of a circle or a straight line, never by means of a person.[16] Similarly he portrays the demonic not by painting demons or witches but by inventing a line which is demonic. Regularity is carefully avoided. In Wols's water colors and drawings there are no straight lines, no circles or squares which would allow the spectator to comprehend the drawing. Wols's line eludes us; it lives, moves, and changes as we try to read it. In it we lose ourselves as in the tangled masses of hair which *art nouveau* had used to suggest the power of woman or in the cascading trees and rocks of Altdorfer's drawings. It is suggestive without making a definite statement. We think of lichen or moss, microscopic detail, intestines, sexual organs, festering wounds. Wols's art is disgusting; it is also disquieting and exciting. We may long for a less stifling climate; for rectangles, squares, and circles; for pure unbroken colors; for Malevich or Mondrian. Yet even if disgusted, we are moved by Wols's creations as the bloodless world of Malevich or Mondrian cannot move us.

16. Ewald Rathke, "Zur Kunst von Wols," in *Wols: Gemälde, Aquarelle, Zeichnungen, Fotos* (Catalogue of the exhibition of the *Frankfurter Kunstverein*, November 20, 1965–January 2, 1966), p. 7.

9 / The Search for Immediacy

WHENEVER THE ACCEPTED ideal image of man is too one-sided to do justice to what man is and desires, it casts a shadow. A counter-ideal is posited in which what has been suppressed finds expression. It accompanies the ideal, challenging its demands with demands of its own. These may become so powerful as to cause it to displace the ideal. Today there are signs of such a displacement. This is not to deny that the traditional emphasis on the spirit still governs our common sense. But another image of man has emerged to contest its claims. One only has to think of Darwin or Freud—both, though often misunderstood, have done their share to shake our belief in the importance of the spirit, one by suggesting that man is created in the image of the monkey rather than in that of God, the other by stressing the importance of the unconscious. Such concepts as spirit, reason, and intellect do not seem to exhaust the being of man; indeed, there is a suspicion that they do not even point out what is most essential. This has led to attempts to develop a new view of man which would bring out into the open what the tradition had left unsaid.

The foundation for such attempts was laid by Schopenhauer. Breaking with the traditional view, Schopenhauer denied that man is first of all a thinking being. Man is not a disembodied soul which happens to find itself in a body; he is desire and discovers himself to be such by discovering himself to be body. This entails a rejection of the Platonic-Christian conception of man. For Schopenhauer the body is no longer something which

we possess accidentally, as Plato would have us believe. Man does not *have* a body, he *is* his body; he does not have a sex (as if his sex were something external to him), he is essentially sexual. Nothing could be more misleading than Plato's metaphor of the coat for the body. Man cannot cast off his body as he takes off a coat. Take away the body and nothing remains. Similarly, Schopenhauer refuses to follow the traditional tendency to see in detached "objective" understanding the paradigm of human activity. To do so is to overlook the fact that such thinking is a derivative and artificial mode of behavior, as artificial as the conception of man as spirit. Before man seeks detached contemplation he wants to live, eat, and procreate. Thinking is only one way in which the individual attempts to assert his dominion over the situation into which he has been cast; disengaged "objective" thought presupposes other, more engaged modes of encounter. We can liken man to an iceberg: the largest part of his nature is concealed in half- and sub-conscious regions, which are nonetheless very real; and when a too one-sided emphasis on the spirit fails to give this part of man's being its due, it will reassert itself in spite of all attempts to keep this region covered.

In one important respect Schopenhauer's conception of man agrees with the tradition. Schopenhauer, too, sees man as dissatisfied: dissatisfaction is implicit in the nature of desire. Like consciousness, desire is polar; it presupposes a gap between itself and the desired. Desiring, man lacks the desired. To make desire constitutive of man is to say that man is by his very nature a being in need.

As was pointed out in the first chapter, this recognition is at the very heart of the Platonic conception of man. But Plato could interpret this need or lack in terms of the tension between the truly real and the temporal: due to his fall from being into time man has become alienated from his true being. His search for satisfaction is a search for his true self. Schopenhauer's interpretation of this need is very different. He no longer believes in the Platonic ideal; according to him there is no transcendent essence of man. Consequently it is impossible to view human actions as being for the sake of such an ideal. This makes life just a sequence without rhyme or reason. Man's demands for final satisfaction can never be fulfilled; the ideal of satisfaction is incompatible with his essence.

Yet Schopenhauer does not give up this ideal. Recognizing its incompatibility with his description of man, he draws the conse-

quences: if his nature denies satisfaction to man, he must re-
nounce that nature. To escape from the suffering which is part
of conscious existence man must sacrifice himself.

This sacrifice can take many forms. Schopenhauer's philoso-
phy of renunciation points to just one, rather extreme, version
that because of its extremity proved difficult to follow. Reason
may a hundred times suggest that man's existence is a source of
suffering; yet this does not break life's hold on man. As Camus
points out: "In a man's attachment to life there is something
stronger than all the ills in the world. The body's judgment is as
good as the mind's, and the body shrinks from annihilation. We
get into the habit of living before acquiring the habit of
thinking." [1] In the face of the spirit's insistence that life is point-
less, life reasserts itself.

Schopenhauer had sought the source of human suffering in
desire, of which spirit is only the highest manifestation; but is it
not the latter which makes suffering overt and thus posits it?
When Schopenhauer's view of man is accepted, while at the
same time the source of suffering is sought not in desire as such
but in the spirit, a different program suggests itself: to negate
the spirit in order to affirm more fundamental dimensions of
man's being and to strip the world of that veneer with which the
spirit has endowed it. Life in its unending spontaneity is opposed
to the individuating spirit. The project of pride gives way to a
project to return to that paradise from which the questioning
spirit has expelled man.

The art to which we now turn is its witness.

[2]

IN ART the desire to return to the origin appears first
of all as a rejection of the world as we know it. In this such art is
like the subjective art which we have been discussing. Both have
their foundation in a dissatisfaction with the world to which our
daily cares and concerns bind us. But while the subjectivist seeks
a substitute reality in the constructions of the free spirit and
rejects everyday reality because it is not spiritual enough, we now
turn to an art which attempts to escape from the rule of the
spirit and rejects everyday reality because it is thought to be

1. *The Myth of Sisyphus,* trans. J. O'Brien (New York, 1955), p. 8.

contaminated by the understanding. Instead of retreating from phenomenal being, this art wants to penetrate its secret; it wants to seek out and reveal what Schopenhauer called the Idea, the essential reality behind particular appearances.

> When the clouds move, the figures which they form are not essential, but indifferent to them; but that as elastic vapor they are pressed together, drifted along, spread out, or torn asunder by the force of the wind: this is their nature, the essence of the forces which objectify themselves in them, the Idea; their actual forms are only for the individual observer. To the brook that flows over stones, the eddies, the waves, the foam flakes which it forms are indifferent and unessential; but that it follows the attraction of gravity, and behaves as inelastic, perfectly mobile, formless, transparent fluid: this is its nature; this, *if known through perception*, is its Idea; these accidental forms are only for us so long as we know as individuals. The ice on the window-pane forms itself into crystals according to the laws of crystallisation, which reveal the essence of the force of nature that appears here, exhibit the Idea; but the trees and flowers which it traces on the pane are unessential, and are only there for us. What appears in the clouds, the brook, and the crystal is the weakest echo of that will which appears more fully in the plant, more fully still in the beast, and most fully in man.[2]

In this passage we can still detect a trace of humanism which the anti-individualistic tenor of Schopenhauer's philosophy may not seem to warrant. Why does the will appear most fully in man? Has not man removed himself most from the immediacy of the will by becoming a self-conscious, self-seeking individual? If we want to escape from this egoism must we not descend on this ladder, down from man to animal, from animal to plant, from plants to those forces which have not yet assumed definite form? Why should we say that the will appears "most fully in man" and why take an art portraying the individual human being to be the highest? Franz Marc is more consistently anti-humanistic when he writes:

> Very early I had found man ugly: the animal seemed more beautiful, more pure. But in it, too, I discovered so much which disgusted me, so much ugliness, that instinctively, due to an inner

2. *The World as Will and Idea*, trans. R. E. Haldane and J. Kemp (Garden City, 1961), p. 195.

force, my representations became more schematic and abstract. With every passing year, trees, flowers, and earth showed me more ugly, disgusting aspects until suddenly I became fully conscious of the ugliness and impurity of nature. Perhaps our European eye has poisoned and disfigured the world.—My instinct led me away from the animal to the abstract, which excited me even more and in which the feeling of life speaks in its purity. . . . [Abstract art] is the attempt to let the world speak herself, instead of our own soul, excited by the images of the world.[3]

Marc does not want to subject nature; he wants her to speak, free from the distorting interpretations of the human understanding. To let her speak in the work of art, the painter must try to create as a part of nature. Like Marc, he must "sense in pantheistic empathy the trembling of the blood in nature, in trees, in animals, in the air." [4] Art, according to this view, presupposes that the artist is able to bridge the gulf which separates man from man, creature from creature. Schopenhauer had described the ethical man as one whose sympathy with others lets him make less distinction between himself and others than usual. Marc takes over this notion of sympathy and extends it to all beings. "When I now look at flowers and leaves some feeling of sympathy, of secret understanding, is always present, we look at each other without saying anything, only with a gesture: we understand each other: truth is in quite another place; we all come from it and will return to it." [5] With Marc sympathy becomes a magic key which enables the artist to enter the soul of other creatures, to paint them not as external objects, from without, but, sharing their being, from within.

I saw the picture that is reflected in the eyes of a moor hen when it dives: the thousand rings that enclose every small life, the blue of the whispering sky, absorbed by the lake, ecstatic reappearance in a different place—see, my friends, what pictures are: reappearance in a different place.[6]

Is there a greater mystery for the artist than the way in which nature mirrors herself in the eye of an animal? How unimaginative

3. Walter Hess, *Dokumente zum Verständnis der modernen Malerei* (Hamburg, 1956), p. 79.
4. *Ibid.*, p. 78.
5. *Ibid.*, pp. 78, 79.
6. In Hans Konrad Roethel, *Modern German Painting*, trans. D. and L. Clayton (New York, n.d.), p. 80.

and soulless is our convention to put the animal into a landscape which belongs to *our* eyes, instead of submerging ourselves in the soul of the animal, in order to guess the circle of its images. What does the animal have to do with what we see? [7]

Art is, or rather will be metaphysical: this has become a possibility only today. Art will liberate herself from the purposes and the will of man. We will no longer paint a grove or a horse as they please or appear to us, but as they are in themselves, how it feels to be grove or horse, their absolute essence which dwells behind the illusion which we see (p. 79).

The longing for indivisible being, for freedom from the deception of our ephemeral life is the basic mood of all art. To show an unearthly being which dwells behind everything, to break the mirror of life, so that we may look into being. . . . Appearance is the eternally shallow, but draw it away, entirely away, entirely out of your mind, think yourself and the image of the world which you have away, the world remains in its true form, and we artists see this form. A demon allows us to see in between the fissures of the world and in dreams leads us behind its colored stage (p. 79).

We only have to recall Braque's belief that there are no things-in-themselves to see how different, at least in its aims, this art is. Both Marc and Braque presuppose a dissatisfaction with the everyday world, with man who dwells in this world, and with all art that takes this world for granted, be it nineteenth-century realism, academicism, or impressionism. But they move away from this world in different directions. The constructivists are engineers of the spirit; Marc is a magician, chanting magical formulas to force a hidden reality to show itself. The spirit which before dwelt supreme is rejected. For the spirit has broken the unity to which man wants to return. The animal is closer to this unity, but still not close enough. Marc's art suggests Camus' statement that if he could be an animal among animals, a tree among trees, the problem of meaning would not arise: "I should *be* this world to which I am now opposed by my whole consciousness and my whole insistence upon familiarity." [8] Marc's art is part of a struggle to return to paradise. It is born out of homesickness, out of a dissatisfaction with life which leads to a movement of renunciation.

"There is only one blessing and redemption: death, the de-

7. Hess, *Dokumente*, p. 78.
8. *The Myth of Sisyphus*, p. 51.

struction of the form, which liberates the soul. . . . Death leads us back into normal being." [9] Soon after he had written these lines, Marc was to die near Verdun.

Sympathy denies the individual's will to power. Given this will, it must be rejected as a destructive emotion, a surrender of everyday concerns and the everyday world which can complete itself only in death. But this flight from the world is seen not as an escape into empty ideality but as a return to the earth. Thus while the constructivists' striving for autonomy represents an attempt to cut their roots, the members of *Der Blaue Reiter* stress that the artist must possess roots. Klee likens him to the trunk of a tree through which the strength of the earth must pass into branches and leaves, into works of art.

> Let me use a metaphor, the metaphor of a tree. The artist has concerned himself with this variform world, and, let us assume, he has adjusted himself to a certain extent; quite quietly. He is well enough adjusted to bring some order into the fleeting manifestations and experiences of this world. I should like to compare this orientation concerning nature and life, this interwoven and ramified order, to the roots of a tree.
>
> From these roots the sap rises to the artist, to pass through him and through his eyes.
>
> Thus he takes the place of the trunk.
>
> Pressed and moved by the power of the rising sap, he passes the things seen into his work.
>
> Just as the crown of the tree spreads itself visibly to all sides in time and space, so does the work. Nobody would ever ask that the tree should form its crown exactly as its roots. Everyone will understand that there can be no exact mirror view between below and above. It is evident that the different functions in various basic spheres will produce lively variations.
>
> But people nevertheless try at times to forbid the artist, of all people, to vary from the original, although the composition alone demands that he should. He has even been accused of inability and intentional falsification.
>
> And yet he does nothing but fulfill his function as trunk, and collects and passes on that which came from below. Neither serving nor governing, only mediating.
>
> He thus occupies a truly modest position. And the beauty of the crown is not he himself, it has only passed through him.[10]

9. Franz Marc, *Briefe aus dem Felde* (Berlin, 1959), pp. 81, 147.
10. Paul Klee, "On Modern Art," in Roethel, *Modern German Painting*, pp. 80–81.

The strength of the work of art is said to be the strength of the earth. The artist is to create like nature, or rather nature is to create using the artist as its medium. Thus the artist is not bound to follow the images he sees before him; Klee dreams of an art which is natural in a far more fundamental sense. "What are pictures?" Marc had asked, and his answer was: "Reappearance in a different place." The artist dives into the ocean of immediacy and becomes one with the forces of nature. His creation is a reappearance in a different place, different because the world with which we are familiar has been left behind. Yet the new place to which the work of art carries us, just because it is different and strange, makes it impossible for us to take what we see for granted and thus lets us see more clearly the essence of nature which our familiarity with the world conceals.

This is not as much a description of what art is as a dream of what art should be. It indicates a project rather than an achievement. Marc's own artistic development betrays his commitment to this project. He began under the influence of the academic naturalism reigning in Munich at the turn of the century. The encounter with *art nouveau* caused his art to become more two-dimensional and linear, while a stay in Paris brought him into contact with French impressionism. A sentimental, melancholy preoccupation with nature is in evidence in many of the paintings produced in this period. Gradually his forms become simpler, more forceful, more essential, and less particular. Color becomes more vibrant and symbolic rather than representational. Man disappears. Characteristic of this period is *Three Red Horses:* the lines which define the animals are echoed in the rest of the painting; a rhythm of parallel forms integrates the animals into the landscape. Under the influence of cubism, futurism, and especially of Delaunay, Marc began to fracture the forms of animals and vegetation. Unity is no longer achieved by means of parallel undulating lines. Instead the painting presents us with a force field out of which animals and vegetation crystallize. *Fates of Animals, Tower of Blue Horses,* and *Tirol* are representative works of this later period. The first of these paintings, with its emphasis on the suffering of the individual creature, trying in vain to resist fate, particularly suggests Schopenhauer. A last step takes Marc to the dynamic abstract expressionism of *Fighting Forms.* Here the forces which are represented have not yet differentiated themselves sufficiently to form objects. "The feeling of life speaks in its purity."

[3]

MARC'S DEVELOPMENT fits the pattern of an art in search of the origin almost too neatly. The work of Klee or Kandinsky, who shared many of Marc's convictions, is too complex to fit into this simple a schema. Thus Kandinsky moves all the way from an art rather close to that of Marc to one which seems to have more in common with that of Malevich. In Kandinsky's work we find both the dynamic expressionism of *Der Blaue Reiter* and the formal abstract constructivism of the Moscow school. Like Marc's first creations, those of Kandinsky tend to be somewhat sentimental. This sentimentality is overcome by a movement towards abstraction which culminates in the abstract dynamic expressionsim of the *Improvisations*. The theory which Kandinsky develops to support and explain his view of art has again much in common with Marc's views. Kandinsky, too, wants to leave the skin of nature in order to reach the core.

> The time will come when one will prove beyond the shadow of a doubt that abstract art does not exclude a relationship between art and nature, but that, on the contrary, this relationship is greater and more intense than ever before in recent years. Abstract painting leaves the skin of nature, but not her laws. If you will permit me the great word, her cosmic laws. The abstract painter does not receive his inspirations from a definite object in nature, but from nature in her entirety, from her varied manifestations which he sums up and expresses in his work. This synthetic basis seeks the form of expression that is best suited to it, and that is the abstract. Abstract painting is more comprehensive, freer, and possesses more content than representational art. . . .
>
> I call the encounter with the "secret soul" of all things which we see with the unaided eye, or with a microscope or a telescope the inner "vision." This vision penetrates the hard shell, the outer "form," and reaches the inner being of things, it lets us grasp the inner pulse with all our senses. And this reception becomes in the artist the origin of his work. Inanimate matter trembles. And still more: the inner voices don't sound in isolation, but all together—the harmony of the spheres.[11]

Like Klee, Kandinsky chides artists who think of art as deliberate invention; the results of such an approach must be hollow and disgusting. To be meaningful art must express some-

11. Hess, *Dokumente*, p. 87.

thing. What is expressed is identified either with the "secret soul" of things, or with emotion. There is no real difference, for this secret is not understood but felt; man cannot approach it from without; it must come to life within man himself. This is possible only because man is part of nature. While the understanding creates the illusion that he is at a distance from it, on the level of emotion there is no such distance. The life of the emotions is closer to nature than the life of the understanding; the expression of emotion can therefore reveal nature as a careful copy of nature cannot, and the more immediate this expression, the more natural the result will be.

By taking art to be the language of the emotions or the "secret soul" of things, Kandinsky applies Schopenhauer's aesthetics of music to painting. So does Marc when he interprets the shift towards abstraction as a shift from appearance to the will: "The modern artist no longer clings to the natural image, but destroys it in order to show the mighty laws which dwell behind pretty appearance. To speak with Schopenhauer, today the world as will triumphs over the world as idea." [12] This is to say that modern art has become music in Schopenhauer's sense, for according to Schopenhauer music alone expresses "the inner nature, the in-itself of all phenomena, the will itself." [13]

Having succeeded in creating such a musical art, Kandinsky seems to abandon it; after 1920 his lyrical abstractions give way to geometric compositions. Commenting on this shift, Kandinsky tells of his dissatisfaction with his dynamic expressionism for giving expression to particular emotions that are characteristic of man in his individuality while failing to penetrate the principle of individuation. The response to his art and that art itself struck him as being too personal. He wanted an art that would be more universal. The true artist, he suggests, must be objective; that is to say, he must be able to bracket himself as this particular individual, bound to this particular situation. Kandinsky's desire to penetrate to more fundamental levels of reality led him to develop an art which seems less spontaneous, colder, more cerebral.

The later paintings (1925–1944) serve to illustrate this final phase of his work, in which his symbolic language has become

12. "Die konstruktiven Ideen der neuen Malerei," *Unteilbares Sein,* ed. Ernst and Majella Brücher (Cologne, 1959), p. 11.
13. *The World as Will and Idea,* p. 272.

wholly concrete or objective, and at the same time transcendental. That is to say, there is no longer, and deliberately so, an organic continuity between the feeling and the symbol which "stands for" it; there is rather a correspondence, a correlation. In liberating the symbol in this way, Kandinsky created an entirely new form of art, and in this respect was more revolutionary than Klee, whose symbols are an organic development of his feelings, flowers which have stems and roots in his individual psyche. To a certain degree sensibility itself became suspect to Kandinsky; at least, he insisted on the distinction that exists between the emotion in the artist to be expressed, which is personal, and the symbolic values of line, point, and colour, which are impersonal. In painting, he might have said, one is using a universal language, as precise as mathematics, to express, to the best of one's technical abilities, feelings that must be freed from what is personal and imprecise. It is in this sense that works of art would in the future be "concrete." [14]

As Herbert Read points out, Kandinsky wanted to create an art free from all personal associations. This forced him to use a vocabulary which does not evoke them. He found it in the impersonal language of geometry and in clearer, less suggestive colors. Using this vocabulary Kandinsky created dramatic situations, e.g., a horizontal touching a vertical or a circle meeting a triangle, situations which Kandinsky thought no less intense than God's finger touching that of Adam in Michelangelo's fresco— perhaps more so, for the fresco leaves us in the presence of the all too personal.

Kandinsky's demand that art be most definite in its formal aspects and most indefinite in its content is difficult to distinguish from the demand made by the subjectivistic aesthetic discussed above, even if it is reached by a very different route. In Kandinsky's later work the two approaches which I have contrasted seem to meet. The possibility of such a meeting has already been suggested in our discussion of Wilhelm Worringer's *Abstraction and Empathy*. Abstraction, Worringer argues, has its foundation in a dissatisfaction with the temporal, phenomenal world. This dissatisfaction leads to attempts to escape from the phenomenal world to a stable, transcendent order. In art this project of escape leads to the construction of an ideal environment. The revealed transcendence is man's own. The artificial order created by the artist has its foundation in and is a revelation of the free spirit. But this interpretation is not Worrin-

14. Herbert Read, *A Concise History of Modern Painting*, p. 174.

ger's. Worringer identifies the transcendence revealed in abstract art with the thing in itself. Kandinsky agrees with Worringer; the movement towards abstraction is interpreted as a movement towards a revelation of a more fundamental level of reality.

The two interpretations are not as different as they at first appear to be. To say that the transcendence revealed in abstract art has its foundation in man's freedom is not to deny that it may also be a revelation of a more fundamental reality. Such a denial would be necessary only if we were to divorce man's freedom from that reality. If with Schopenhauer we argue that everything, including man and his freedom, is an expression of the will, then the self-expression of man's freedom must also be a revelation of this will—and it is evident that this point could be restated, given other views of reality. This is Worringer's position: the abstract artist does not have to go beyond himself to discover the laws which find expression in his art. "It is a necessity of thought for us to assume that these laws are implicit in the organization of man." [15] The very demand for order, which leads to a dissatisfaction with the phenomenal world and gives rise to abstraction, is not arbitrary. The ideal that man uses to measure the world is not his invention but has its foundation in the nature of man, who himself belongs to nature. Man's freedom, on this view, is not an empty transcendence. It is founded in demands made on man by what he is. [16]

It is possible to demand a more radical freedom. Thus an artist might argue that to exchange the rule of nature for that of geometry is to exchange one form of heteronomy for another. To

15. *Abstraktion und Einfühlung* (Munich, 1959), p. 54.
16. Schopenhauer, too, provides room for an art which is abstract in the way Worringer and Kandinsky suggest. "We can assign to it [architecture] no other aim than that of bringing to greater distinctness some of those ideas, which are the lowest grades of objectivity of will; such as gravity, cohesion, rigidity, hardness, those universal qualities of stone, those simplest, most inarticulate manifestations of will; the bass notes of nature; and after these light which, in many respects, is their opposite. Even at these low grades of objectivity of will we see its nature revealing itself in discord; for properly speaking the conflict between gravity and rigidity is the sole aesthetic material of architecture; its problem is to make this conflict appear with perfect distinctness in a multitude of different ways" (*The World as Will and Idea*, p. 226). This and similar passages point in the direction of an art which would be abstract and expressive of "the bass notes of nature." There is no reason why this road should be open only to architecture, although given his time, it is clear why Schopenhauer in his search for such an art turned to it. But the place which he allots to architecture can just as easily be filled by the geometric art of Kandinsky or Mondrian.

escape all forms of heteronomy, the artist must create works that have freedom as their sole foundation. Yet the attempt to replace the world with constructions that have their foundation in freedom alone can *in the end* not be distinguished from the opposite striving to have artistic creation be nothing more than spontaneous expression.

This had been seen very clearly by Malevich. The very point of his art was to induce such a transformation. Malevich thought of the white square as marking the point of conversion. It invites what Malevich calls a "white state of mind." Care and concern disappear, as meanings and values are silenced. Malevich wanted to free himself and us from all projects. To be free in this sense is to exist immediately, without planning to do something. Having freed himself from all intentions, the artist becomes a vehicle of spontaneous expression; the empty ideality demanded by the project of freedom gives way to immediacy. Someone who demands meaning of such a white surface may find it opaque. Someone else, who no longer approaches it with such expectations, will find it curiously alive.

This point can be made more general: I have suggested that the attempt to make freedom the foundation of the work of art leads to the demand for a silent art. But does silence not always remain an unrealized ideal? In the end the artist cannot escape the material factor. It remains, regardless of all attempts to escape from definite meanings and content; and not only does it remain, it asserts itself more forcefully. The emancipation of form from its representational function leads to an emancipation of the colors given to these forms. Albers' studies of the square show this. The simple, geometric construction of these paintings eliminates factors which might call the attention of the spectator away from the mere presence of color. A severe formal approach is used to restore to our vision an immediacy that it has lost due to its tendency to associate colors with familiar contexts and meanings. By isolating the geometric, spiritual factor, the artist liberates color in its sensuous immediacy; the more extreme the one, the more insistent the other. This is true even when the artist, in an attempt to escape from all associations, paints a canvas all one color. In his series of black paintings Ad Reinhardt has consciously eliminated all suggestion of personal expression. His art is impersonal. Neither line nor texture suggests an individual expression. The black pigment does not say anything. It has no meaning. As Reinhardt has pointed out, his

art is the result of an attempt to find a formula for the greatest possible degree of artistic freedom. And yet the result of this cutting out of all that might distract or even interest the spectator does not result in silence. Our restless eye refuses it and endows the black surface with mysterious life. Like wind breaking the deadly calm of the mirror-like surface of a lake, our eye creates fleeting shadows, images, hallucinations. We cannot control our vision. It refuses to remain steady but assumes an immediate life of its own, unemcumbered by ideals and intentions.[17] The search for freedom leads to the restoration of immediacy, while the search for immediacy leads to simple, geometric forms. The *non plus ultra* of both projects is the empty canvas.

17. Jürgen Klaus, *Kunst heute* (Hamburg, 1965), pp. 79–83.

10 / The Veil of Isis

THERE IS SOMETHING naïve about most attempts to recapture lost innocence—the very effort to idealize and to try to return to what has been lost only emphasizes the distance separating the individual from what he seeks. This is particularly true of the search for lost immediacy: the attempt to overcome the principle of individuation is always the attempt of an individual and thus bound to the very thing which is to be denied. Idealizations of childhood, of peasant life, of South Sea islanders, or of the Middle Ages do not succeed in restoring to man what he is lacking; rather such presentations of the ideal reveal to him the lack in him that gave birth to the ideal. The return home is idealized only by the homeless. Only those who are no longer children will dream of childhood.

Similarly the artist's attempt to return to a more original state should not be confused with the return itself. Frequently it is indeed little more than a dream of such a return. Such a dream can be mistaken for reality only in bad faith. Thus Franz Marc may have tried to create, as Hans K. Roethel suggests, "a kind of paradisiac fairy world, in which the animal, transfigured by an unresisting participation in the universe, becomes the expression of a religious feeling;" [1] but this fairy world is hardly a revelation of an actual state of innocence. Undoubtedly this was intended. But it must be admitted that what is revealed in these works of

1. *Modern German Painting*, trans. D. and L. Clayton (New York, n.d.), p. 40.

art is the intention rather than the intended; instead of being genuine, Marc's faith is desired; instead of being real, the return to the origin is only illusory. Marc himself writes that great art is possible only where there is faith.[2] But the return to faith cannot be willed. Man must wait to be called. Such waiting takes strength and courage. Too easily it leads us to mistake the longing to be called for the calling itself. In art such attempts lead to Kitsch. A substitute is offered for the paradise which has been lost; the work of art becomes little more than an occasion designed to elicit a quasi-religious mood which may be enjoyed by those lacking the strength to face the isolation of the individual. Marc, like many of the expressionists, constantly had to struggle against this temptation. But in his best works, such as *Tirol,* he overcomes it. Instead of furnishing man with a saccharine substitute paradise, he succeeds in portraying nature in such a way as to reveal to man his precarious situation, desiring, but not possessing faith, longing to surrender to and yet estranged from the origin.

The very attempt to reveal a reality which man's individual understanding hides from him, seems contradictory. What is revealed must always remain at a distance; the ideal of an existence not rent by the polarities of consciousness can be posited but not realized. Innocence is not recaptured by direct attack. But if the direct route seems impassable, may it not be possible to try a more indirect approach? Instead of trying to reach for that which lies behind the veil of the finite, the artist can try to lift or tear this veil. Such art would once more be negative; yet at the same time it would strive for revelation. It would negate only to remove those obstacles that prevent man from escaping from the finite spirit and its world and thus return him to the origin.

There are hints of such an approach to art in Klee's parable of the tree. In that parable, part of which was quoted in the last chapter, Klee likens the artist to a tree trunk through which the earth creates leaves and branches, the works of art. But how is the artist to create like nature, or rather, how is he to become a medium through which nature creates? To gain this spontaneity the artist must free himself from the familiar and refuse to be bound by that vision and understanding which he has learned to take for granted. In an effort to do so, the artist reflects on the

2. Walter Hess, *Dokumente zum Verständnis der modernen Malerei* (Hamburg, 1956), p. 81.

limitations imposed on him by his particular situation in order to overcome them.

> This world has looked different in the past and will look different again in the future.
> With regard to the non-terrestrial, however, he says: completely different forms may have developed on other planets. Such versatility in the natural ways of creation is a good training in form.
> It can profoundly move the creator, and, versatile himself, he will nurture the freedom of development in his own creative work. Taking this into consideration, one cannot blame him if he considers the contemporary stage of the visible world he happens to have been born into as accidentally retarded, retarded in time and place, all too retarded in comparison with his deeper vision and quicker emotions.
> And is it not true that just the relatively small change of a view through a microscope presents the eye with pictures which we would all declare fantastic and eccentric if, without the intelligence to understand them, we saw them somewhere quite accidentally? . . .
> Is the artist then concerned with microscopy, history, palaeontology?
> Only comparatively, only for the sake of versatility, not for the sake of keeping a scientific record of faithfulness to nature.
> Only for the sake of freedom.[3]

The modern artist, Klee suggests, tries to rid himself of the accepted ways of seeing things in order to penetrate beneath the surface, making it possible for his own works to express that spontaneity that dwells in man as it does in all of nature. Ideally the work of art is a gift of nature. According to this view art cannot be taught. Academic training can only try to eliminate those obstacles that prevent inspiration from finding adequate expression. The teacher can do little more than furnish his student with certain technical skills, while at the same time showing him material designed to prevent him from settling too soon for a frozen understanding of what things can look like. Thus the prospective artist should study the different worlds revealed to him by telescope and microscope, not to copy either, but only to discover in both the same fundamental rhythms, which are the rhythms of nature herself.

Andreas Feininger's photographic studies exhibit a similar

3. In Roethel, *Modern German Painting*, p. 81.

concern with showing how different natural formations are but expressions of the same natural force. There is something playful and "unscientific" about a sequence of photographs which lets us recognize the similarity between the patterns traced by water crystallizing on a window pane, a bird's feather, an electric discharge pattern, and an aerial view of some tributaries of the Colorado. The similarity is obvious; still we do not quite know what to make of it. Is there an explanation? But whether there is such an explanation or not is of course beside the point. The visual evidence does not need such a crutch. The photographer has accomplished his purpose:

> To document the unity of natural things, their interdependence, and their similarity; to show the beauty of the living functional form; perhaps to foreshadow the ultimate findings of science—a simple universal plan; and to make you feel related to the rocks and the plants and the animals—you, an integral part of nature, a part of the universe.[4]

Klee wants art to begin where Feininger's photographs leave off. Feininger's aim is to let the spectator see himself as an integral part of nature. Klee views the artist as one who, because he is essentially at one with nature, is capable of creating like nature; or rather, nature creates through him forms that are "natural" though not yet found in nature as we know her.

If this view is accepted, the artist can hardly claim credit for his art. He is only the medium, not the creator. He has no control over inspiration; he can only court her by refusing to be bound to the everyday. From here it is only a step to Max Ernst's pronouncement that surrealism has attacked and destroyed one of the last great myths surrounding the activity of the artist: the fairy tale of his creativity. Like Klee, Ernst emphasizes the passive role of the artist: he is to be only a medium for what Ernst calls poetic inspiration. The only way in which the artist can still be said to be active is for him to furnish a mechanism that will liberate him and the spectator from reason, morality, and aesthetic preconceptions.[5]

This view calls for a spontaneous art not governed by the artist's intentions. Yet as long as the artist idealizes spontaneity, his creations continue to be governed by an intention: the inten-

4. Andreas Feininger, *The Anatomy of Nature* (New York, 1956), p. xi.

5. Hess, *Dokumente*, p. 119.

tion to be free from all intentions. This intention expresses itself as an absence of expected meanings and associations. This absence is part of our encounter with the work of art. Simply by looking at something as art we view it as something the artist chose to do. In this sense freedom is constitutive of the work of art. Unlike spontaneity, freedom implies intention. To choose to create spontaneously is to aim at an art which negates itself as something that the artist intended to do, i.e., an art that is natural rather than artificial. And yet to say this is to admit that we confront such art not as we would an abstract pattern produced by nature but as a freedom struggling to be free of itself in order to become spontaneity. Pollock's abstractions thus proclaim their origin in such a project of liberation and invite the spectator to participate in it.

[2]

IF THE ROLE of inspiration is de-emphasized as being beyond the artist's control and greater importance is given to the project of liberation, art becomes a kind of game, designed to destroy whatever stands in the way of spontaneity. Instead of trying to reach directly for a more fundamental reality, the artist plays a game in which the spirit is asked to make a sacrifice of itself in order to let man descend.

At least since the beginning of the romantic era, there have been such attempts to invent a magic game, embracing all that is part of the world as we commonly know it, which would free the player from the finite and let him rejoin the infinite whole from which the spirit has expelled man. Novalis dreams of an "infinite play" with possibilities, an unending invention of unlikely combinations, the aim of which would be not to free man from reality, but to awaken in him a sense of that mystery which can speak to us in a plant, the wing of a bird, or an egg shell, which is all around us and which we are yet unable to find because in our desire for clear and distinct knowledge we have forgotten how to read the secret signs of nature. Novalis sees the artist as a priest introducing the neophyte to the mysteries of Isis, teaching him to read the *chiffre* of the divine in the manifold patterns surrounding him, instead of reducing these patterns to empty shells by labeling and classification. If only man could learn once more how to feel instead of trying to understand he would be in touch

with the entire world. Novalis is, as Walther Rehm calls him, "in every sense of the word a true *ludi magister*," [6] who refuses to be bound by the limits assigned to man by his finite understanding, but strives to surpass them in his playful combinations in which the Goddess of Sais is to show herself, restoring man, at least for a moment, to the origin from which he has emerged and to which he wants to return.

In his novel *Magister Ludi*, Hermann Hesse takes up this suggestion and develops it in his description of the game with glass pearls which furnishes an age which has experienced the death of God and the disintegration of the old value system with a substitute. Though the game is too weak to yield new values that would enable its devotees to live in the world, it is strong enough to present them with a refuge from the void left by the collapse of the traditional value system. Values and insights that once were living are now only occasions for play; what once could express what really mattered now retains only a vestige of this meaning. In this godless age only echoes remain. Out of such echoes the *magister ludi* weaves his game.

The rules of this game resemble those of musical composition:

> One theme, two themes, three themes were stated, expanded, appeared in variations and underwent a fate similar to that of a theme in a fugue or in the movement of a concerto. The game could, for instance, start with a given astronomical configuration, or with the theme of a fugue by Bach, or with a sentence from Leibniz or the Upanishads. [7]

An aesthetic order is created by manipulating items borrowed from other disciplines. In some respects such a game is like philosophy. Like philosophy it presupposes other disciplines and borrows from them images and concepts which it strives to fit into a certain order. But unlike philosophy no attempt is made to discover comprehensible connections which in some way reflect the structure of reality. The connections which are created in the course of the game in no way agree with the structure of the world as it is discovered by an objective investigation. Indeed the very point of the game is to avoid such agreement.

Thus if one seeks truth in such games, in the sense of a

6. *Novalis* (Frankfurt a.M., 1956), pp. 9–10.
7. Hermann Hesse, *Das Glasperlenspiel, Gesammelte Dichtungen* (Berlin and Frankfurt a.M., 1957), VI, 112.

correspondence between the order created by the player and the actual existing universe, one cannot but be disappointed. No such truth is to be found. But then the game is not an attempt to describe the world.[8] It is "a select symbolic form of the search for the perfect, a sublime alchemy, an approach to the one spirit which stands beyond all images and multiplicities, that is to God."[9] This intuition is not gained by comparative analysis. Such analysis will only lead to a third concept, sharing the lack of mystery which is common to all concepts. It appears rather when the mind passes from one concept to another. To make such a passage possible there must be a certain relation between the two concepts which we can seize and yet do not understand. But this relation, perhaps a superficial similarity, may not be explicable by analysis. If an explanation is lacking, the mind, meditating on the nature of the relation, unable to give a reasonable account for it, is freed for the intuition of a reality which transcends or underlies the finite and conceptual. The game does not lead us to "examples, experiments, or proofs, but to the center, the mystery, the inner core of the world, to primordial knowledge."[10] Once more we find ourselves in the neighborhood of *Der Blaue Reiter*. Hesse seems indeed to have thought of Klee as striving to give expression to a similar ideal.

The game with glass pearls is based on the belief in a mysterious, divine force which transcends the multiplicity of the conceptual and yet finds expression, if only inadequate, in it. It is intuited when the mind is forced to acknowledge its limitations. Take one of Hesse's examples in which he likens a formula expressive of the distribution of vowels in a certain poem to a formula expressing the motion of a planet. This is of course absurd. Common sense tells us that whatever similarity there might be must be altogether accidental. But to listen to common sense is to refuse to play the game. The devotee contemplates the seemingly absurd relationship, using its very absurdity to break the hold of common sense. Precisely when man ceases to measure the relationship by his understanding of what is reasonable or to be expected does he sense the mystery of the holy. The structure which is created in the course of the play is in no sense an image of reality. And yet, the player, by leaving the surface, tries to find once more the whole that has been fragmentized by

8. Cf. *ibid.*, p. 222.
9. *Ibid.*, p. 112.
10. *Ibid.*, p. 197.

our conceptualization. The spirit is put into a position where it must negate itself. Man seizes the seemingly absurd relationship and keeps looking for a mediating third term, which he cannot find. Meditating on his own inability he acknowledges his own limitations and in this acknowledgement is thrown beyond them. Common sense is absolutely right in insisting on the absurdity of such an attempt; the game with the glass pearls is nonsense; but its magic lies precisely in the fact that it invites us to part with common sense. Its method is somewhat analogous to that of the Zen Buddhist who asks: "If two hands clapped together make a noise, what is the noise made by one hand?" This, too, is absurd, but absurdity furnishes a point of departure for the journey into being or nothingness. That such riddles are rather popular today suggests an inability on the part of those who seek significance in nonsense to find meaning in the situation into which they have been placed.

[3]

HERMAN HESSE'S DESCRIPTION of the game with glass pearls is itself a playful analysis of a project not uncommon today, a project that in art is most evident, perhaps, in surrealism. This is not to say that all surrealism is to be understood in this way. Some of it simply negates what is expected, for the sake not of revelation but of rebellion; some of it shows a world turning into slime or makes reference to the world of our dreams; some of it is simply Kitsch; but a considerable part of what is called surrealism has as its goal the descent to a more immediate level of experience by means of a destruction of our superficial understanding of what is real. Thus Max Ernst suggests that the strongest poetic effect is produced when we force two completely different objects together without providing a third, mediating image; his example, borrowed from Lautréamont, is the copresence of a sewing machine and an umbrella on a surgeon's table.[11] In his less amiable, more strident way Dali makes the same point when he tells us that we are idiots if we cannot imagine a horse galloping on a tomato. The surrealists provide us with such images in their paintings. Magritte's *Le Chateau des Pyrenées* is a good example. As Canaday puts it,

11. Hess, *Dokumente*, p. 120.

Magritte is a painter of "absolutely concrete impossibilities that tell no story"; in this case he shows us a huge boulder, topped by a fortress, floating easily, like the fabled island of Laputa, above a rather conventionally painted sea.

> Magritte takes us to a party where all the guests are normal, but one. This one is a person who, while perfectly natural in every other way, floats around the ceiling like an escaped balloon. This floating, however, seems to be taken for granted; the other guests obviously accept it as nothing extraordinary; to point out the abnormality would be rude at best and dangerous at worst, since we begin to wonder why we, alone, find the circumstance unusual. The end is that we begin not to doubt our own eyes but to doubt our experience that has taught us that people do not float.[12]

Hans Sedlmayr defines surrealism as the systematization of confusion.[13] By this the surrealist does not hope to subject confusion to a system and thus to assert the supremacy of the ordering spirit. He creates his order only so that the idea of system may itself become suspect in the association. Surrealism is destructive, but only of those chains that it feels restrict the spontaneity of our vision. What does this vision reveal? One is not quite sure how to answer. Does Magritte show us anything? Or is he just having a good time, revealing nothing but his own freedom and inventiveness? Once more an art dedicated to the return to the origin is difficult to distinguish from that of subjectivity.

A quotation from Dostoevsky's *Notes from the Underground* illustrates a surrealism which has passed the demarcation line and belongs clearly to nothingness.

> Twice-two-makes-four is, in my humble opinion, nothing but a piece of impudence. Twice-two-makes-four is a farcical, dressed-up fellow who stands across your path with arms akimbo and spits at you. Mind you, I quite agree that twice-two-makes-four is a most excellent thing; but if we are to give everything its due, then twice-two-makes-five is sometimes a most charming little thing, too.[14]

Twice-two-makes-five appears here as the ultimate refuge of a freedom which tolerates no limitations.

But again: is this really quite as "clear" as I have suggested?

12. John Canaday, *Embattled Critic* (New York, 1962), pp. 107–8.
13. *Die Revolution der modernen Kunst* (Hamburg, 1956), p. 83.
14. *The Best Short Stories of Dostoevsky*, trans. D. Magarshack (New York, 1955), p. 139.

Perhaps—especially if this passage were to appear in a different context—it could be looked at as something like a Zen Buddhist koan designed to reveal a nothingness which is yet the veil of Being. I indeed find it difficult to distinguish between the two, in spite of the fact that they seem to call for very different emotional responses: in the first case we have a statement made by one who finds existence void of purpose; in the second, a statement made by one who takes the void as his purpose. But perhaps there is a more significant difference that I am unable to detect. I am content to point out how greatly an art which wants to draw away the veil of Isis and one which does not want to reveal anything except the freedom of the individual can resemble one another, and how close both seem to be to insanity, as if only in insanity man could save his freedom or return to the ground of his being.

11 / Art and Psychoanalysis

To GUARD AGAINST CONFUSION, I want to emphasize that this chapter is in no way to be read as an attempt to give a psychoanalytic interpretation of art. The purpose of this study, to view art as an attempt to give expression to an ideal image of man, precludes this. It deals only with that aspect of creativity which lies above the threshold of consciousness. An examination of the role played by the unconscious does not fall within its scope. This, of course, is not to deny that this role may be highly significant. But what interests us in this context is rather the often very self-conscious appropriation which artists have made of psychoanalysis in an attempt to give content to the project of returning to the origin. When a contemporary work of art uses symbols which seem to demand in a rather obvious way a Freudian or Jungian interpretation, this very obviousness should put us on our guard. In all likelihood what we have before us is not so much the product of a spontaneous welling forth of the unconscious, much as the artist may wish that this were so, but a deliberate manipulation of learned symbols, which can be explained rather well in terms of a project which the artist has chosen. This observation does not apply only to post-Freudian creations; the self-conscious use of borrowed symbols is at least as old as Plato's myths.

Herbert Read's discussion of Picasso's *Guernica* suggests the possibility of such an interpretation, although the author wants to argue for the spontaneity of Picasso's symbolism. Quoting Picasso, Read points out that in this painting the artist wanted to

"clearly express [his] abhorrence to the military caste which has sunk Spain in an ocean of pain and death." [1] In part, at least, this intention is carried out by Picasso's choice of certain symbols:

> It is a picture so rich in symbolic significance, that one is almost persuaded that Picasso has at some time made a study of Jung and Kerényi! In addition to the figure of the Wise Man . . . we have the Minotaur, representing the dark powers of the labyrinthine unconscious; the sacrificial horse, bearing on its back the overpowered libido; and confronting them the divine child, the culture bearer, the bringer of light, the child-hero who fearlessly confronts the powers of darkness, the bearer of a higher consciousness. [2]

But does the presence of such symbolism entitle us to say that here we have "the most complete revelation of the unconscious sources and symbolic significance" of a rite which found early expression in Mycenean and Minoan art? [3] Is the primitivism of so much modern art to be understood as a return to sources which once flowed freely but were then clogged by an overdose of civilization? Or is it again only a dream of such a return, which our self-consciousness prevents us from achieving?

In the case of *Guernica*, Read himself seems to have doubts: "Picasso's use of these symbols is unerringly orthodox, and the question is whether he is orthodox because he is learned in the history of symbolism, or because he allows his symbols to emerge freely from his unconscious." [4] "Picasso is not a naive artist," Read points out, "he is a man of culture who reads voraciously. It is not inconceivable, therefore, that the traditional symbols he uses are used with deliberate intention. Such symbols are activated by surface emotions, and not by the unconscious." [5] By implication, the artist who makes conscious use of symbolism is charged with being superficial, at least in this respect—Read does believe that there are other things to be discovered in *Guernica* which would save it from this charge. Granting this, we must ask: in what sense is the conscious use of symbols superficial? Such a charge makes sense only if we presuppose with Read the importance of the contributions made by the unconscious. "Artistic creation, to the same degree and in the

1. "The Dynamics of Art," in *Aesthetics Today*, ed. M. Philipson (Cleveland, 1961), p. 338.
2. *Ibid.*, p. 339.
3. *Ibid.*, pp. 337–38.
4. *Ibid.*, p. 341.
5. *Ibid.*

same manner as effective symbolism, implies spontaneity: the artistically valid symbols are those which rise, fully armed by the libido, from the depths of the unconscious." [6] "The artist is merely a medium, a channel, for forces which are impersonal." [7] According to Read the essence of creativity must be sought in *spontaneity*. It is important to distinguish spontaneity, as Read uses it, from *freedom*. Freedom is of the spirit, while spontaneity is tied to the unconscious. To stress the freedom of the artist is to view the work of art in terms of a project, governed by a certain end; to stress spontaneity is to view it as a more or less automatic product of unconscious processes. Spontaneity cannot be said to be personal. It is immediate, a force which acts through man but is not controlled by him. It is not his possession, but a gift, bestowed on man by nature or the gods.

The theory which Read presents can look back to a venerable ancestry. Plato writes in the *Ion:*

> For all good poets . . . compose their beautiful poems not by art, but because they are inspired and possessed. And as the Corybantian revellers when they dance are not in their right mind, so the lyric poets are not in their right mind when they are composing their beautiful strains: but when falling under the power of music and metre they are inspired and possessed; like Bacchic maidens who draw milk and honey from the rivers when they are under the influence of Dionysus but not when they are in their right mind. . . . Therefore God takes away the minds of the poets, and uses them as his ministers, as he also uses diviners and holy prophets, in order that we who hear them may know them to be speaking not of themselves who utter these priceless words in a state of unconsciousness, but that God himself is the speaker . . .[8]

Kant's theory of genius, the romantic conception of inspiration, and Klee's parable of the tree express a similar view of the creative act. The artist is the servant of Dionysus; to serve his god, he may not let his own individuality come in between the god and those whom he calls. Art is impersonal, Read emphasizes again and again. One is reminded of Schopenhauer's view that art gives us at least temporary respite from having to be individuals.

Yet pronouncements such as "art is impersonal" are difficult

6. *Ibid.*
7. *Ibid.*, p. 334.
8. *Ion* 533, 534; Jowett translation.

to assess. Do they describe what art as a matter of fact is or do they give us a prescription? Part of the meaning of "art" is that it is meaningful. But meaning does not reveal itself as such to a neutral observer. Man discovers meaning only when engaged in a project. A detached description of what art is would thus seem to be an impossibility. Any description of art contains an element of prescription. This is certainly true of Read's analysis. Read's criticism is itself part of the attempt to return to the origin. Thus when he writes, "Of all the groups which have contributed to that complete 'transvaluation of all values' which the modern movement in art represents, it seems to me that the four painters who came together in Munich in 1912 had the clearest realization of its philosophical basis," [9] he shows his own commitment more than he gives us an objective assessment. Read writes in the spirit of *Der Blaue Reiter*. He, too, is at work on the creation of a new ideal image of man from which his philosophy of art cannot be divorced; but while Marc, for example, used Schopenhauer and Nietzsche, Read has at his command the far richer material furnished by such men as Freud, Jung, and Kerényi. Still, the project remains very similar.

[2]

IN FAIRNESS TO FREUD, it must be pointed out that such an idealization of the impersonal and the unconscious was hardly his intention. If in his anthropology he followed the general outline provided by Schopenhauer, he remained strongly committed to the ideal of the spirit. Freud was hardly the high priest of the unconscious that some of his more enthusiastic followers tend to consider him. His interest in the unconscious is in the service of consciousness. Thus he likens man's struggle to live with his unconscious to the struggle of the Dutch to live with the sea, protecting the cultivated land with dikes while striving to gain new land from the sea wherever possible. The appropriation of psychoanalysis by a surrealist such as André Breton, who in his *First Manifesto of Surrealism* appeals to Freud while advocating that man deliver himself from the rule of logic, serves an ideal which demands that all dikes be broken and that land be changed back into sea. Yet while such an appropriation

9. *The Philosophy of Modern Art* (New York, 1957), p. 191.

may be fundamentally un-Freudian, it is still true that it found a natural ally in the conception of man presented by Freud and his followers.

Read's philosophy of art offers a good example of this idealization of the unconscious and the rejection of the Platonic conception of man which it implies. Speaking of Plato and Hegel, Read writes that

> they were both right in considering that the sensuous phenomena of art—the completely irrational basis of the imaginative faculty—are inconsistent with such a reflective culture. But what we now assert with the strongest conviction is our disbelief in either the inevitability or desirability of such a culture. The whole evidence of history, as well as of modern psychology, causes us to reject without hesitation such a fool's paradise of idealism.[10]

Sadism and masochism are said to be the price with which man has to pay for his one-sided commitment to the spirit. To this fool's paradise Read opposes his own image of the golden age: "The only absolutely pacifist races (if any such still exist) are those which live in a golden age of hedonism, such as, apparently, the Minoan civilization enjoyed for many centuries." [11] Art, at least that art which does not follow a regimen imposed by the spirit, i.e., romantic rather than classic art, restores to man some of the spontaneity, the freedom from rule and ordinance, which marked that lost golden age. Read, too, dreams of innocence. That his dreams are clothed in a vocabulary derived from Freud and Jung should not lead us to mistake them for detached description.

Read's demand for innocence and spontaneity is too self-conscious to be completely convincing. Thus, while he argues that symbolism which is borrowed or deliberately constructed rather than spontaneously discovered tends to be hackneyed or stale, when confronted with the symbolism of *Guernica* he himself is unable to come to a final conclusion as to which it is. He even goes so far as to suggest that the issue could only be "settled by a direct appeal to the artist." [12] But what would such an appeal change? The work is finished and done. Read's uneasiness suggests that his own approach to art is far less spontaneous than his theory would seem to demand. His appreciation is filtered by

10. *The Philosophy of Modern Art,* p. 119.
11. *Ibid.*
12. "The Dynamics of Art," p. 341.

the project he has adopted, which lets him look at art in a way which may do violence to the work in question. I do not wish to criticize such an approach; I only want to point out the need for a distinction between true spontaneity and the dream of spontaneity, which has its root in the project of return. Freud may help us to understand both; but whether he does or not, he certainly has furnished our dreams of spontaneity with an inexhaustible wealth of material.

Perhaps the rationale behind this appropriation of Freud is seen most easily when Freud's view of man is compared to that of Schopenhauer. Like Schopenhauer, Freud presents us with a psychology from below. His conception of the *id* seems quite close to Schopenhauer's conception of man as desire. Freud describes it as

> a chaos, a cauldron full of seething excitations. We picture it as being open at its end to somatic influences, and as there taking up into itself instinctual needs which find their psychical expression in it, but we cannot say in what substratum. It is filled with energy reaching it from the instincts, but it has no organization, produces no collective will, but only a striving to bring about the satisfaction of the instinctual needs subject to the observance of the pleasure principle.[13]

The similarities between this view and that of Schopenhauer are apparent. There is a stronger commitment to the scientific spirit on Freud's part which leads him to make the attempt to found man's instinctual needs in the body. There is a suggestion that desire is itself to be derived from man's bodily make-up. But this attempt to give psychology a biological foundation is not more than a suggestion. As far as the theory itself is concerned, Freud's fundamental conception of the libido comes very close to Schopenhauer's understanding of desire.

Schopenhauer had argued that the principle of sufficient reason and the entire logical apparatus which has its foundation in this principle govern only the subject's encounter with objects. But man is subject-encountering-objects only insofar as he is spirit or consciousness. It follows that the principle of sufficient reason does not govern the lower regions of man's being. Freud

13. "New Introductory Lectures on Psychoanalysis," *Standard Edition of the Complete Psychological Works of Sigmund Freud*, trans. James Strachey in collaboration with Anna Freud, assisted by Alix Strachey and Alan Tyson (London, 1953–66), XXII (1964), 73.

similarly points out that "the logical laws of thought do not apply in the id, and this is true above all of the law of contradiction." [14] This is one of those passages which seems to give a scientific foundation and justification to the artist's flirtation with the irrational.

The second constituent part of the self is the *ego,*

> that portion of the id, which was modified by the proximity and influence of the external world, which is adapted for the reception of stimuli and as a protective shield against stimuli, comparable to the cortical layer by which a small piece of living substance is surrounded. . . . But what distinguishes the ego from the id quite especially is a tendency to synthesis in its contents, to a combination and unification in its mental processes which are totally lacking in the id. . . . It alone produces the high degree of organization which the ego needs for its best achievements. [15]

Again the similarities between Freud and Schopenhauer are striking. For Schopenhauer, too, consciousness is only a modification of desire or will, demanded if the highly complicated human organism is to survive in his environment. Following Kant, Schopenhauer views consciousness as the faculty of synthesis and order, the source of the principle of sufficient reason.

The third constituent part, the *super-ego,* is described as "the representative for us of all moral restriction, the advocate of a striving towards perfection—it is, in short, as much as we have been able to grasp psychologically of what is described as the higher side of human life." [16] The super-ego is the most derivative of the three parts, presupposing both id and ego, while itself not presupposed by the others. Only here does morality make its appearance. Like Schopenhauer, Freud is forced by his view of man to reject the Kantian stress on the moral a priori. Morality becomes the product of an internalization of external restrictions, a formulation reminiscent of Nietzsche.

Read thought that this picture of man could be used to put romantic aesthetics on a sounder foundation. Surrealism is for him the reaffirmation of the romantic principle on a scientific basis. Not that science could ever furnish us with the romantic principle. Such a principle arises only in the context of the

14. *Ibid.*, p. 73.
15. *Ibid.*, pp. 75–76.
16. *Ibid.*, p. 67. Cf. Herbert Read, "Art and the Unconscious," in *A Modern Book of Esthetics,* ed. Melvin Rader (New York, 1952), pp. 148–50.

project to escape the strait jacket of order and control; it can be defended only by an appeal to a certain ideal image of man which places a premium on spontaneity. Science cannot provide such an ideal; it can tell us only what man as a matter of fact is, not what he ought to be. The commitment to a particular project cannot in the end be justified by an appeal to fact; the appeal to fact is itself governed by such a project. But given the romantic project of return, Freud does indeed furnish us with information which may be used to elaborate this project. What is presented as a description of the human situation may be transformed into an ideal image of man by emphasizing those aspects in the analysis which support the project. Only now does Freud's assertion that the laws of logic do not hold for the processes of the id become an invitation to liberate art from logic. Only this idealization totally inverts the traditional conception of man and transforms the sober researcher into a prophet of romanticism.

[3]

READ DESCRIBES the work of art in terms of this idealization of Freud's image of man:

> It derives its energy, its irrationality and its mysterious power from the id, which is to be regarded as the source of what we usually call inspiration. It is given formal synthesis and unity by the ego; and finally it may be assimilated to those ideologies or spiritual aspirations which are the peculiar creation of the superego.[17]

The latter is taken to be the most expendable factor. Often it is indeed a hindrance. Works which proclaim their ideological message too prominently tend to lose their roots in the id and make only a rather superficial appeal. The ego is necessary to provide organization and comprehensibility. It is thus not quite accurate, even for Read, to speak of the artist as a mere medium. He does have a function, even if it is the rather modest one of ordering what has been provided by inspiration. Better than Klee's metaphor of the tree trunk is Read's image of the artist as an "alchemist, transmuting the *materia prima* of the unconscious into those 'wondrous stones,' the crystal forms of art." [18] Alchemy is magic

17. "Art and the Unconscious," p. 151.
18. "The Dynamics of Art," *Aesthetics Today,* p. 346.

transformation. The artist is a magician manipulating what his unconscious has furnished to him in such a way as to create forms in which he "gives concrete existence to what is numinous, what is beyond the limits of rational discourse: it brings the dynamics of subjective experience to a point of rest in the concrete object. But it only does this in virtue of a certain imaginative play—*eine psychische Spielerei.*" [19] Little separates this conception of art from the game with glass pearls.[20]

The work of art is for Read a place where the surface which conscious understanding has placed over the life of the unconscious is broken. Thus it permits man to peer into the core of his being. Read likens the work of art

> to a "fault" in geology, as a result of which in one part of the mind the layers become discontinuous, and exposed to each other at unusual levels. That is to say, the sensational awareness of the ego is brought into direct contact with the id, and from that "seething cauldron" snatches some archetypal form, some instinctive association of words, images, or sounds, which constitute the basis of the work of art. Some such hypothesis is necessary to explain that access, that lyrical intuition, which is known as inspiration and which in all ages has been the rare possession of those few individuals we recognize as artists of genius.[21]

The similarity between Read and those artists who hoped to use irony to lift the veil of Isis, to break the hold of the finite and show forth the infinite, is unmistakable. But the infinite is now identified with the unconscious. It has received what Read believes to be a scientific foundation, as compared to the metaphysical fancies of earlier writers.

The appeal of such art can only be understood in terms of a project to recover man's essence by turning to the unconscious. This project, like any such project, presupposes that man is a being in need. Like the Platonic-Christian tradition, Freud sees man alienated from himself. This alienation is rooted in the discrepancies between what is demanded of man by the id, on the one hand, and by his social existence, on the other. According to Read, romanticism follows the call of the former, classicism that of the latter. "There is a principle of life, of creation, of

19. *Ibid.*
20. Cf. Hermann Hesse's letter to C. G. Jung, *Betrachtungen und Briefe, Gesammelte Schriften* (Berlin and Frankfurt a.M., 1957), VII, 577.
21. "Desire and the Unconscious," *A Modern Book of Esthetics,* p. 154.

liberation, and that is the romantic spirit; there is a principle of order, of control, and of repression, and that is the classical spirit." [22] The Marxist overtones of such a formulation are difficult to ignore. The social establishment is blamed for man's alienation from himself. Surrealism's affront to the establishment becomes a blow for the liberation of man from an oppressive society.

But if Freud is correct, man's lack of health cannot be remedied by a change in the social structure. Read's dream of the innocent hedonism of the Minoans is little more than a fairy tale. Sickness is part of the human condition. Freud agrees with Nietzsche and Kierkegaard, even if his interpretation is different.

Freud's view of man makes it possible to explain the genesis of art in terms of a project to overcome this lack of health.

> An artist is originally a man who turns away from reality because he cannot come to terms with the renunciation of instinctual satisfaction which it at first demands, and who allows his erotic and ambitious wishes full play in the life of phantasy. He finds the way back to reality, however, from this world of phantasy by making use of special gifts to mould his phantasies into truths of a new kind, which are valued by men as precious reflections of reality. [23]

Once more we have a view that likens art to play: the dissatisfactions of the individual give rise to substitute satisfactions. What is enjoyed is the illusion of having satisfied one's desires. Here Freud's conception of art threatens to become just another theory of Kitsch. Aesthetic pleasure is described as self-enjoyment. The artist indulges in an illusion. To do so he brackets reality, finding satisfaction in a world which he himself has created. Instead of revealing reality, the artist dreams of revelation, forgetting in his dream his own predicament.

[4]

IN GIVING CONCRETE EXPRESSION to what belongs to his unconscious, the artist does not communicate something which is of concern to him alone. On the contrary, with respect

22. *The Philosophy of Modern Art*, p. 114.
23. "Formulations on the Two Principles in Mental Functioning," *Standard Edition*, XII (1958), 224.

to the make-up of the id men are more or less alike. Only the superstructure which is raised on the id as man develops in a certain environment causes individuality to appear. If art has its foundation in the id, the historic or personal style of the artist is accidental rather than essential; what really matters in art transcends such variations. Such an approach to art will de-emphasize the historic position of a work of art. This makes it possible to tie modern art to that of primitive man. Without hesitation a critic such as Read discovers in Moore's sculpture the same archetypal patterns found in Mayan art. The essence of art is presumed to be static.

This is evident when Read, taking up Freud's suggestion that dreams possess not only a private but a public import as well, writes: "The technique of the poet or the artist is in some way a means of breaking down the barrier between individual egos, uniting them all in some collective ego such as we found typical of the undifferentiated life of primitive people." [24] The artist aids us in breaking the hold which the principle of individuation has on us. Freud hardly would have approved of such an interpretation of his work. He was far too convinced of the value of the individual to turn to such an anti- or, perhaps better, supra-individualistic view. Read's interpretation is more in the spirit of Schopenhauer and Jung. Jung, too, sees in the process of individuation the root of the dissatisfaction which is at the heart of the human situation. The original sin of man is to have lost contact with the whole. The human spirit has cut itself off its ground. It has become rootless, a splinter, a mere part. The very fact that man is spirit entails this rootlessness. As a conscious, temporal being, man has to affirm himself; he has to choose, determining what he is to be. This choice takes place against the background of what man is. What is affirmed stands in a more or less pronounced tension with the actual being. The more conscious an existence, the greater the temptation to identify man's consciousness with his essential being and to seek reality in the empty constructions of the spirit. Art is for Jung one answer to this temptation. The more highly developed the spirit, the greater the need for art to restore the balance. Art, for Jung, is a descent to the mothers, a product of the irrational activity which precedes consciousness and is its foundation. Jung, too, considers the artist a medium: the attempt to explain art in terms of

24. "Art and the Unconscious," p. 147.

the personal problems of the artist puts the cart before the horse. The artist will tend to have such problems, simply because he is an artist and has been seized by the god. The artist is called by the unconscious. This call renders him ineffective in his dealings with others who demand that he affirm himself as an individual to whom certain roles have been assigned. In this view art, as Schopenhauer had suggested, is closely related to insanity.

Regardless of the truth or falsity of Jung's conception of man, it furnishes once more a statement that can be developed into an ideal that promises release from the burdens of individuality. It is here, rather than in his scholarly achievement, that the source of Jung's popularity must be sought. Jung is another *ludi magister*, manipulating symbols that are almost dead in order to catch an echo of the language of the dead gods. Where gods have become silent, man can at least dream of them, and in his dreams recover their shadows.

12 / The New Realism

MAN'S SITUATION IS AMBIGUOUS. He is part of the world, but he is more than that. He is in the world as stones or animals are, but his consciousness enables him to oppose himself to it. The absurdity of human existence has its foundation in just this: that man, although in the world, is estranged from it; that he is engaged and disengaged; that while the world confronts man as an incomprehensible other, he is yet bound to it. The world has an immediate claim on man and yet he can reflect and doubt the meaning of this claim.

Man can try to escape from this absurd mixture of familiarity and distance by choosing one or the other: he can either refuse to oppose himself to the world or he can emphasize what separates him from it—in either case the question of meaning is not answered but disappears. Man can renounce his individuality in an attempt to regain immediacy; he can also emphasize the distance separating him from the world either by withdrawing from the world into his own self and its imaginary realms or by withdrawing from the world only to turn back to it—but with an objectivity which asks nothing of the world. The former leads to the abstract formal art discussed above, the latter to a new realism.

In 1912 Kandinsky predicted the rise of a "great realism" which would complement the movement towards abstraction.[1]

1. "Über die Formfrage," *Der blaue Reiter*, ed. W. Kandinsky and F. Marc, new ed. K. Lankheit (Munich, 1965), p. 147.

Traditional academic art had used form to prettify representation and representation to give content to form. Beauty was sought in a balance of the two. The artist weighed one against the other until a kind of equilibrium was achieved. "It seems that today this ideal is no longer a goal, the lever holding the scales has disappeared." [2] Kandinsky predicted that in the future abstraction and representation were going to lead lives of their own. On the one hand we would find an art which reduces the representational element to a minimum in order to reveal form (Kandinsky himself led this movement); on the other hand there would be a new realism which reduces form to a minimum in order to reveal objects as they really are.

To reveal is to unveil. What veils reality according to Kandinsky is our familiarity with it. We are so used to the world that we generally take it for granted and do not bother to really look at it. One only has to live with children to be taught this. How easily is a child upset when we put something, a cup or a chair, somewhere other than in its usual place. We do not mean to do it, we do not even know we were doing it, and we are upset ourselves that such a little thing should cause such a commotion. It seems unreasonable. What difference does it make? We may even get stubborn and try to convince the child of this. But what do we mean when we say it makes no difference? It makes no difference given what we take to be important. We impose on the child our own way of seeing things, as we teach him what matters and what does not.

We are so used to the world that we walk through it with our eyes half-closed. The very things that are closest to us, the tools we use or the things we wear, are usually taken for granted and thus not really seen. Our shoes, for example, call themselves to our attention only when they fail us in some way. As long as they perform well, they can be forgotten. And yet a shoe is something worth looking at; its shape, the texture of aged leather, a worn heel—these have an aesthetic significance of their own. But to see such things we must free ourselves from our involvement with the world. We have to take a step back from the world to look at it as if we had not seen it before. To lead us to take this step is one task of art.

This task, Kandinsky thought, could no longer be fulfilled by traditional art. For it and its conception of beauty had become

2. *Ibid.*, p. 148.

stale; man had become accustomed to this beauty. "The spirit had absorbed" it and now could find in it "no new food." [3] Art had turned into an empty gesture.

Among the worst offenders Kandinsky counted those art critics who condemned a work of art because it lacked something that they took to be essential. Kandinsky denied that art possesses an essence that can be established once and for all. "One may never believe a theoretician (art historian, critic, etc.) when he asserts that he has discovered some objective error in a work of art." [4] The critic is entitled only to the more modest assertion that he has not seen this sort of thing before. When he goes beyond this and condemns it because it does not measure up to his conception of art, he fails to do justice to the work of art. Such conceptions erect "a wall between the work and the naive observer. From this point of view (which unfortunately is usually the only one possible) art criticism is the worst enemy of art." [5]

When the accepted canon of beauty has become so rigid and familiar as to cause a particular conception of art to be taken for granted, the artist must turn against it and reject the tendency to beautify or idealize as a temptation. From a traditional point of view the resulting art must be judged ugly. But it is just this ugliness that forces the observer to look. It is an antidote to the merely pretty, to beauty which has become a cliché, to Kitsch. Just when we reduce the artistic element to a minimum, what Kandinsky called the "pure inner sound" of the object is most readily heard.[6] By robbing us of the crutch of familiarity, the artist opens our eyes.

The power of this device is familiar to us all, and not only in art. Sometimes when we turn on a television set the face of an announcer or entertainer appears while the sound is still missing. Without the sound, the opening and closing of the mouth, the mute motions of the hand are robbed of the context in which alone they are familiar. We are thrown back to the visual element. For once we are forced to look at the speaker, instead of seeing him only through a veil of words. The same principle can lead us to discover the magic dwelling in something as ordinary as an old cigar butt. Usually the crumbling tobacco, the ashes

3. *Ibid.,* p. 154, n 1.
4. *Ibid.,* p. 164.
5. *Ibid.*
6. *Ibid.,* p. 161.

scattered next to the ash tray, the stale odor are only slightly nauseating reminders of the night before—we get the dust pan and clean up. But even such trivial objects have an aesthetic significance which reveals itself once their ordinary meaning has been bracketed, and the more successful we are in doing so, the more this appeal will gain in strength.

Such freedom from conventional ways of seeing and representing things attracted Kandinsky to primitive and folk art, to the art of amateurs, and especially to the art of children, where the practical point of view has not yet restricted vision and artistic training has not yet taught the child what it means to draw something correctly. "In every child's drawing the inner sound of the object reveals itself, without exception." [7] Children create with the "inner necessity" that the work of grownups generally lacks. They are the original artists, who should teach grownups rather than be taught by them.

But "for every young talent an academy. These are no tragic words but a sad fact. The academy is the most certain way of erasing the described power of the child." [8] "Academy" refers here not so much to some institution as to anyone, perhaps a parent or teacher, who tries to help the child to "draw correctly": "'This man cannot walk because he has only one leg.' 'On your chair one cannot sit since it is tilted.' The child laughs at itself. But he should cry." [9]

Kandinsky idealized childhood, just as Read has idealized the unconscious. It furnished him with an ideal which the artist seeks to recover. This ideal would remain even if there never had been children like those envisioned by Kandinsky. It would therefore be pointless to attack Kandinsky by challenging his descriptions of childhood and the art of children as if they were assertions of fact.

We are no longer children and have to be taught to see as children do. Abstraction offers the artist one way of getting others to look, to step out of their attitude of familiarity and confront what is before them once more in wonder. As long as an artist paints landscapes or portraits the danger is always that, instead of looking, someone will say, "Just like our summer place in Maine," or "What a terrible thing to do to that poor woman— Grandmother never looked like that." The picture is looked at not

7. *Ibid.*, p. 168.
8. *Ibid.*, p. 169.
9. *Ibid.*, p. 168.

for what it is, but for what it is not. A set of expectations places itself before the work of art. Instead of listening to what it has to say, the spectator is concerned with something that lies outside it. If he clings to this concern, he cannot but reduce the work in question to a mere occasion, e.g., to evoke a memory; but this memory stands in the way of the work of art. What matters is not what the painting represents, but what it presents. Art does not need the crutch of representation. On the contrary, representation tends to cast the observer back into a world with which he is already too familiar. The veil of familiarity continues to hide reality.

Of course the observer may try to bracket concerns which sidetrack him. Thus he can try to look at a painting like Manet's *Olympia* as if it were an abstract painting; but in so doing he lets another preconception come between himself and the work of art. After all, *Olympia* is not an abstract work of art. In looking at the painting as if it were, we fail to do justice to it. The painting loses an important dimension. If *Olympia* really were to be looked at in this way, Manet would have been better off to choose a less suggestive theme or to abandon representational elements altogether. The abstract work of art does have an advantage in that it is more obviously a sensuous presentation that has its end within itself. This the insistence on representation has tended to disguise. The movement towards abstraction is in part due to a conviction that as little as possible should be permitted to come between the spectator and the work of art. Abstract art opens our eyes and lets us see. It teaches us to let the work of art show itself to us as it is. By reducing the representational element to a minimum, the revelatory power of art is raised to a maximum.[10] But for Kandinsky the path towards abstraction is not the only one which the modern artist can follow. Instead of turning to abstraction the artist can attempt to let the things speak for themselves. The result is a new realism.

In Henri Rousseau Kandinsky discovered his antipode, the childlike father of a "new great realism" that would complement the "great abstraction" he himself was aiming at. What makes Rousseau extraordinary is that in so many of his paintings—his jungle scenes are least interesting from this point of view—we are confronted with the ordinary, but in such a way that we are led to forget that it is ordinary. As Canaday puts it:

10. *Ibid.*, p. 155.

> The unreality of Rousseau is a paradoxical combination of fantasy and factualness; the painter offers each object in his street scenes and country landscapes with unquestioning acceptance of their perfect ordinariness, yet not one of the objects is ordinary after he paints them. The human figures are so isolated and so immobile, the trees are so neatly patterned and their foliage is so meticulously rigid and delicate, the streets, houses, walls are so pristine, yet so familiar as elements of daily life—everything, in short, is so commonplace and yet so uncommonly revealed, that reality and unreality reach perfect fusion and one is indistinguishable from the other. We cannot say that Rousseau shows us a new world, for we have seen all these things many times; yet we cannot say, either, that this is a world we know, for these things exist in new relationships and even in new shapes. It becomes a world of dream, whose reality the dreamer accepts without question, and whose fantasy he recognizes only upon awakening.[11]

The ordinary becomes extraordinary, the familiar unfamiliar. The primitivism of Rousseau, regardless of whether it is due to naïveté or a consciously adopted method, is an alienating device: objects appear sharply delineated as if cut out of metal; Rousseau's rigid forms and lifeless colors add to this sense of strangeness. Everyday reality becomes like a dream, and yet it is still that same reality, suggesting perhaps that it is only his too intimate engagement in the world which prevents man from seeing the dreamlike quality of life. The new realism of which Kandinsky is thinking moves everyday reality into the neighborhood of the dream, but this movement is interpreted not as a movement away from reality but towards it. Reality becomes like a dream precisely when our ordinary ways of dealing with it are bracketed. Only such a bracketing furnishes the distance necessary if man is really to look at what is before him.

Sometimes particular situations invite us to abandon our normal ways of seeing the world—as when unusual atmospheric conditions let us see something familiar as if it were for the first time, e.g., in fog, or in the late afternoon sun, or when the usual relationship between sky and earth is reversed and the sky is darker than the land beneath. Chirico interprets his *pittura metafisica* as an attempt to evoke the poetry of such moments:

> I spent some cold winter day in the court yard of Versailles. Everything was quiet and silent. Everything cast its strange and

11. *Mainstreams of Modern Art*, (New York, 1959), p. 391.

questioning glance on me. Then I saw that every corner of the palace, every column, every window, had a soul which was a riddle. I saw the heroes of stone surrounding me, immovable beneath the clear sky, beneath the cold rays of the winter sun which shed light *without love* like the deepest songs. A bird sang in a cage hung into a window. Then I felt the mystery which drives people to create certain things. . . .

The truly new thing, which Nietzsche discovered, is a strange and profound, infinitely mysterious and lonely poetry, which depends on the mood of an autumn afternoon, when the atmosphere is clear and the shadows longer than in the summer.[12]

[2]

THIS CALL for a realistic art can also be derived from Schopenhauer's definition of art as "the *way of viewing things independent of the principle of sufficient reason,* in opposition to the way of viewing them which proceeds in accordance with that principle, and which is the method of experience and of science." [13] Similarly Chirico distinguished between the usual and the "spiritual or metaphysical" aspect of the thing which is recognized only in "moments of clairvoyance and metaphysical abstraction," [14] while Kandinsky opposed the "inner sound" of the thing to its contextual, everyday meaning. Ordinarily man looks at the world in terms of the projects in which he is engaged. His understanding of the world is part of an attempt to master his environment; knowledge stands in the service of the will to live. But it is just this self-centered nature of knowledge that prevents man from confronting things as they really are. To do so, knowledge would have to become disinterested.

Now, as this requires that a man should entirely forget himself and the relations in which he stands, *genius* is simply the completest *objectivity, i.e.,* the objective tendency of the mind, as opposed to the subjective, which is directed to one's own self—in other words, to the will. Thus genius is the faculty of continuing in the state of pure perception, of losing oneself in perception, and of enlisting in this service the knowledge which originally existed

12. Walter Hess, *Dokumente zum Verständnis der modernen Malerei* (Hamburg, 1956), p. 111–12.
13. *The World as Will and Idea,* trans. R. E. Haldane and J. Kemp (Garden City, 1961), p. 198.
14. Hess, *Dokumente,* p. 111.

only for the service of the will; that is to say, genius is the power of leaving one's own interests, wishes, and aims entirely out of sight, thus of entirely renouncing one's own personality for a time, so as to remain *pure knowing subject,* clear vision of the world.[15]

The man of genius lets the world reveal itself. Art is revelation of the essential nature of a thing. Ordinarily we are too interested in the world, too busy asking it questions, to listen to it. "While to the ordinary man his faculty of knowledge is a lamp to lighten his path, to the man of genius it is the sun which reveals the world." [16]

Schopenhauer found such objectivity in the works of "those admirable Dutch artists who directed this purely objective perception to the most insignificant objects, and established a lasting monument of their objectivity and spiritual peace." [17] Such art, regardless of whether it depicts a bowl of fruit, or a landscape, or the face of an old man, is fundamentally portraiture. It presupposes respect for the portrayed and is born out of a willingness to let the portrayed be what it is. This stress on objectivity and the discovery of the aesthetic significance of the insignificant are equally characteristic of Kandinsky's new realism. Kandinsky, however, would have insisted that purposes and preconceptions are so much a part of what we take to be reality that its literal representation cannot free us from them. Most of us find it rather difficult to get terribly excited about Dutch still lifes. They offer "no new food," as Kandinsky said of beauty which had become expected and accepted. Perhaps photography is partly to blame for this. It has led us to take more or less literal representations for granted.

Schopenhauer sees the appeal of such realistic art in the fact that it delivers us from the root of all dissatisfactions, the individual will. It has its foundation in a project of escape. The goal of this project is "the deliverance of knowledge from the service of the will, the forgetting of self as an individual, and the raising of the consciousness to the pure will-less, timeless, subject of knowledge, independent of all relations." [18] The pure, merely contemplating subject does not desire, does not demand. As complete objectivity is achieved, there are no longer any particular interests which tie man to the world. Man loses himself in the

15. Schopenhauer, *The World as Will and Idea,* p. 199.
16. *Ibid.,* p. 201.
17. *Ibid.,* p. 210.
18. *Ibid.,* p. 212.

contemplation of the aesthetic object. At this point it is no longer accurate to speak of an object standing over against the subject as something other. Otherness is no longer constitutive of the experience. "The subject and object reciprocally fill and penetrate each other completely; and in the same way the knowing and known individuals, as things in themselves, are not to be distinguished." [19] An extreme emphasis on objectivity delivers the individual from the subject-object polarity in which the absurd has its foundation. No question has been answered; but no question remains.

In our day Heidegger has provided a philosophy which seems to call for something like Kandinsky's new realism. Schopenhauer's demand that the artist liberate himself from the principle of sufficient reason has found an echo in Heidegger's demand that the poet liberate himself from the tyranny of grammar. [20] Just as the principle of sufficient reason conceals what a thing really is by placing it into an interpretative framework that is incapable of doing justice to the individual in its individuality, so Heidegger sees grammar as concealing the revealing power of the word. Grammar should not be understood here in a technical sense; it simply refers to the context in which a word operates. Thus when the meaning of a word is identified with its use, we give in this sense a "grammatical" definition. The word is placed in the context of a particular language game. These games, in turn, will express the different projects in which man is engaged. This observation can be extended to apply to the things which surround us. Their usual meaning, too, is given by the projects that occupy us. But useful as such an approach may be, it also conceals what individual words or things really are. Meaning cannot be reduced to use. Thus by listening to others, a blind man could to some extent learn to use color words correctly; for him, too, roses would in some sense be red, the sky blue, grass green. But in using words in this way he would merely be repeating what he has heard others say; he would not be describing the situation in which he finds himself. The words he uses do not reveal that situation to him. Meaning as use has to be complemented with meaning as revelation. The latter meaning, according to Heidegger, is the concern of the poet or artist.

Schopenhauer and Heidegger ask for an emancipation from

19. *Ibid.*, pp. 193–94.
20. Cf. my "Heidegger and Hölderlin: The Limits of Language," *The Personalist*, XLIV, no. 1 (Winter 1963), pp. 5–23.

the contextual approach because it prevents the things around us from revealing themselves to us. This demand conflicts with the demand that man learn to master the world and that he deal with it as efficiently as possible. To do so he cannot give individual things their due. If it were not for the many conventions which enable us to deal with things superficially, and ordinary language is perhaps the most important of these, we would be paralyzed by the world. It would be impossible to do something so apparently simple as reading a newspaper. If the newspaper were really to reveal what it describes, we would recoil—horror-struck—from the first page. What enables us to pass lightly over another crisis in the Near or Far East, another airplane accident, another murder, is that the words stand between us and what we read about. They have lost their revelatory power. What they speak of is not really made present. Linguistic conventions thus protect us from the world. Man demands clichés to spare himself the shock of having to face reality. They enable him to take what is said for granted.

The same is true of artistic conventions. They, too, can protect us from what is portrayed. Some examples of this were discussed in the chapter on Kitsch. Advertising art offers others. The purpose of such art would seem to demand that there be little distance between the advertisement and the spectator—after all, usually the spectator is to be taken in; an advertisement that would invite the spectator to assume a distanced attitude would fail in this purpose. The spectator would look instead of being sold the product. I strongly suspect that all artistic advertising, and it is not difficult to find examples, fails as advertising and can be indulged in only by those who do not have to sell their products, unless the advertised product is itself a work of art or some other object of marked aesthetic value.

One should, however, keep in mind that the conventional can be revealed as the conventional; in this way an artistic effect can be obtained by a conscious manipulation of clichés. Thus when Roy Lichtenstein magnifies a comic strip drawing to immense proportions, this displacement prevents us from assuming our ordinary attitude to it. We are forced to step back and look at the cliché before us. But a cliché functions as cliché only as long as it lulls the spectator into taking for granted what is presented. In recognizing a cliché for what it is we are already beyond it. Pop art has thus a therapeutic value, although this is hardly its most significant aspect.

What Heidegger has in mind when he demands the emanci-
pation of the word from grammar is, however, something rather
different. Literally understood such a demand makes little sense.
The word cannot function apart from some linguistic context.
The poet must use a vocabulary that the audience understands.
The same is true of any other artist. He cannot but begin, if he is
to communicate at all, with a "language" which is not private to
him, but belongs to all—and which is more or less taken for
granted. Our everyday understanding of the world presupposes
such a language. Here the artist must start. But if he is to
succeed he must use this same language in such a way that it
can no longer be taken for granted. The familiar must be trans-
formed into the unfamiliar.

This view of poetry can be extended to the other arts. Just as
a poet can use language in such a way that the word is liberated
from the tyranny of grammar, the artist can try to liberate things
from the tyranny of the contexts into which they are placed by
our everyday understanding. Duchamp pointed the way towards
such emancipation when he presented a bottle dryer or a urinal
as works of art. The least that can be said for such "creations" is
that they are interesting. But their significance is not exhausted
by this, although interest may very well have been what was
foremost in Duchamp's mind. To present such objects as works
of art is to displace them. They are presented out of context. And
this very displacement frees us for an encounter with the object
as this particular form. As long as the shock of seeing the object
out of context lasts, this aspect of the experience will remain
submerged; and the more shocked we are, the less likely it is to
appear. For this reason the bottle dryer is more successful than
the urinal, given the project of a new realism, while the reverse
is true, given the project of the interesting. The interesting pre-
supposes an awareness of the context in which the object nor-
mally appears, even as it denies this context and disappoints the
expectations connected with it. The new realism, on the other
hand, would like to have us forget this context; such a forgetting
destroys the interesting. Only as we get over our shock, as we
cease to find the object before us interesting, can the "inner
sound" of the object be heard.

In various ways such recent developments as pop art or "com-
mon object painting" have taken up this possibility of moving
from Duchamp in the direction of a new realism. At the center of
these efforts we find a concern to liberate the individual things,

to destroy the contexts in which they normally appear. The simplest way of doing this is to take, as Andy Warhol has done, as trivial an object as a can of Campbell's soup and to offer and sell it as art. But to think the object trivial is already to suggest that such attempts are interesting. From the point of view of the new realism, whether the object is trivial or not should make no difference. For what makes something trivial or non-trivial is precisely the meaning with which we endow it. As long as this distinction is made, we have not achieved the desired objectivity. The new realist when asked, "Why did you choose this object?" should always answer something like: "I found it lying around; I had no particular reason."

But have we not arrived here at a modern counterpart of those Dutch still lifes Schopenhauer liked, and must not some of the objections that were raised against them be repeated here? In the Dutch paintings, too, we find a re-presentation of everyday things. But is mere re-presentation a strong enough device to free us from our normal involvement with them? When we are offered a coke bottle or a can of soup as art we are likely to be amused; some of us may be affronted. In either case there is interest. But this does not last very long. Soon the supposed work of art is once more just a can of soup or a coke bottle. And what counts then is the content.

There are more subtle ways of breaking the tyranny of everyday understanding. The artist can take some very ordinary object and challenge its usual meaning by introducing it into a painting or some other composition in which it has to play quite another part. For example, we can introduce a pin-up picture into a painting in such a way that it functions as part of the formal composition while yet retaining its character as a pin-up—a coke bottle, an old sock, or a worn tire would do as well. The object now possesses two roles, two meanings; these two meanings modify one another; each prevents the other from realizing itself. An oscillation between these two levels of meaning results which threatens to disrupt the work of art. The object that from one point of view is integrated into the painting seems to fall out of it and threatens to destroy it when we look at it from another point of view. It seems to rebel against the artist and the role which he has assigned to it. This rebellion is intended; thus Robert Rauschenberg once said that he did not like to use objects in his combine paintings which could not defend themselves. The artist engages the object in a struggle that does not aim at

its subjection; rather the struggle is to end in a stalemate. As the two levels of meaning neutralize each other, a third level emerges. The object no longer speaks to us as it usually does; nor does it lose its identity by becoming just a part of the work of art. It speaks, but not with its everyday voice. The "pure inner sound" of things is heard: the epiphany of the everyday.[21]

21. Jürgen Claus, *Kunst heute* (Hamburg, 1965), pp. 185 ff. In his discussion of Robert Rauschenberg, Claus speaks of "the epiphany of objects." The idea is borrowed from Walter Höllerer and ultimately derives from James Joyce.

13 / Realism and Kitsch

DOES KANDINSKY'S new realism deserve its name? Can we call an art realistic that so obviously denies our ordinary understanding of what is real and presents us instead with its magically transformed image? To call this "realism" may seem to give the term such broad meaning as to make it almost empty. Does not realism, properly understood, rule out such transformation? The realist, one could argue, must take the world at its face value; refusing the temptation to idealize, he must accept what he observes for what it is; realism requires truth to nature. In this sense Courbet, Eakins, and Leibl are sometimes considered realists. One thinks of photography as the measure of all realism. On the other hand, it is quite possible to give a rather faithful description of reality without revealing it in any way. Examples of this were discussed in the chapter on Kitsch. Is Bouguereau a realist? He seems to have considered himself one. Or Waldmüller? It would be difficult to deny that there are few painters who painted goats as accurately.

But literal representation can stand in the way of revelation. This is the presupposition of Kandinsky's new realism. Realism here refers to an art which does not simply copy reality but reveals it, and since we are so involved in the world as to lack the distance required to really see it, it is necessary to transform it. Given our ordinary understanding of what is real, such transformation must be judged a departure from reality.

What then is realism in art? There is no easy answer. At first one is tempted to call that art realistic which gives us a faithful

description of what as a matter of fact is seen. But is this not itself governed by a project? In what sense do a child, a peasant, and an artist looking at the same apple tree see the same thing? More importantly, in giving such a definition we should not forget the nature of art. Like any artistic program realism, too, must have its foundation in the artist's project to be himself. There is no realism free from idealization. Given different ideals, we should expect different answers to the question of what constitutes realism. One artist may carefully portray lush forest glades and lonely moors and consider himself a realist. Another artist might charge him with refusing to face up to reality and feel that he would do better to turn to some ash cans behind a delapidated tenement house. The landscape painter who is criticized in this manner could retort by suggesting that realism, when tempered by a social commitment which finds expression either in a condemnation of existing conditions—Goya, Daumier, and Kollwitz come to mind—or offers an ideologically transfigured vision of reality, hardly deserves its name. Does not the vision of the good life interfere, making it impossible for the "social realist" to present things as they really are?

Similar objections can be raised against anything which passes for realism in art. Usually it is not too difficult to point out the underlying project that determines what the artist chooses to look at and how he represents it. "Reality" is not so much a descriptive as an honorific term. When an artist proclaims himself to be a "realist," he understands by "reality" something which cannot be divorced from the project in which he is engaged. Corresponding to the variety of projects, we can expect a variety of realisms.

Nonsense, one may object. Is it up to the individual to choose his reality? Are the facts not simply there? But this is not the issue. Whether there is indeed a simple given or whether whatever confronts man bears the stamp of the project in terms of which it is interpreted matters little in this context. It is sufficient to point out that when we speak of realism in art we presuppose that reality is something in which the artist is interested; meaning must be taken as constitutive of reality. In this context reality cannot be identified with a neutral given. Otherwise it would make no sense to make realism into an artistic program. This is evident when Gottfried Benn writes that "there was no style in Europe between 1910 and 1925 other than the anti-naturalistic style, for there was also no reality, only its

caricature." [1] When the artist doubts the reality of the world, he is not questioning the fact that this world is present to him; there are no scientific experiments which can allay or confirm such doubt, no facts which could prove him wrong. To doubt the reality of the world is to doubt that it has a claim on man, to feel that the situation in which man finds himself is indifferent to his demands for meaning. The recognition of the absurdity of man's situation is necessarily coupled with a loss of the sense of reality. Such recognition makes man a stranger and the world unreal.

To compensate for this loss of reality, man will look for reality elsewhere. Thus he can turn to his "inner reality" or he can seek reality behind mere appearances; in either case what is ordinarily understood to be real is bracketed. This is also true of Kandinsky's new realism. If we refuse to surrender our familiar point of view, such art, far from being judged realistic, must be judged to have transformed reality into dream. Yet from another point of view this transformation may be said to have opened man's eyes to reality.

Which point of view is the correct one? A question such as this can be answered only if one is in possession of an adequate understanding of what matters. As long as this is lacking we must be content with the more modest observation that while modern art may be described by some of its supporters and creators as authentic realism, it nevertheless cannot be denied that it treats what is ordinarily taken to be real as something to be overcome, for in this so-called "reality" the absurd has its foundation. In this sense modern art, including the new realism, can be described as an anti-realistic art of escape.

Such descriptions of modern art are by now rather familiar and usually imply a negative judgment. They suggest that modern art, in spite of what its creators may proclaim, has lost touch with reality—the question of what reality is usually either is not raised or the answer conveniently is taken for granted. Thus for a Marxist like Georg Lukács the distortions of modern art follow from that alienation of man from himself and reality which is a product of modern society.[2] They have their root in the artist's unwillingness to accept the distortion of man caused by bourgeois society. In his rejection of what that society calls reality, the modern artist is justified. But his response to this situation

1. *Essays* (Wiesbaden, 1958), I, 277.
2. "Grösse und Verfall des Expressionismus," *Schicksalswende, Beiträge zu einer neuen deutschen Ideologie* (Berlin, 1948).

has led him in the wrong direction. Instead of becoming a social critic and a servant of progress, the artist has become introverted. He has forsaken the reality of the social situation for his own inner reality until all sense of objectivity has been lost. Today this illness has progressed to a point where even the desire for health and normality has disappeared and abnormality is made the measure of art. That this response is not necessary is shown by Goya and Daumier, in whom Lukács professes to find an understanding of the distorting power of society. By presenting diseased society in its diseased state these artists point towards a state of health. That an examination, especially of Goya's paintings, does not always bear out such an interpretation need not affect the theory. But we must recognize that Lukács' criticism of modern art makes sense only if we grant him the fact that he possesses an adequate understanding of what constitutes health. If we were convinced of this, we could join Lukács in raising the banner of social realism and demanding of the artist that he place himself and his art at the service of the progress of mankind. But is Lukács in possession of an image of man which is exempt from doubt? If so, modern art must be rejected, for its premise is that man is a being in search of himself, that man is not sure of himself but is puzzled about his vocation. This rules out that security which derives from a belief that man has an adequate grasp of what he is. The commitment to an ideology which furnishes its followers with a definite account of the essence of man is incompatible with modern art.

Like Lukács, Hans Sedlmayr, in his notorious *Der Verlust der Mitte*, criticizes modern art for failing to do justice to the essence of man. Sedlmayr's understanding of man, however, is determined not by Marxist thought but by the Christian tradition.[3] Still, there are considerable areas of agreement. Sedlmayr, too, deplores the dehumanization and derealization of modern art. Instead of seeking the origins of this deviation in the social situation, he looks for a theological explanation. Modern art, Sedlmayr suggests, can be understood only in terms of the disintegration of the relationship between man and God. Crises in man's relationship to himself, to others, and to nature are the consequences. I have great sympathy with Sedlmayr's interpretations—the present study owes them a great deal. But must one follow Sedlmayr to his negative evaluation of modern art? Like

3. *Der Verlust der Mitte* (Frankfurt a.M., 1959).

that of Lukács, Sedlmayr's rejection of modern art presupposes that the critic is in possession of an adequate conception of man. This makes it possible to interpret modern art as the fruit of sin—man's free decision to turn away from God in whose image he was created. The death of God is for Sedlmayr not so much a fate as willed self-deception. Pride is the mother of modern art.[4]

But is it still possible today to take man for granted? Do we still have a conception of what constitutes health adequate enough to make it possible to diagnose the sickness which finds expression in modern art, as Lukács and Sedlmayr do? Do we even have the right to speak of sickness at all? I agree with Sedlmayr that the distinctive character of modern art cannot be understood apart from the collapse of the *imago Dei* conception. But the movement away from that conception is not rooted in human perversity, nor are its origins ultimately to be discovered in the development of modern science, technology, and capitalism. One may not forget that the rise of modern subjectivism, from which the disintegration of the traditional conception of God cannot be divorced, antedates these developments. Whether one deplores it as a source of sickness or applauds it as a great awakening, in either case it is difficult to maintain that this subjectivism is something which man himself has chosen. The high degree of self-consciousness which characterizes modern man is his fate rather than his choice; the same is true of the crisis in which he finds himself. This makes it impossible to criticize man for his deviation from what is supposed to be reality.

It is not necessary to deplore this lack of a clear answer to such questions as "what is reality?" or "what is man?" On the contrary, this lack of clarity is a condition of freedom. If man could have no doubts regarding his essence, his projects would be dictated to him by what he is. To be free is to be capable of determining, at least to some extent, what one is to be. Where man insists that he be given an essence, freedom is easily short-changed. If man is fundamentally a being in search of himself, all programs must be rejected which cut short this search by suggesting that man is in possession of a definitive answer and that further questioning is unnecessary. The seductive power of this view derives from its promise of a security that is denied to

4. *Ibid.*, chaps. 12, 13.

man by his freedom; the price exacted for this security is this freedom. Such is the appeal of Kitsch. Here, it seems to me, lies the greatest danger confronting modern art, and its critics, such as Lukács and Sedlmayr, should take care lest they prepare the way for the ultimate triumph of Kitsch.

[2]

LIKE OTHER FORMS of modern art, Kitsch presupposes the rise of subjectivism and the disintegration of the traditional value system that threatens to transform the world into a collection of mute objects.[5] But instead of making an attempt to deal with this danger, Kitsch refuses to recognize its presence, disguising it by absolutizing splinters of the old value system or by erecting new idols in the place of the hidden or dead God. Finding no real values man is content with substitutes. The project of Kitsch is one of self-deception. The more total the sway of Kitsch, the more vehemently those under its domination will deny this and insist on the genuineness of their emotions; for to recognize oneself as subject to Kitsch is to be already beyond it. The distance gained by such recognition destroys the immediacy demanded by Kitsch and the satisfactions granted by it become hollow. To combat such an unmasking, the devotees of Kitsch are likely to insist that theirs is the true realism. They alone present reality as it really is; they alone know what matters. Unlike most modern art, which betrays the precariousness of its project, Kitsch seems to be sure of itself. Kitsch pretends to be in possession of an adequate image of man. Most modern art is too self-conscious to be that confident; the artist is at a distance from his project. This gives him freedom with respect to that project. This distance is lacking in Kitsch. Kitsch denies freedom; its project is essentially that of an escape from freedom, but this project is not acknowledged. Thus Kitsch is by its very nature in bad faith.

The art of Hitler's Germany was perhaps the best example of an art completely committed to Kitsch and at the same time vehement in proclaiming that it gave sensuous expression to the

5. Hermann Broch, "Das Böse im Wertsystem der Kunst," *Essays,* (Zurich, 1955), I, 311–50.

ideal. The language which was used to defend the artistic pro-
ductions of the Third Reich is reminiscent of the Platonic tradi-
tion: "As long as a people exists, it is a fixed point in the flux of
appearances. It is what truly is and endures. Art is the expres-
sion of this being. It, too, is therefore something which truly is
and endures." [6] This utterance by Hitler falls into the schema
provided by traditional aesthetics, which interprets art as the
sensuous presentation of the ideal. If we put "people" in the
place of "ideal," we obtain Hitler's definition. According to this
view, too, art brings about the epiphany of the truly real. What
distinguishes Hitler's definition from others we have considered
and at the same time points to a fundamental characteristic of
Kitsch is the identification of reality with the people. Hitler still
speaks the language of the Platonic tradition when he opposes
the flux of appearances to true being. But to identify this being
with the pseudo-biological conception of race or people is to put
the finite in the place of the transcendent. This shift is not
acknowledged. Rather it is veiled by using a language which
speaks of the finite as if it were the transcendent. The finite and
the transcendent are collapsed, thrown together in a muddle of
words and thoughts which speak now prophetically, now with
the voice of science. The golden calf is put in the place of God.
The millennium is sought on earth and made subject to quasi-
scientific speculation.

This transformation of the transcendent into the finite has
one immediate advantage. Whereas the nature of transcendence
implies that it is more or less concealed from us, the ideal can
now be exhibited in the world. This makes it possible to be
dogmatic and to revive the academic spirit. The artist becomes
an artisan who receives his orders from the ministry of propa-
ganda, which furnishes him with a readily recognized and easily
imitated image of man:

> The Führer demands that the artist abandon his isolation; that he
> address himself in straightforward manner to the people; this
> must be apparent in the selection of a theme which must be both
> popular and easily understood, and which must be important
> within the heroic ideal of national socialism; it must express itself
> in a commitment to the ideal of beauty of the pure Nordic man;

6. Adolf Hitler, in a speech made at the opening of the *Grosse
Deutsche Kunstausstellung,* reprinted in *Die Kunst im Dritten Reich*
(Munich, July–August, 1937), p. 52.

and it must express especially the will and ability of the artist to speak in a correct and understandable manner.[7]

The traditional commitment to a transcendent ideal, which by its very nature cannot be anything but vague, gives way to the commitment to the heroic ideal of the party and the ideal beauty of Nordic man.

It should be evident that it is in no way necessary to confine Kitsch to this particular manifestation. The Nordic ideal, compounded of Siegfried and Gretchen, can give way to the proletarian ideal of the worker or the bourgeois dream. These, too, have produced Kitsch in profusion. Indeed, wherever the merely finite is put in the place of the transcendent, we will find Kitsch and its pseudo-transcendences. The mixtures of forest scents and sex or of sex and religious titillation, both so popular today, belong here as much as the taste of blood and soil which Hitler preferred.

The transformation of the ideal into something finite not only makes it possible to give definite content to what is demanded of the artist but makes dogmatism imperative. For the very fact that the ideal is made finite precludes the possibility of an adequate defense. There is no reasonable answer to the question why Nordic man should represent the apex of creation. An answer is in principle ruled out, as the questioning subject necessarily transcends the merely finite. Man can find meaning only in a reality which transcends his being. Unable to provide the latter, Kitsch insists on a dogmatic refusal to reason. Given this project, Hitler is only consistent when he makes dogmatism part of art. "Art," he insists, "is a sublime mission, demanding fanaticism." [8]

The products of this particular fanaticism have disappeared from the museums; Thorak and Breker, Ziegler and Eber no longer interest us. But Kitsch itself is a hardier plant. The precariousness of the human situation faces man with a perennial temptation to seek refuge in a pseudo-ideal which may be based on an illusion, but which has the advantage of assigning to man a definite place. Man's project to be himself gives way to a project not to have to be himself but to be told who he is. The transcendence which gives direction to the authentic project gives way to the pseudo-transcendence of the inauthentic proj-

7. Hans Kiener, in a speech made at the opening of the *Grosse Deutsche Kunstausstellung*, reprinted in *Die Kunst im Dritten Reich*, p. 19.
8. *Die Kunst im Dritten Reich*, p. 52.

ect. This pseudo-transcendence prevents man from seeing things as they really are. Kitsch may take pride in its realism, in the fact that it is popular and readily understood, that it does justice to what we commonly understand reality to be, but reality is constituted here by an inauthentic project that refuses to let man be himself. Art is pressed into the service of a pseudo-ideal. The world is transformed in the image of that ideal. Reality is slightly prettified, in this particular case slightly Nordified—where other words can be substituted to fit other illusions.

14 / Conclusion:

Beyond Modern Art

[1]

MODERN ART HAS ITS ORIGIN in the disintegration of the traditional order of values which once assigned to man his proper place; knowing this place, man knew what to do. With the death of God this order has lost both founder and foundation. It still remains and offers a semblance of shelter and security, but only to those who refuse to recognize that it has become a ruin. The death of God leaves man displaced and without a sense of direction. In a godless world, as Nietzsche pointed out, everything seems to be allowed and by the same token everything threatens to become meaningless.

Yet even the nihilist continues to demand meaning, and this demand makes it impossible for him to accept the absurdity of his situation. Man cannot live with the absurd but must struggle against it, and if the absurd has its foundation in the situation of modern man, this struggle will lead him to deny himself. Modern art is part of this effort.

But why posit absurdity as something to be overcome? Does this not presuppose an awareness of meaning? By itself absurdity cannot impel to action. If the absurd really were to triumph over all meaning, only apathy would remain. The choice to escape from the absurd would itself be pointless were it not felt to be a choice of something more meaningful. It is therefore necessary to give a positive interpretation to the flight from the absurd. Modern art thus appears either as an attempt to restore to man lost immediacy or as a search for absolute freedom. In

either case man has given up his attempts to discover meaning in the world of objects; if there is to be meaning it must have its foundation in something beyond that world. But it is no longer possible to give definite content to this transcendence.

Both projects are open to doubt and criticism. While they do justice to the fact that man cannot find meaning in a world of mere objects, they fail to provide a real alternative to the absurd. Thus the notion of being is too indefinite to give meaning to man and his projects, especially art. There is still a vague sense of significance, but there is no way of passing on to something more definite. The mysterious call of being is difficult to distinguish from silence. A defender of the meaning of being could reply with Schopenhauer that, given our ordinary understanding of meaning, being is indeed a meaningless nothingness and the return to the origin indistinguishable from self-destruction.

> We freely acknowledge that what remains after the entire abolition of the will is for all those who are still full of will certainly nothing; but, conversely, to those in whom the will has turned and has denied itself, this our world, which is so real, with all its suns and milky ways—is nothing.[1]

As Franz Marc put it: "There is only one blessing and redemption: death, the destruction of the form which liberates the soul. . . . Death leads us back into normal being." [2] One thinks of Plato's *Phaedo*, of Socrates cheerfully taking leave of his friends. But this Platonic-Christian hope for immortality and an existence beyond this life has lost its foundation. Can we still believe that death is the gate to "normal being"? Marc's hope cannot be justified; it remains as a last inheritance from a faith which he no longer shares. In the twilight of traditional faith, being, understood as the ground of man's being in the world, assumes a shadowy resemblance to the lost God. Only this makes its idealization possible. But this resemblance is deceptive. To speak of God is to speak of a transcendence that is not only the ground of man's existence but the measure of man. Knowing God, man knows his place in the world and what is asked of him. To put being in the place of God is to say that man has no measure. Unmediated being casts no light on the situation of man; its

1. *The World as Will and Idea*, trans. R. E. Haldane and J. Kemp (Garden City, 1961), p. 421.
2. *Briefe aus dem Felde* (Berlin, 1959), pp. 81, 147.

opaque transcendence yields no meaning. The sense of the numinous turns to nausea and boredom.

The attempt to escape from the absurd by giving meaning a new foundation in man's freedom is hardly more successful. It, too, borrows from the Christian tradition, even as it turns against it. Is it possible to put freedom in the place of God? Man cannot choose to create meanings *ex nihilo;* the consciousness of having done so is sufficient to render such meanings void. This the worshipper of freedom refuses to admit. Instead he insists on the possibility of a humanism which can dispense with a positive notion of transcendence and leave the place which God occupied empty. Yet freedom sheds no more light on man's situation than unmediated being. The faith in freedom becomes a superstition when freedom is made absolute.

To the extent that modern art can be interpreted in terms of this project to escape from the absurd by putting freedom or being in the place of the Christian God, it must share in the inadequacy of this project. Modern art, too, presupposes the Christian tradition, and although it often rebels against what remains of the old value system, it still lives off it. So far it has lacked the strength to offer a real alternative. This is suggested by the fact that the more successful it has been in emancipating itself from the tradition, the emptier it has become. For some time now modern art has been approaching a limit where it must either become something entirely different or cease to be altogether. The silent "white" art of Malevich or the ready-mades of Duchamp point toward this limit; to offer an empty canvas as a work of art is to have reached it. Such an empty piece of canvas can still be interpreted as a work of art which reveals man's freedom to him; one could even argue that it does so to a greater extent than all preceding art—just because it leaves everything unsaid it leaves the spectator completely free. To put just one line or one speck of color on the canvas is to rule out certain possibilities and thus to abridge the openness that is necessary if the spectator is to remain completely free. For fear of limiting freedom the artist chooses to say nothing at all. A similar extreme is reached by the artist who picks some object at random and offers it as a work of art. By "choosing" it not for its shape or texture, not for its significance or lack of it, not ironically or to disappoint expectations, but for no reason at all, the artist invites the spectator to look at the object simply as something which is. Just because *what* the object is has become a matter of

indifference, the object can reveal *that* it is. Such a "work of art" says no more than the empty canvas; both are opaque and meaningless. They mark the limit where modern art becomes silence. Once modern artists have approached and recognized this limit, modern art, at least in the sense in which it has been understood here, must come to an end if it is not to become even less than mere boring repetition. But what will take its place?

[2]

IF, AS NIETZSCHE PROPHESIED—and in the light of what has happened since he does not seem to have been too bad a prophet—what awaits us is the rise of nihilism, one can hazard the parallel prediction that what awaits us in art is the triumph of Kitsch. If the truth is that there is no transcendent meaning, man will live without the truth. Man demands to be given a meaning, and if this should be incompatible with his real situation, he will deceive himself. If honesty must lead to nihilism, man will be dishonest. The will to live is stronger than the will to the truth. In the place of the missing ideal man will erect a pseudo-ideal and hide from himself that it has no foundation. The world has not plunged into despair over the rise of nihilism, nor will it do so now. Rather nihilism will give birth to and be defeated by Kitsch as man seeks refuge in bad faith.

But why speak of bad faith? Why use a term which suggests disapproval? Why is bad faith bad? If the will to the truth only leads man to recognize the absurdity of his situation, there is no reason why he should be honest. Is the demand for honesty not itself part of the Platonic-Christian tradition which has finally shown its bankruptcy? The commitment to the truth makes sense only if we believe that human existence has a meaning which reason can reveal. But is this optimism justified? Modern man has become so reasonable that he demands that his trust in reason be justified, and the suspicion grows that such justification may not be forthcoming. But if there is no transcendent measure of man and the belief in such a measure but a Platonic superstition, how is it possible to oppose Kitsch to a more honest art? That most of us still do so must be admitted. But are we justified in drawing this distinction, or do we do so only because we are still too Platonic, too Christian—because our habits have outlived the belief in which they once had their foundation?

Why should art not be dishonest? Can the artist even afford to be honest? Is there something which demands of us that we be honest, a demand which man can refuse to heed only by becoming somehow less? When Socrates tells his fellow Athenians that only the examined life is worth living, is he stating something we must all assent to, or is he introducing a particularly sinister illusion, sinister because it prevents man from taking himself and his way of life for granted?

The Socratic demand for self-examination makes the essence of man a problem; the meanings which we usually take for granted are challenged. This challenge does give man a new freedom, but by the same token it makes him rootless. Man can bear this freedom only if he can turn to a transcendent meaning to guide it. Socrates required Plato to complete his work. But did Plato succeed? Did his successors succeed? Perhaps, as young Kierkegaard suspected, Aristophanes rather than Plato presented us with the true Socrates; perhaps Socrates is only the servant of the clouds, and the ideals with which Platonism and Christianity populated these upper regions are mere illusions; now that these illusions have been dispelled and we see clearly, we see once more only clouds.

If this view is accepted, man's pursuit of a higher meaning becomes a pursuit of illusion, an illusion which may not be acknowledged as such if the absurdity of this effort is not to be recognized. In this case our definition of art as a revelation of meaning must be translated to read: art is a creation of illusions. As the world does not justify man's demands for meaning he invents an imaginary world in which he can feel at home. If the world is indifferent to man and his needs, illusion is necessary.

To understand art as a creation of illusions is not to say that it is therefore necessarily in bad faith. To be in bad faith man must recognize in some way what it would mean to be in good faith. Bad faith presupposes that the individual could recognize illusion as illusion if he so chose. But illusion may be mistaken for the truth in good faith. Thus although we may deny the existence of God—a denial which would imply that much traditional art is based on an illusion—this does not force us to say that such art was created in bad faith and is therefore Kitsch. For the illusion, if indeed it was that, was the foundation of what was felt to be a genuine claim. Only when man has emerged from his supposed ignorance and has recognized his transcendence over the God he formerly worshipped does bad faith

emerge—as man flees from freedom and the nothingness which it reveals back to the safety of what he must now know to be an illusion. Kitsch makes a project out of ignorance. It is characterized by the recognition of man's transcendence over what he has made the center of his projects and by a refusal to acknowledge this. Like modern art Kitsch has its foundation in the freedom of modern man; but Kitsch seeks to escape from it. In dread of freedom man pretends that the meanings with which he has endowed the world transcend their creator. Kitsch is unable to discover meaning and beauty except in illusion; and yet it cannot admit this but must pretend to be genuine if the illusion is to be enjoyed.

Kitsch may in time give birth to a new innocence. What is at first believed only in bad faith may gradually begin to be taken for granted. As bad faith becomes second nature, the awareness of self-deception recedes into the background until in the end it disappears altogether and bad faith becomes faith. In this case Kitsch, like modern art, would be characteristic of an age in transition, an age between the God of the tradition and some new divinity, no more real than the old God, yet real enough to endow life with meaning.

If there is to be an alternative to Kitsch it must be possible to discover a meaning which does not have its foundation in man's freedom. Only the belief in such meaning enables one to insist on honesty and to condemn Kitsch. Error, Nietzsche writes, is due not to blindness but to cowardice, and while this is certainly not true of all error, it is true of the error which accounts for the falsity of Kitsch. Error here has its foundation in a lie to oneself, a lie born by the dread of having to face the human situation as it is, without the merciful veil of illusion. Kitsch is the art of the "last man," of the coward who needs his cowardice to safeguard happiness. But again we must ask whether the rejection of cowardice can be justified. To demand that man be truthful and in good faith is to presuppose that man is measured even if we do not know clearly what this measure is. If this belief in a vocation of man were lacking, why would one choose to struggle to be in good faith only to meet in the end with certain defeat? Why should one not succumb to illusion? We can insist that man should act and create in good faith only if we believe that man's search for himself makes sense and that the goal of this search, although not transparently given, is nevertheless somehow present. In some obscure way man must be aware of his measure. It

is this belief—whether it can be justified is another question—which enables Nietzsche to condemn the last man who has chosen to forget himself and has found happiness in this forgetting. Nietzsche, too, is engaged in the search for the unknown God.

Modern art participates in this search. Its great myths, the myth of absolute freedom and the myth of a return to immediacy, reveal the predicament of modern man. Forced to be free, man yet lacks autonomy and depends on a transcendent meaning if he is to affirm himself and his freedom. Modern art lacks the strength to reveal that transcendence; it does not show man his calling. Yet by offering resistance to the temptation of Kitsch, it reveals man to have a calling, even if it does not say what this calling is. The nihilistic strand of modern art is demanded by man's freedom, but if it is not to destroy all meaning it must be tempered by a recognition that man is called. If modern art is not to be supplanted by Kitsch, artists must know how to listen and must try to reveal what it is that calls man. This is not to say that we must return to the tradition; unless the artist still finds himself called by the God of the tradition, such a return is possible only in bad faith. But to say that God does not call man is not to say that man is not called at all. We may no longer know our place in the world, yet the world still speaks to us. A geometric figure, a crack in a concrete wall, neon reflections on wet pavement, melting snow, a wrinkled skirt, the motion of a hand—we have to listen carefully to hear this language at all. Such listening takes modesty and patience, modesty because first man must recognize that he depends for meaning on something transcending his freedom, patience because we capture meaning only in fragments. Modern man lacks the comprehensive vision of past ages; this lack faces him with a constant temptation to erect idols in the place of the absent God. Only the will not to permit oneself to be deceived guards us against Kitsch. Such honesty could lead to a realism which breaks with the great myths of modern art—and there are signs of such a development in contemporary art. Such a realism no longer searches for the novel or the interesting, nor does it sacrifice the world to its vision of more fundamental levels of being. It is content to explore the meanings of the world in which we find ourselves. Perhaps out of such fragments a new, more comprehensive vision will once more emerge.

Index